THE LAND WE ARE

THE LAND WE ARE

ARTISTS & WRITERS UNSETTLE
THE POLITICS OF RECONCILIATION

EDITED BY GABRIELLE L'HIRONDELLE HILL
& SOPHIE McCALL

ARP BOOKS, WINNIPEG

ARP BOOKS (Arbeiter Ring Publishing)
201E-121 Osborne Street
Winnipeg, Manitoba
Canada R3L 1Y4
arpbooks.org

Printed in Canada by Friesens
Cover design by Sébastien Aubin
Interior design by Relish New Brand Experience Inc.

ARP acknowledges the financial support of the Government of Canada through
the Canada Book Fund for our publishing activities.

ARP acknowledges the support of the Province of Manitoba through the Book
Publishing Tax Credit and of Manitoba Culture, Heritage, and Tourism through
the Book Publisher Marketing Assistance Program.

We acknowledge the support of the Canada Council for our publishing program.

With the generous support of the Manitoba Arts Council.

Printed on paper from 100% recycled post-consumer waste.

LIBRARY AND ARCHIVES CANADA CATALOGUING IN PUBLICATION

The land we are : artists and writers unsettle the politics of
reconciliation / edited by Gabrielle L'Hirondelle Hill and Sophie McCall.

Includes bibliographical references.
ISBN 978-1-894037-63-1 (pbk.)

1. Native art--Canada. 2. Art, Canadian--21st century.
3. Reconciliation. 4. Canada--Race relations. I. Hill, Gabrielle
L'Hirondelle, 1979-, editor II. McCall, Sophie, 1969-, editor

N6549.5.A54L34 2015 704.03'97071 C2015-901657-6

CONTENTS

PART FOUR
Insurgent Pedagogies, Affective Performances, Unbounded Creations

Acknowledgements

Reconciliation. A troubled and troubling term often used to impose a sense of closure on experiences of colonization that are very much alive and ongoing. We are grateful to the artists and writers who took it upon themselves to engage with this concept, to shake it up, to wrestle with it, and to insist on other possible futures. We thank the contributors for generously offering their time, their words, their images, and their intelligence to this book project which, above all, asserts a role for art and artists at sites of conflict between Indigenous people and the settler-colonial system.

In many ways this book is connected to and emerges from other projects and conversations that have been ongoing over the past several years. To those who attended the *Reconciliation: Work(s) in Progress* symposium at Algoma University in September 2012 and the *Reconsidering Reconciliation Residency* at Thompson Rivers University in August 2013, we deeply appreciate your contributions in workshopping the concepts and methods behind *The Land We Are,* and we thank you for continuing to do challenging and critical work in the arts. To Ashok Mathur and Jonathan Dewar, we thank you for organizing those events and supporting this venture, and for being part of this dialogue over many years. We acknowledge the Truth and Reconciliation Commission of Canada and the Social Sciences and Humanities Council of Canada, whose financial assistance made this book possible. A special thank you is due to the Shingwauk Residential School Centre for their support and ongoing friendship. We also owe thanks to Dave Gaertner for offering feedback

on our earliest drafts; to Gabrielle's mother, Madeleine MacIvor, for advising us at times when we were unsure how to proceed; to Sophie's partner, David Chariandy, for always being her first reader; to Stacey Bishop, Christine Kim, and Deanna Reder for their invaluable suggestions regarding the introduction.

We are grateful to ARP Books, both for publishing *The Land We Are* and for their continued support of Indigenous authors and intellectuals, especially Josina Robb and John Samson, who worked closely with us to craft the final text. Thank you to Terry Corrigan for his design work and Sébastien Aubin for the cover.

We are thankful to the publishers and authors of works that appeared previously in other venues: an earlier version of Leah Decter and Jaimie Isaac's chapter was published in *West Coast Line* 74 (Summer 2012): 160-77; Jordan Abel's "please check against delivery" was originally published in *SubTerrain Magazine* 67 (Summer 2014): 3; and the excerpt from Layli Long Soldier's *Whereas* first appeared on the website *Pen America* (November 20, 2013), as well as in a print volume of the magazine.

We gratefully acknowledge Rebecca Belmore for allowing us to use images of her work, *Ayum-ee-aawach Oomama-mowan: Speaking to Their Mother*. All other images are courtesy of the artist or photographer named in the captions.

Art moves us but does not necessarily move us to action. Gestures in the aesthetic realm may symbolically resist the dominant culture, but there is little empirical evidence to show that art leads to direct action or that viewing it makes us better people. And yet some of us do feel changed, and we continue to make and enjoy the stuff *as if* it mattered, *as if* it made a difference. What art does do—and what is difficult to measure—is that it changes our individual and collective imaginaries by particles, and these new pictures of the world can influence behaviour. Queer pride parades and Idle No More round dances do change how we see and treat each other and ourselves.—DAVID GARNEAU

I challenge the idea that the colonial relationship between Indigenous peoples and the Canadian state can be significantly transformed via a politics of recognition. ... I take "politics of recognition" to refer to the now expansive range of recognition-based models of liberal pluralism that seek to reconcile Indigenous claims to nationhood with Crown sovereignty via the accommodation of Indigenous identities in some form of renewed relationship with the Canadian state. ... [T]he politics of recognition in its contemporary form promises to reproduce the very configurations of colonial power that Indigenous peoples' demands for recognition have historically sought to transcend.—GLEN COULTHARD

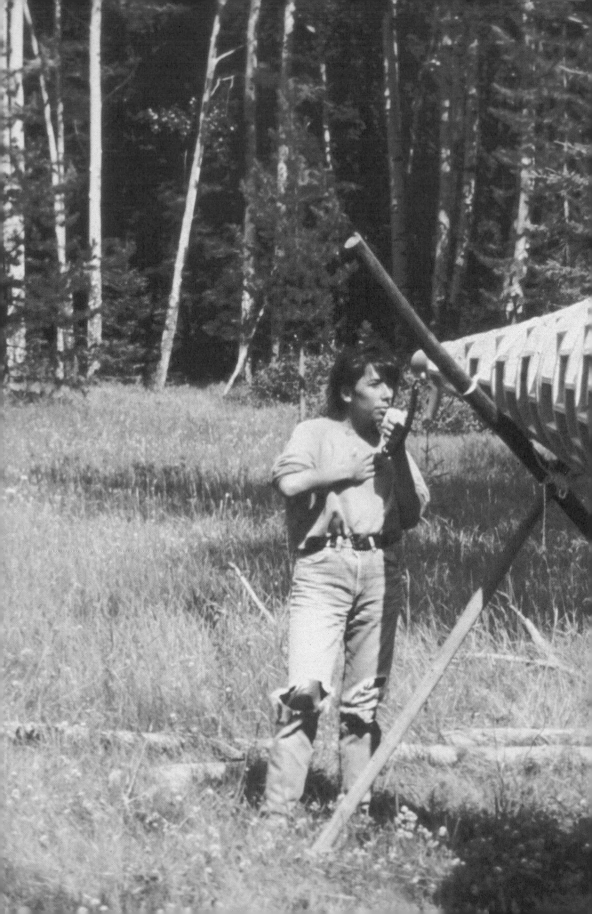

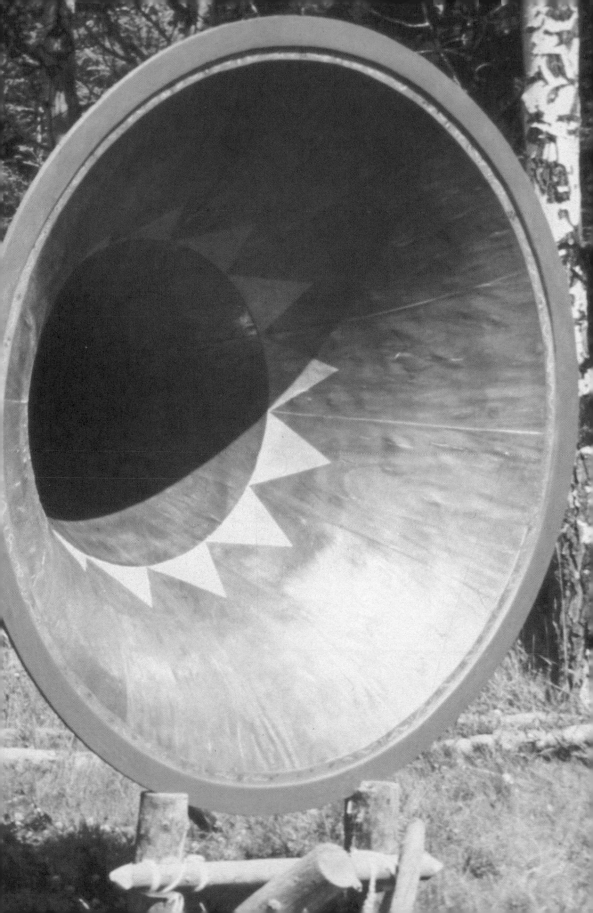

PREVIOUS PAGE: Rebecca Belmore. *Ayum-ee-aawach Oomama-mowan: Speaking to Their Mother*. Gathering in Banff National Park, Alberta. 1991. (MONTE GREENSHIELDS)

INTRODUCTION

Gabrielle L'Hirondelle Hill and Sophie McCall

This chapter opens with a photograph of Rebecca Belmore's *Ayum-ee-aawach Oomama-mowan: Speaking to Their Mother*, a work created in the aftermath of what Belmore calls the "Indian summer" of 1990, the 78-day standoff between the Mohawks of Kanehsatà:ke and the Canadian Armed Forces.[1] The artist took *Ayum-ee-aawach Oomama-mowan*, a larger-than-life wooden megaphone, from blockade to blockade throughout the summer of 1992, inviting Indigenous people to speak to the land they wished to protect. In an interview at the Wiggins Bay Blockade in Northern Saskatchewan, Belmore explains: "I wanted ... to take it out to the people, to Native people, and turn it towards the land, so that the people could speak to our mother, to the earth, and feel very positive about speaking out and not be afraid to speak out" (Beaucage). We begin with this image because it addresses a crucial cross section of concerns at the heart of this book: land, the role of the artist, and the contested discourse of reconciliation in Indigenous cultural politics. If, as recent scholarship has argued, the current federal policy of reconciliation first emerged as a strategic response to the standoff at Kanehsatà:ke, and was intended to undermine the growing movement of Indigenous land-based activism in Canada, then *Ayum-ee-aawach Oomama-mowan* can be understood as an alternative response. Rather than expressing a desire to move away from conflicts like the one at Kanehsatà:ke, Belmore's work foregrounds the importance of such activism, frames barricades as places of creativity and community, and asserts a role for art and artists at sites of dissent between Indigenous people and the settler colonial system.

As the editors of *The Land We Are: Artists and Writers Unsettle the Politics of Reconciliation*, we acknowledge reconciliation as contested

terrain in relation to Canada as an ongoing settler colonial enterprise. Accordingly, we approach the concept as a problematic narrative about Indigenous-settler relations, but also as a site where conversations about what a just future looks like *must* occur. In this context, we believe that given the prominence of the arts as an avenue through which reconciliation is promoted, contested, and reimagined, artists and writers have much to contribute as actors in the struggle over and against this complex discursive field.

While Indigenous artists have long been addressing the experience of colonization, recent public interest in the Truth and Reconciliation Commission of Canada (TRC), as well as in renewing relations with Indigenous peoples more generally, has motivated the arts sector to respond with unprecedented funding, programming, gallery and museum shows, public events, and symposia for reconciliation-themed work. In 2010 the TRC issued an open call for artists to submit works that addressed the legacy of Indian Residential Schools, as well as concepts of "apology, truth, cultural oppression, cultural genocide, resistance, resilience, spirituality, remembrance, reconciliation, rejuvenation and restoration of Aboriginal culture and pride." Not only does the subject matter exclude land rights or restitution, the terms of the discussion are set in the TRC's statement that "artists have a profound contribution to make in expressing both truth and *reconciliation*" (emphasis ours). Municipally and provincially funded public arts projects similarly constrain the discourse. The City of Vancouver, for example, commissioned ten public artworks in 2013 to "honour and celebrate the City's Year of Reconciliation" (City of Vancouver, "Platforms"). In spite of these efforts to prescribe a promotional role for the arts in the discourse of reconciliation, artists, curators, writers, and researchers in the arts have challenged the framework and made significant contributions to a radical re-evaluation of reconciliation. In this collection, artists and writers explore how art and the narrative of reconciliation have been shaped by these funding bodies, and furthermore they assert the potential of art to contribute to a project which, through a critical take on reconciliation, foregrounds issues of land, spiritual and epistemological resurgence, and ideological struggle. In spite of the many pressures of co-optation, the artists and writers brought together here persist in asking: what can and does art *do* to bring about the necessary

process of decolonizing the mind that intellectuals in anti-colonial strug-
gles across generations and continents have invoked?

A significant feature of *The Land We Are* is that the works included
were produced collaboratively. Throughout the text, collaboration becomes
a way to talk about issues central to the task of decolonization, including
Indigenous and settler roles and responsibilities, as well as conflict as a
site of creative and political productivity. Many of the contributors to this
volume have been working together, directly or indirectly, over the course
of many years, challenging one another to further develop their art prac-
tice and to deepen their critical engagement with the topic. Beginning in
2010 with a project funded by the TRC, several of the artists involved met
together to discuss, make, plan, collaborate, perform, and learn from one
another in a series of workshops, exhibitions, performances, and artis-
tic residencies held at Simon Fraser University (2011), Algoma University
(2012), and Thompson Rivers University (2013). Much of the work that is
showcased in this collection is a direct result of the relationships fostered
during these gatherings.

Many of the contributions address the rewards and challenges of work-
ing through difference within collaborative relationships, often highlight-
ing the divergence among their voices as much as their confluence. Our
own collaboration as Métis artist and settler scholar crosses many bound-
aries, and as we worked together on the introduction, differences emerged
reflecting our disparate preoccupations or concerns, as well as our varied
experiences, backgrounds, and interests. Throughout this introduction
we highlight the many voices that are a part of this conversation, at times
interrupting the text to create dialogue between others. If read carefully,
the differences in our voices can be detected, though through the edit-
ing process we have come up with a shared text that we both stand by.
Ultimately, our goal in drawing on many voices and creating a multi-lay-
ered document, in a dialogic presentation of quotation, image, and text,
is to suggest that the politics of reconciliation is an ongoing site of strug-
gle, disrupting teleological constructions that insist on "moving on" from
conflict created by a colonial event safely located in the past.[2]

The book is divided into four sections. Part One, "Public Memory
and the Neoliberal City," focuses on how artists have challenged the con-
ceptual framework of the City of Vancouver's "Year of Reconciliation"

public art program. Against efforts by the city to capitalize on Indigenous imagery to sell itself in an increasingly competitive international market, Indigenous and settler artists have created works that affirm Indigenous claims to land, territory, and sovereignty. Part Two, "'Please check against delivery': The Apology Unlocked," addresses what has been called "the age of apology" (Brooks 3) in settler colonial political contexts, as the contributing artists and poets respond to, reject, and rewrite official state apologies to Indigenous peoples in Canada and the United States. Part Three, "Collaboration, Creative Practice, and Labour," explores the absences and silences within official settler narratives of history, using questions of work, collaboration, and art practices to rediscover the voices and lives of those missing in the wake of a violent colonial history. Part Four, "Insurgent Pedagogies, Affective Performances, Unbounded Creations," looks at politically engaged strategies of performance, teaching, and art-making in programs for social change.

Together, the chapters demonstrate the many fracture lines within discourses of reconciliation: fractures created by and through the struggle for decolonizing Indigenous lands, peoples, and histories in Canada. To Canada's offer of a reconciliation based on closure and unity, the artists in this book make a counter-offer of conflict and disjuncture; they acknowledge the experience of colonialism as ongoing, and dissent as a righteous and productive space from which we might continue to forge a world together. Settler scholars Allison Hargreaves and David Jefferess reaffirm this potential in their chapter, "Always Beginning," when they write about Indigenous road blockades:

> At sites of seemingly irreconcilable conflict between Indigenous and non-Indigenous communities, the barricade is mistaken in the mainstream as the violent embodiment of this impasse rather than an opportunity for its transcendence. ... [T]he barricade could provide an opening onto a different relationship to land and to one another—one that both acknowledges the violence of settlement and resource extraction, and that affirms shared obligations to care-take the land for the wellbeing of future generations. (209-10)

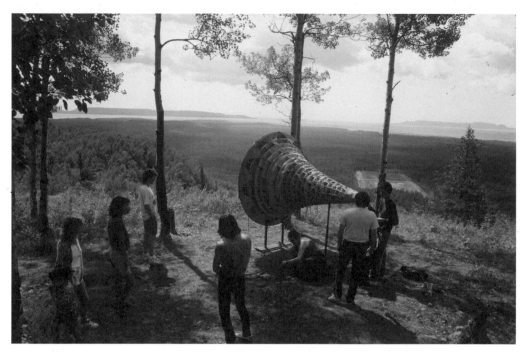

Rebecca Belmore. *Ayum-ee-aawach Oomama-mowan: Speaking to Their Mother.* 1991. Gathering at Mount McKay, Fort William First Nation, Thunder Bay, Ontario. 1992. (MICHAEL BEYNON)

"MY MEMORIES OF THAT SUMMER at Kanehsatake are so different from the stories told by the media. Their attention was focused on the barricades. To most of them, this was just a cop story; the police and soldiers were there to "restore law and order," to put things back the way they were. But most of the people behind the barricades were my family, friends, and relatives. And they didn't want things to go back to the way they were. They knew that would mean a certain and steady ride down a one-way street to an oblivion called assimilation."

—DANIEL DAVID, MOHAWK WRITER AND JOURNALIST, FROM *PEOPLE OF THE PINES.*

"WAVE YOUR HANDS and leap for joy...
We are the future,
Our nation will succeed,
We have the right to live where
 we want to live,
Everybody say yeah!
This is *our* land."

—MEMBER OF THE WIGGINS BAY BLOCKADE IN NORTHERN SASKATCHEWAN, AUGUST 1992, PARTICIPATING IN REBECCA BELMORE'S *AYUM-EE-AAWACH OOMAMA-MOWAN* PROJECT. (BEAUCAGE)

The idea that spaces of dissent can be generative and creative has deeply informed *The Land We Are*. In conversation, the voices of the contributing artists and writers deny any notion of reconciliation as settled discursive territory. However, there are common threads that run through the contributions. One is an insistence on the importance of land to any discussion of the relations between Indigenous people, settlers, and the state. Another commonality is a belief in the role that art can and must play—whether that role is one of healing, disruption, or contributing to an ideological shift. And finally, the artists and writers involved in this project make clear the stakes that both Indigenous people and settlers have in refusing the empty words and gestures of reconciliation as a substitute for action and change.

Residential Schools, Land, and Fault Lines in the Discourse of Reconciliation

> For 300 years we have been engaged in reconciliation processes. We have no land to show for that. We have retained no land rights.—LEANNE SIMPSON

> Without massive restitution made to Indigenous peoples, collectively and as individuals, including land, transfers of federal and provincial funds, and other forms of compensation for past harms and continuing injustices committed against the land and Indigenous peoples, reconciliation will permanently absolve colonial injustices and is itself a further injustice.—TAIAIAKE ALFRED

> we're in the forefront of a powerful movement,
> asserting ourselves as the landlords
> we may not get it all back, but we will get something, psychologically
> even if you have a small reserve, it's important to know that you're the
> landlord.—ALEX JANVIER

The Truth and Reconciliation Commission hearings, as well as other manifestations of reconciliation like Vancouver's Walk for Reconciliation,[3] have been important for many people as steps towards acknowledging and addressing the experiences of Indigenous people in Indian Residential Schools. Many survivors, including those who have worked tirelessly for decades to bring the history of residential schools to light, experienced

these events as moments of achievement and personal healing. Furthermore, as Leanne Simpson points out, these events politicized many non-Indigenous Canadians, teaching them about an important and devastating aspect of colonization in Canada. As Simpson says, "this is a very good thing" ("Restoring"). However, reconciliation can also function hand-in-hand with Canada's drive to forget and turn the page on what Prime Minister Stephen Harper has referred to as the "sad chapter" of residential school history.

For many writers and thinkers who have considered deeply the challenges of decolonization, reconciliation is a top-down initiative that, far from addressing the root causes of the fractured relationship between Indigenous people and the State, fixates upon resolution and absolution. In this context, the desire to *resolve* is connected to the desire to *forget*. For Kanien'kehá:ka scholar Taiaiake Alfred, reconciliation often works as a "pacifying discourse," demanding that Indigenous people become "reconciled with imperialism" ("Restitution" 182, 183). Instead, Alfred argues, what should be pursued is a politics of restitution of Indigenous lands and of Indigenous traditions of governance. In a compelling analysis, Alfred puts resurgence and redress, not reconciliation, at the centre of his project.

As Alfred and other decolonization theorists insist, it is important to acknowledge that residential schools are only one aspect of a larger set of colonizing forces; the expropriation of land, resources, and power must also become part of the conversation. In this vein, many writers have approached calls for reconciliation skeptically. Paulette Regan suggests that a "deep divide exists between Indigenous peoples and Canadians about what reconciliation is and how best to achieve it" ("An Apology" 47): while advocates for Indigenous rights often highlight the need for reparations in the form of land, resources, and other forms of restitution, Canada wants to "achieve legal certainty" (48).

"Certainty," for the provincial and federal governments of Canada, requires a final solution to a climate of economic insecurity created by Indigenous legal claims to land on one hand, and Indigenous social movements on the other, both of which disrupt land and resource development. In a "Fact Sheet" on the treaty process, the Government of Canada explains how "uncertainty about the existence and location of Aboriginal

rights creates uncertainty with respect to ownership, use and management of land and resources. That uncertainty has led to disruptions and delays to economic activity in BC. It has also discouraged investment" (Aboriginal Affairs and Northern Development Canada). Reconciliation, with its focus on closure and a unified nation, seeks certainty by placating social unrest while simultaneously reinforcing the image of the state as making every effort to address Indigenous concerns.

Indeed, there exists convincing evidence that the federal government developed a policy of reconciliation as a means to manipulate negotiations with Indigenous people away from issues of land and restitution. In Chapter 11 in this volume, Adrian Stimson recalls in his interview with Jonathan Dewar that reconciliation emerged on the political scene in the 1990s, a decade marked by an upsurge in radical Indigenous mobilization around land rights. At that time, Stimson was working as a tribal councillor and community land claims negotiator for the Siksika Nation, of the Blackfoot Confederacy. He says that at the same moment that he and the other Blackfoot land negotiators were close to securing a deal, the government would stall: "We were well ahead in terms of negotiations and it all just fell apart, quite simply because every time we would come up with a notion of self-government that suited us, it didn't suit the government" (185).

Significantly, the concept of reconciliation first appeared as part of the official government response to the Oka crisis. In January 1991, a few months after the violent end of the standoff in Quebec, the embattled Mulroney government struck the Royal Commission on Aboriginal Peoples (RCAP) and asked the commissioners to "make recommendations promoting reconciliation between aboriginal peoples and Canadian society as a whole" (Canada, "The Commission's Terms" 699). Following Oka and RCAP's recommendations, a series of reconciliation initiatives were created: in 1998 Jane Stewart, Minister of Indian and Northern Development, delivered the "Statement of Reconciliation"; also in 1998 the Aboriginal Healing Foundation was established; in 2005 British Columbia created the Ministry of Aboriginal Relations and Reconciliation, which was mandated with the task of modern treaty making; and in 2008 the TRC was formed. Many of these supposed reconciliation programs either

bracket questions of land or impose closure and certainty with regards to land and Indigenous rights.[4]

Yellowknives Dene scholar Glen Coulthard, who also discusses the Oka crisis as a point of origin for Canada's policy of reconciliation, notes that Oka came at a time of heightened land-based Indigenous insurgence: "From the vantage point of the colonial state, by the time the seventy-eight day standoff at Kanesatake started, things were already out of control in Indian Country" (*Red* 118). The true danger posed by these instances of insurgence, argues Coulthard, was not in the potential for violence but in the "breakdown of colonial subjection and thus ... the possibility of developing alternative subjectivities and anticolonial practices" (115). For Coulthard, then, Canada's politics of reconciliation diverts attention from the underlying question of land and also aims to produce a cooperative Indigenous subject.

Anishinaabe writer and activist Leanne Simpson identifies the impossible predicament Indigenous peoples are faced with when asked to simultaneously embrace discourses of reconciliation while relinquishing claims to land. For Simpson, the state-sanctioned official routes to asserting Indigenous land rights against encroachment and environmental devastation have proven ineffectual and too easily circumvented. She describes Indigenous communities attempting to register their dissent through Canadian legal strategies and environmental impact assessments but states: "Our dissent is ignored. ... Slowly but surely we get backed into a corner where the only thing left to do is to put our bodies on the land" ("Restoring"). Although she acknowledges the important work that the TRC has done and its transformative effect on many, Simpson approaches this "new" era of reconciliation with suspicion. Will the apologies be followed by action, she asks? For Simpson, practicing traditional knowledges like medicine gathering and ceremony on the land is crucial to asserting Indigenous rights and sovereignty today. However, she reports experiences of harassment and surveillance by police forces and settlers when she attempts to do so. She asks, "How can we be living in a time of reconciliation when I am harassed every time I go out on the land?" ("Restoring").

"AFTER I GRADUATED FROM LAW SCHOOL, I returned to my father's traditional land near the Whitefish reserve and to the waters that I had been to when I was a child, and they were gone. The waters had dried up! It was a terrible thing to witness.

When my father and I went back to his traditional hunting lands, his cabin was gone. There was just a huge burn mark on the ground. When my father saw it, he just stood there, so quiet, so upset. It was terrible to watch.

I started investigating, and I learned that the conservation officers had blocked hunting roads to keep the traditional indigenous hunters away, and the lands were being logged. I felt intensely protective of the land and the water, so I went around nailing boards on trees, saying, 'No Trespassing. Treaty 6 Territory!'"—SYLVIA McADAM , COFOUNDER OF THE IDLE NO MORE MOVEMENT. (VAN GELDER)

"THIS IS OUR FAMILY'S TRAPLINE ... this is the area where we're going to build the cabin ... and we're doing it for our family and taking back our land to live in. We've had this trapline from a long time ago, beginning with my dad and his father and so forth. We've always been around this area. Around here we trap, we fish, we swim, we bring the children to show them about the bush and we're trying to get our city relatives to come back to the land as well, to be free of the city life. We just want our family back here and situated where they're rightfully from, where they should be."—DARLENE NECAN , WHO FOUGHT CHARGES AND OVER $10,000 IN FINES FOR BREACHES TO THE PUBLIC LANDS ACT AFTER BUILDING A CABIN ON HER ANCESTRAL TERRITORY. (FELIPE)

The question of land is a theme that is returned to again and again in this book. Many contributors draw attention to the uneasy relationship between ongoing struggles over land and the demand to embrace reconciliation as if it were an alternative to addressing land rights. The two chapters in Part One both note how the City of Vancouver has used the emotional

discourse of reconciliation as a way to reinscribe national belonging in the context of multiculturalism. In response, artists in Vancouver have sought to assert the key importance of land, territory, and Indigenous sovereignty. In Chapter 1, Stó:lō scholar Dylan Robinson and settler academic Keren Zaointz examine closely the city's impulse to incorporate Coast Salish design elements in public works—from the spindle whorl design on Vancouver's storm-drain covers to the thunderbird motif on the hoods of Vancouver RCMP vehicles—as well as to commission a broad range of public art by Indigenous and settler artists. Robinson and Zaointz argue that a "civic infrastructure of redress" simultaneously acknowledges and potentially dismisses unceded territory and Indigenous history (22). Members of the Indigenous arts group The New BC Indian Art and Welfare Society Collective (NBCIAWSC), in their collaborative drawings and co-authored essay in Chapter 2, further consider the implications of public art in relation to Indigenous space and land in the city of Vancouver. The collective's drawings were selected to be part of Vancouver's 2014 "Year of Reconciliation" public art program and were exhibited in bus shelters across the city. In their essay, the artists critically question the significance of this initiative, assessing the dual potential for Indigenous art in Vancouver to be co-opted by the City to create an attractive profile for international investors on the one hand, and to assert the right of Indigenous bodies and nations to take up public space and land on the other.

In Chapter 8, settler artists Leah Decter and Ayumi Goto bring into dialogue two art projects that focus on land, settlement, and labour. Decter's installation, *castor canadensis: provokas*, asks the audience to consider how the beaver has been used as a symbol of Canada's "industry" and moral "industriousness" while at the same time denying or covering up the true cost of colonial invasion and appropriation of land, bodies, and labour. Likewise, Goto's performance, *sonorous shadows of Nishiyuu*, honours the importance of land in the work of Cree artist Cheryl L'Hirondelle as well as in the actions of the Cree Nishiyuu walkers, who traveled 1568.5 kilometres during the winter months of 2013 to petition for an audience with Prime Minister Stephen Harper. In dialogue, Decter's and Goto's projects underline the key importance of Indigenous land in discussions of

decolonization and reconciliation. These and other chapters in this book suggest that the question of land remains central to Indigenous art and cultural politics. While the official terms of reconciliation often distract from more materially grounded demands for restitution and social change, the artists and writers in this book insist that Indigenous land rights are central to reimagining the future between Indigenous and settler peoples.

The Role of Art and Artists in Reconciliation, Resurgence, and Decolonization

> As the Canadian Government works through its process and further bureaucra-tizes Aboriginal suffering, I seek another way to reconcile my experience: I do it through my art making.—ADRIAN STIMSON

> Today, most art is ugly, because it's not responsible to the people it steals from. Real, honest-to-God true art steals from the people. It's a thief.... It comes in, and you don't even notice that it's there, and it walks off with all your stuff, but then it gives it back to you and heals you, empowers you, and it's beautiful.
> —MARIA CAMPBELL

Arts-based approaches to reconciliation are often touted as a positive step forward and are viewed favourably in narratives of "moving on" and "heal-ing" in the name of a unified nation. The widely accepted truism that art heals suggests an affective process that does not necessarily involve insti-tutional change. Furthermore, it implies that art's function is to smooth over, to make whole rather than to disrupt. With considerable funding op-portunities and institutional support, arts-based approaches to reconcili-ation have become an industry in itself: galleries, museums, universities, and other art institutions have taken on art and reconciliation as a theme; cities have embraced reconciliation through the arts as a way of creating a civic profile in an age of gentrification and neoliberalism; governments have sponsored artists to create works that suggest that reconciliation has been or can be achieved; and, of course, Canada's Truth and Reconciliation Commission has requisitioned artworks, has an open call for artistic sub-missions, and has curated exhibitions.[5] While many of the contributors to this volume have taken part in these kinds of initiatives, they also critically

question what's behind this impulse to promote reconciliation through the arts. They have explored the possibilities and limits of art to contribute to ideological shifts, promote dialogue, and even to heal, as well as to create productive sites of discomfort, disconnection, and disruption.

In his essay "Imaginary Spaces of Conciliation and Reconciliation," Métis scholar and artist David Garneau analyses the symbolic function of art within the discourse of reconciliation, wherein the "public display of private (Native) pain" is expected to lead to "individual and national healing" (37). In contrast to this exhibitory imperative of reconciliation and the TRC, Garneau proposes alternative spaces in which art can be made, displayed, and reimagined. He describes "irreconcilable spaces of Aboriginality" where Indigenous artists and cultural producers make things apart from the shaping gaze of the colonizer, as well as "Aboriginal sovereign display territories" (37), places managed by Aboriginal people yet open to respectful outsiders. As spaces of "perpetual conciliation" (38), rather than "reconciliation," these sovereign display territories have potential as places of cross-cultural exchange, in which historically entrenched roles are consciously challenged and re-imagined.

Garneau's experiment with Chinese Canadian artist Clement Yeh in the performance and game *Apology Dice*, described in Chapter 4, generates this mixed pedagogic space. The work consists of three carved dice that, when rolled, combine to form personal statements about the reconciliation process in Canada. The aspect of chance as well as the scale of the oversized dice cast doubt upon appropriate and well-worn sentiments, such as "We are / so / sorry," and make approachable offensive and unvoiced expressions like "I am / very tired / of this." While *Apology Dice* does the work of creating room for dialogue and new relationships among the players, it also denies a fixed response, an official narrative of unity, offering instead, as Garneau and Yeh write in this book, "an intellectual and empathetic dissonance" (77).

In Chapter 9, Skeena Reece and Sandra Semchuk reflect on the making of Reece's affectively wrenching video work, *Touch Me* (2013), and similarly assert the possibilities of art to address the fractured relationships created by settler colonialism. Reece's *Touch Me* shows the Cree/Tsimshian performance artist carefully bathing Ukrainian Canadian artist Semchuk

as she lies in a claw foot tub. The video, while it denies any easy sense of closure, speaks to the damages that residential schooling and other systems of colonial violence have wreaked upon families, intergenerational ties, and our ability to care for one another. In this sense, *Touch Me* begins the work of repairing safety and intimacy within Indigenous communities—work Leanne Simpson argues is core to rebuilding Indigenous nationhood. For Simpson, the effects of residential schooling on familial relationships strike at the heart of Indigenous sovereignty: "Families are the core of our governance and our political system," she explains, "breaking that was the point of residential schools" ("Restoring"). Moreover, Simpson argues, the family violence that stems from residential schools helps maintain and reproduce colonial power. While many of the authors in this text are rightly critical of the narrative of healing in official discourses of reconciliation, Reece and Semchuk's chapter powerfully underscores the real need for both Indigenous and settler people to consider how colonialism has damaged families and their relationships, and to work to repair that damage.

Many of the contributors to this book insist that art possesses a potential to disturb, to challenge, or to claim space. In Chapter 11, in his interview with Jonathan Dewar, Adrian Stimson states: "I've always believed that the art object itself cannot heal" (193). Rather, what art is capable of, Stimson explains, is expressing an experience that the audience can use to reflect upon and challenge their own knowledge and understanding:

> artists are a conduit for the community in many different ways, of the experience that has happened in the community.... I think artists have that role, or are charged with that role, within the community to be seers, to mirror back what's going on so that the community can agree or disagree or be confused, or in some weird way have that information transferred to them for them to resolve. (193)

The role of art in transferring power to the audience is a central theme in this book; the contributors are determined to make art that activates rather than art that resolves or pacifies.

Mobilizing an audience's sense of social engagement is a key goal for Leah Decter and Jaimie Isaac in Chapter 7, in which they describe their collaborative project, *(official denial) trade value in progress*. The project is both an arresting art object—a 12' x 15' textile piece made from reconfigured Hudson's Bay Point Blankets—and a series of ongoing pedagogical interventions. During "sewing actions," participants respond to Prime Minister Stephen Harper's hypocrisy when he apologized to residential school survivors in 2008 and then denied Canada's settler colonial history a year later (Ljunggren). Participants in sewing actions write their responses in books and then choose another person's comment to sew into the blanket. Along with the complex layering of voices that occurs during a sewing action, the interaction between the front and back of the blanket adds meaning to the work. While the front of the blanket highlights the importance of intervening at a key moment in Canadian politics with deliberate, incisive cultural critique, the back of the blanket seems haunted by the unnamed, tangled emotions that swirl around and through settler myths of national amnesia.

Art, for some of the contributors, can work to decolonize through spiritual reconfiguration and ceremonial practice. In Chapter 10, which describes the performance piece *Hair*, Tahltan artist Peter Morin becomes the scissors that cut the hair of residential school students. With twenty-eight heavy stones tied to his arms, legs, and torso, Morin's body at once signifies the burden of colonial violence as well as the purifying potential of pain through ceremony. Japanese Canadian artist Ayumi Goto, Morin's collaborator, responds with a Japanese traditional act of "spiritual gifting," cutting her own hair off and offering it to Morin. For Morin and Goto, art is a space where spiritual practices can be called upon as alternative systems of knowing and doing that help us face difficulties and forge new alliances.

Chapter 6, Jonathan Dewar's narrative and photographic essay on the commemorative art installation, *Walking With Our Sisters* (a collaborative project initiated by Métis artist Christi Belcourt), also underlines the tight interrelationship between art and spiritual practice. Belcourt's installation of almost two thousand pairs of moccasin vamps at the Shingwauk Auditorium at Algoma University, part of the former Shingwauk Indian Residential School, functions more as a memorial than an exhibit. This work initiates an important dialogue between the stories and experiences

of survivors of residential schools with those of murdered and missing Indigenous women. As Dewar emphasizes, every aspect of the project had to be done with ceremony: "our first tasks were to bring together the members of the community who would volunteer to fill the essential roles of Elders and Keepers. In each host community, local Elders are asked to provide guidance over the organization and ceremony to honour local protocols and needs. Keepers work closely with the Elders and take up the responsibility of looking after the bundle, ceremony, and protocols" (90). This community context is resonant of Garneau's "sovereign display territories," a space where shifts in consciousness and dialogue can occur outside of the boundaries imposed by colonial institutions.

Cree poet and scholar Neal McLeod says that the Cree word that refers to the experience of residential schools is ê-kiskakwêyehk, which means "we wear it" (qtd. in Garneau 36).[6] The phrase powerfully suggests the personal weight of residential school legacies. The idea that the experiences of colonialism are worn on the body echoes throughout this book: in Morin's stones, in the vamps in *Walking With Our Sisters*, in Stimson's performance alter-ego Buffalo Boy, and in the NBCIAWSC's drawings of clothing. As Garneau points out, McLeod explains that there is no equivalent in the Cree language for the Western notion of an apology. He says the closest equivalent to "I am sorry" is nimihta tân, which means "I regret something" (qtd. 36). In contrast to the desire to "get over" the past, "we wear it" is an acknowledgement that the past is always with us. "We wear it" asks us to think self-reflexively about the burdens of history that we wear on our bodies, to confront the lies we have been taught, and to end the silence, denial, and forgetting that is a part of the settler colonial landscape of Canada. To "wear it" is to move towards re-*dressing* past and ongoing injustices. Accordingly, the artists and writers in this book insist that art can and must be a place where changes and shifts occur.

Contextualizing Collaboration

How can we, as non-Indigenous people, unsettle ourselves to name and then transform the settler—the colonizer who lurks within—not just in words but by our actions? ... I unravel the Canadian historical narrative and deconstruct

the foundational myth of the benevolent peacemaker—the bedrock of settler
identity—to understand how colonial forms of denial, guilt, and empathy act
as barriers to transformative social-political change.—PAULETTE REGAN

Perhaps precisely because neither of us quite fit the Indigenous and Settler
profiles, we wondered if we might be well suited to devise creative ways to
stimulate conversation about issues of conciliation among all sorts of people
living in these territories. I think of these small, rough, and unofficial gestures
as creative conciliation. They are naïve, symbolic, incomplete, emotional, and
hopeful person-to-person conciliations.—DAVID GARNEAU AND CLEMENT YEH

A distinctive feature of *The Land We Are* is its emphasis on collaboration:
not only is each chapter collaboratively produced by artists, scholars, and
curators, the contributors were also asked to critically reflect on their own
collaborative practice. Furthermore, some of the authors and artists par-
ticipated in the editing process, commenting upon and responding to one
another's responses as this book took shape. The artists in this book ap-
proached collaboration not as a seamless cooperation where differences
are eliminated or effaced, but as a chance to explore the potential for
growth that exists in conflicts created by difference. As a result, working
together through artistic and critical practice became a way of acknowledg-
ing and respecting difference, while being aware of asymmetrical power re-
lationships that inform processes of collaboration. This is precisely Skeena
Reece and Sandra Semchuk's intervention in Chapter 9, which includes our
suggested revisions embedded in the final published version. Reece and
Semchuk's decision exposes the hand we as editors had in shaping the nar-
rative of this book. In the context of reconciliation—a discourse focused
on resolution and unity—a conversation about the value of difference and
dissent in collaborative practices becomes especially pertinent.

In Chapter 12, Allison Hargreaves and David Jefferess engage the con-
cept of collaboration as a model for "reconciliation as *decolonization*"
(emphasis in original). The authors argue that as settler allies, they are
committed to a "collaborative relation of sorts with those who have done
much of this decolonized thinking 'for us.' ... This entails taking our an-
alytical cues from the work of Indigenous scholars, artists, and activists,
while not appropriating this knowledge as our own" (201).

Hargreaves and Jefferess enact this concept of collaboration in their essay, invoking and responding to the words of Indigenous scholars such as Gregory Younging, Jeanette Armstrong, Peter Morin, and Taiaiake Alfred. For Hargreaves and Jefferess, the roles and responsibilities of settlers in projects of decolonization are often obscured, avoided, or denied— because to think concertedly about the responsibilities of settlers would be to acknowledge historical and ongoing complicity with colonization.

Part Two of *The Land We Are*, "'Please check against delivery': The Apology Unlocked," features two poetic works by Indigenous artists that use collaboration in altogether unique and subversive ways. In his poem, Nisga'a writer Jordan Abel appropriates and reconfigures Stephen Harper's "Statement of Apology" to the survivors of Indian Residential Schools in order to reveal the truth beneath the political rhetoric. Similarly, Oglala Lakota poet Layli Long Soldier borrows from President Barack Obama's "Native American Apology Resolution" in her work *Whereas*. Abel and Long Soldier's poems explore the power of language and writing to legally inscribe and bureaucratize colonization, as well as to reclaim, refract, and decolonize. While both works expose the doublespeak of official state apologies, they also enact a type of collaboration that suggests that no narrative is ever closed or sealed against infiltration.

Fractures in discourses of reconciliation are created by and through struggle. There will always be a variety of responses—there is never an end, and there is certainly no closure. Indeed, this is the importance and power of contested critique; conflict suggests in a hopeful way that there is room for change and transformation. The goal of many of the works collected in this volume is to get a diverse range of people engaged in a process of reconceiving a future in the relationship between Indigenous peoples, settlers, and the Canadian state, and to think through in an active, embodied way the contested discursive terrain surrounding reconciliation and decolonization. Land emerges as an important recurring theme—one that exposes as disingenuous a supposedly "new" era of reconciliation. Rather than accepting overly idealistic notions of art as a balm for the wounds created by a colonialism situated in the past, the contributors have asserted a place for art in the conflicts created by the ongoing project of settler colonialism in Canada. The contributors have hope that art can

speak in ways that do not "further bureaucratize Aboriginal suffering," in Adrian Stimson's words ("Suffer" 71). As skeptical as he is about formal processes of reconciliation, Stimson speaks passionately about those moments when art does become transformative on social, psychic, or spiritual levels: "People walked away feeling like they had been changed. Something hit. I think that's so important because, yes, I believe it, I've seen the power of your own personal truth shared. It can be very transformative" (Stimson and Dewar 199).

NOTES

1. Rebecca Belmore explains the impetus for making *Ayum-ee-aawach Oomama-mowan* to the filmmaker Marjorie Beaucage: "The more I looked at all of my feelings over the past year, the summer of 1990, at my self as an artist and what I've accomplished, and what am I doing and why am I doing it, what good is it doing? Am I doing any good? All those questions came together. But also to make it for other people, because all Native people were affected by that summer, it was a big mark in our history" (Beaucage).

2. As Glen Coulthard argues in *Red Skin, White Masks: Rejecting the Colonial Politics of Recognition*, the reconciliation movement frames the rupture between Indigenous people and the state as a historical event that is now behind us, rather than acknowledging it as stemming from the underlying structure of the colonial state (109). As a result of this temporal framing, the onus is placed on Indigenous people to heal from the "legacy" of abuse so that the nation, now whole, can move on.

3. In September 2013, up to 70,000 people gathered in Vancouver to participate in the Walk for Reconciliation, organized by a group independent of the TRC, Reconciliation Canada.

4. For more see Coulthard, *Red*; Simpson, "Restoring"; and Alfred, "Restitution." With respect to the BC Treaty process, Carole Blackburn has argued that the provincial government's drive to impose a sense of "certainty" on Aboriginal rights primarily aims to facilitate large-scale economic development of natural resources in sectors such as forestry and mining (587).

5. To cite only a few examples, please see Vancouver's Year of Reconciliation funding for public arts (City of Vancouver, "Platforms"); British Columbia's Ministry of Aboriginal Relations and Reconciliation funding (British Columbia); and Canada's Truth and Reconciliation Commission open call for artistic submissions (TRC, "Open").

6. We would like to acknowledge David Garneau's essay, "Imaginary Spaces," for bringing this translation to our attention. In an email exchange, Neal McLeod asked us to credit his late father Jeremiah McLeod for the translation of *ê-kiskakwêyehk*.

PART ONE

PUBLIC MEMORY

AND THE NEOLIBERAL CITY

PUBLIC ART IN VANCOUVER AND THE CIVIC INFRASTRUCTURE OF REDRESS

Dylan Robinson and Keren Zaiontz

"First Nations design is so integrated into the fabric of the city. It feels like we're really moving forward on a path to reconciliation." — AUDIENCE INTERVIEWEE FOR VANCOUVER OPERA'S *COAST SALISH MAGIC FLUTE* (2013).

This was not the first time that a settler Canadian colleague had pointed out the benefits of reconciliation for Canada without asking what this integration might mean for the urban Indigenous people who live and work in Vancouver. Why is integration so easily laminated onto reconciliation? From the spindle whorl design on Vancouver's storm-drain covers to the thunderbird motif on the hoods of Vancouver RCMP vehicles,[1] what role does Coast Salish design play in naturalizing the alliance between integration and reconciliation? While many Canadians celebrate integration, and view it as a triumph of multiculturalism, national belonging possesses very different implications for First Peoples. As scholars including Glen Coulthard, Elizabeth Povinelli, and Eva Mackey have argued, the recognition of First Peoples within the integrationist frameworks of late capitalist democratic nation-states constitutes the erosion of First People's sovereign rights.[2] Forms of constitutional recognition such as Canada's official multiculturalism policy (first adopted in 1971) seek to co-opt First Peoples' cultural traditions as enrichments to the identity of the nation-state.

This photo essay examines how the strategies of Indigenous integration have shaped Vancouver's built environment and public artworks. We question the degree to which such integration is at odds with what we call a *civic infrastructure of redress*. This is a form of redress that emphasizes Xʷməθkʷəyəm (Musqueam), Skwxwu7mesh (Squamish), and Tsleil-Waututh history beyond the limits of basic acknowledgment.

Moreover, such redress is concerned with what it means to formally rec-
ognize Vancouver's location on unceded Coast Salish territories through
signs, sculptures, and other artworks in the public realm. We will analyze
how these material practices contribute to and resist self-congratulatory
narratives about nation building that also support Vancouver's claim to
world-class city status. In the ongoing contest between integration and self-
determination, such public art hails the viewer to take a position, spatially
and ideologically, on national belonging. The viewer can recoil from this
hail (as we sometimes did in our walks through the city), feel a sense of be-
longing, or further still a sense of solidarity with the assertion of Indigenous
visibility in Vancouver.

In examining a cross-section of public art that integrates Coast Salish
design and Salishan language, we are particularly drawn to works that
position viewers as readers of Vancouver's cityscape. At first glance, these
works appear to illustrate Michel de Certeau's celebrated argument that
everyday practices such as reading can represent a tactical alternative to
navigating the homogenizing effects of the neoliberal city.[3] But upon fur-
ther scrutiny, such idealism does not hold. Reading the city is not hard-
wired to leftist political intervention—it can be a dynamic path to redress,
but it can also be a form of consumption. A viewer of text-based public
artworks may read the signs but not be called upon to engage with what
they represent, namely the more unsettling fact that such work (like the
city itself) exists in place of the displaced Coast Salish communities that
lived there for thousands of years before settlement. In some cases, the
urban texts that viewers read actively disremember First Nations history
by erasing it from the historical record. In the city's newest neighbour-
hood, the Olympic Village in southeast False Creek, public artworks re-
veal an industrial past and a utopian Olympic future. However, while
First Nations design abounds, First Nations history is markedly absent.[4]

Artist Christos Dikeakos's and architect Noel Best's *Lookout* (1999),
featuring text by poet Robin Blaser, is an installation that explicitly at-
tempts to re-capture the material history of the place where the artwork
stands today. A series of words on the supporting stainless steel walls—
asphalt, lumber, CPR yards, salmon, elk, mudflats, Expo—reference the
site's natural history, its connection to the province's resource economy,

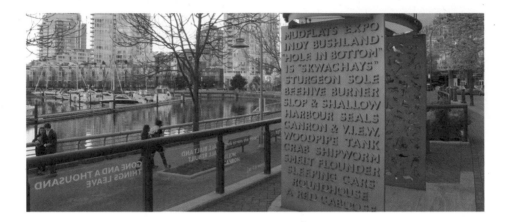

and its modern iteration as a World's Fair. At the top of one of the supporting walls, the words "Hole in Bottom / is Skwachays" disrupts the flow of recognizable English-language words. Skwachàys, or "hole in bottom," is the Skwxw'u7mesh name for the area of False Creek close to Science World; it refers to the part of the Creek that was historically a lagoon that emptied itself at low tide. The inclusion of the word "Skwachays" disrupts the tide of natural and industrial English words, but its inclusion also demonstrates the political limits of acknowledgement. Here, if the viewer takes the time to read through *Lookout*'s two walls of text, she might register this word as a gesture toward cultural difference. But without any reference to the larger history of place that it names, "Skwachays" represents merely difference itself. To the majority of its public readers, it is a vague

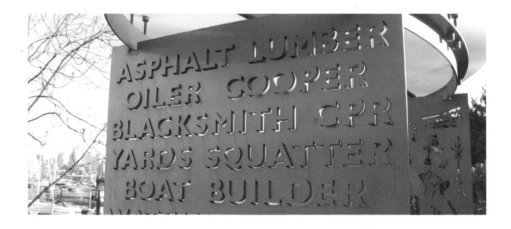

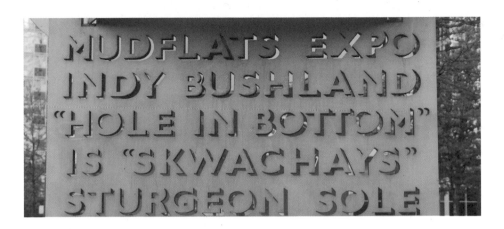

marker of Indigeneity—a sign without referent that is decoupled from the place for which it once stood.

Dikeakos's list of what and who once occupied False Creek is characteristic of much of the public art that documents the history of place in Vancouver. From engravings and markers to monuments and interpretive panels, the language of history covers the city. Too often this language encourages nostalgia for the past, for sawmills and empire, with minimal recognition of its wholesale natural destruction, head taxes, worker exploitation, or colonial violence. These are historical markers scrubbed clean of their forced removals and bloodstains. They are installed in the contemporary city to celebrate the remarkable transformation of the pre-colonial landscape into a site of industry and large-scale production.

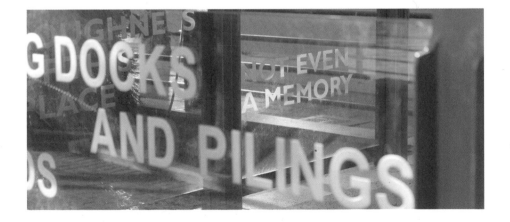

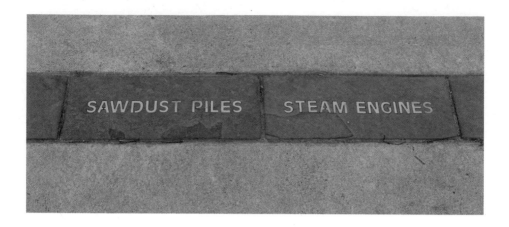

These nods to Vancouver's industrial past prop up the working class pioneer—drawing contemporary settlers in to identify with this labourer as hero—while obscuring the violence done to the land and people in the name of industry.

Historically, the Olympic Village Plaza was a site of urban and industrial fabrication. From the late nineteenth century to the 1960s and '70s, men (and during World War II, women), many of them immigrants, worked in plants as well as lumber, rail, and ship yards along the polluted Creek. City infrastructure was made here (sewer covers and signs), but most resources (lumber, coal, and steel) were shipped elsewhere. This corner of Vancouver, which once held what was most undesirable about the city—namely its working class poor and the city garbage incinerator—today

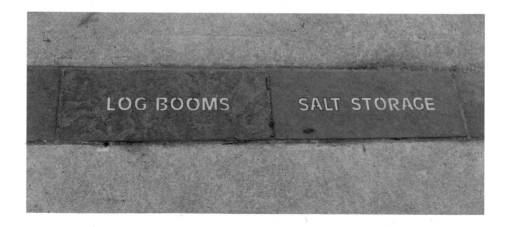

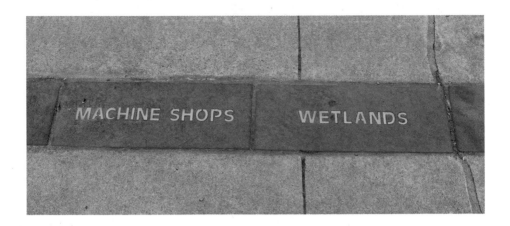

holds its most desirable attributes, its glass towers and craft breweries. The engravings underfoot, the signs beneath our feet, are not monuments but reminders that this was a site of labour and industry. But beyond these words at ground level (pictured here), there is little in the plaza that helps us remember the pre-industrial uses of this site, or what and who were unsettled in order to make it a place of nation building. The Xʷməθkʷəyəm and Skwxwu7mesh peoples' title to and displacement from False Creek—as well as a history of land use that precedes the plants and shipyards by thousands of years—is not monumentalized in the Olympic Village Plaza. Both pre-contact histories of Indigenous trade and negotiation and post-contact Indigenous participation in industrial development are elided through this marking of place in strikingly site-generic terms. These descriptors of

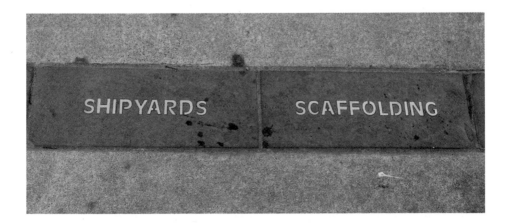

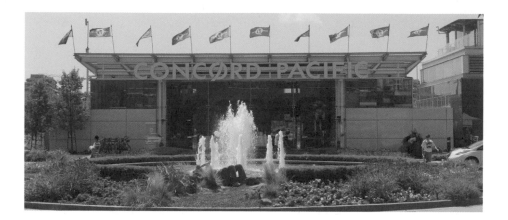

industry could apply to the history of many Northwest coast cities across Canada and the US.

Unlike the neighbourhoods that surround it, such as Fairview and Mount Pleasant, the Olympic Village was not formed by residents but created by the City of Vancouver. In an urban restructuring tale that embodies the shift from industrial port town to resort city, southeast False Creek was rezoned to accommodate global spectacle and land speculation: first for Expo '86 and then for the Vancouver 2010 Olympic Games, where it served as the Athlete's Village. The City used public monies to finance the feckless Millennium Development Corporation to redevelop the site (issuing more than $690 million in loans) (Lee). In doing so it failed to meet its own development plan to create social housing units,

selling off the last of its land to developers in 2014 (City of Vancouver). Following the Games, social housing activists attempted to hold the municipality and private developers to account by establishing an Olympic Tent Village. Situated south of False Creek on west Hastings Street, tent city activists occupied a lot owned by Concord Pacific and leased to the Vancouver Organizing Olympic Committee as a staging area for the Opening Ceremony. Groups from tent city led multiple demonstrations in the former Athlete's Village (now called the Olympic Village) that drew attention to Vancouver's affordable and modest-income housing crisis.[5] Indigenous activists, involved in groups such as the Downtown Eastside Power of Women, were central to the organization of Tent Village. Their outrage at the displacement of marginalized Downtown Eastside

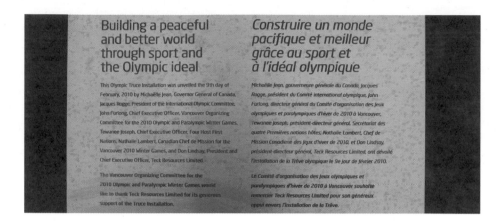

Building a peaceful
and better world
through sport and
the Olympic ideal

This Olympic Truce Installation was unveiled the 9th day of
February, 2010 by Michaëlle Jean, Governor General of Canada,
Jacques Rogge, President of the International Olympic Committee,
John Furlong, Chief Executive Officer, Vancouver Organizing
Committee for the 2010 Olympic and Paralympic Winter Games,
Tewanee Joseph, Chief Executive Officer, Four Host First
Nations, Nathalie Lambert, Canadian Chef de Mission for the
Vancouver 2010 Winter Games, and Don Lindsay, President and
Chief Executive Officer, Teck Resources Limited.

The Vancouver Organizing Committee for the
2010 Olympic and Paralympic Winter Games would
like to thank Teck Resources Limited for its generous
support of the Truce Installation.

Construire un monde
pacifique et meilleur
grâce au sport et
à l'idéal olympique

Michaëlle Jean, gouverneure générale du Canada, Jacques
Rogge, président du Comité international olympique, John
Furlong, directeur général du Comité d'organisation des Jeux
olympiques et paralympiques d'hiver de 2010 à Vancouver,
Tewanee Joseph, président-directeur général, Secrétariat des
quatre Premières nations hôtes, Nathalie Lambert, Chef de
Mission Canadien des Jeux d'hiver de 2010, et Don Lindsay,
président directeur général, Teck Resources Limited, ont dévoilé
l'installation de la Trêve olympique le 9e jour de février 2010.

Le Comité d'organisation des Jeux olympiques et
paralympiques d'hiver de 2010 à Vancouver souhaite
remercier Teck Resources Limited pour son généreux
appui envers l'installation de la Trêve.

residents by aggressive condominium development demonstrates that land unsettlement is not historical or "even past" (to adapt William Faulkner's words). It continues in the guise of inner city gentrification.[6] This present day displacement of First Peoples makes the public art in the Olympic Village—the only remaining public property beyond the waterfront walkway and plaza—all the more damning for its integration of what historian Jean Barman has called "sanitized Indigeneity got from elsewhere" (4).[7]

Signifying local and global elsewheres, the Olympic art commissions located on the grounds of the Village Plaza not only carry the global imprint of the Olympic movement but the cultural imprint of First Nations whose ancestral homelands are located far beyond what is today called

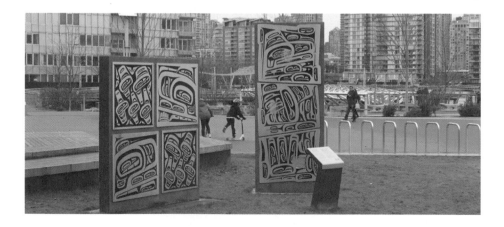

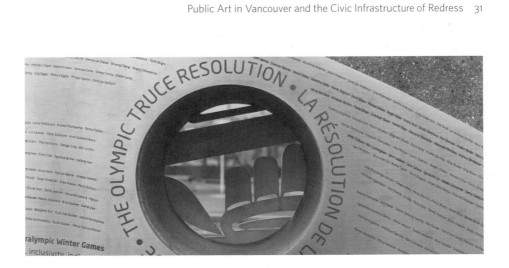

Vancouver. Kwakwaka'wakw/Tlingit artist Corrine Hunt's Vancouver 2010 Olympic Truce sculpture illustrates how Indigeneity from elsewhere gets imported as a permanent local art installation.[8] Two stainless steel truce walls stand in the heart of the Olympic Plaza. One wall shows "the raven in the style of a totem pole," the other "features the orca, designed ... in the style of a traditional ... bentwood box" (VANOC). These are the same images as the 2010 Olympic and Paralympic medals, also designed by Hunt. Here, they are used to facilitate the notion that "sport can inspire peace" (VANOC). Walking by the truce walls, we are struck by how natural it appears for North West Coast First Nations art to materialize the Olympic ideal of "building a better world through sport." It is only later, blocks from the spectacle of the Village, that we ask: Why are the orca

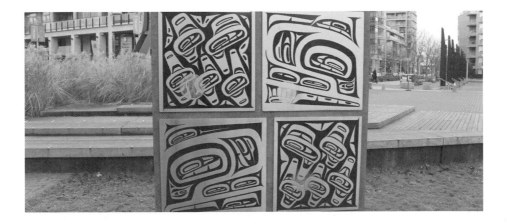

and raven used as props for global Olympic reconciliation? What are the political implications of locating an Olympic Truce by a Kwakwak'wakw/ Tlingit artist on unceded Skwxw'u7mesh and Xʷməθkʷəyəm territory? The emphasis on truce is even more disconcerting given the number of land-claim battles being fought across BC.[9] Here in southeast False Creek, after unsettling traditional lands and frittering away civic property to developers, what remains are market condo units and the borrowed signs of reconciliation.

Around the corner from this newest stretch of "high end, high density, high rise urban living" (Lowry and McCann 189) is the work of collective echoes. As a collaborative project involving emerging Indigenous and settler artists, collective echoes created the public artwork *systems of*

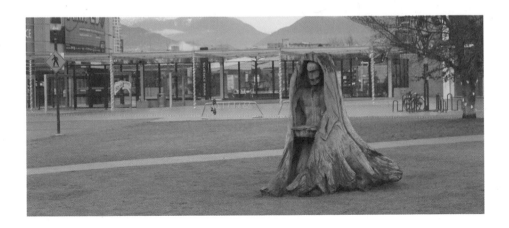

sustenance in 2000.[10] Situated beside the tourist site, Science World, *systems of sustenance* challenges the city's architectural sobriquet, "city of glass," through its aesthetic form. Three gradually rotting wood figures holding salmon occupy the centre of the space. A red-tinted wave with salmon swimming in it crests along the perimeter of an overgrown grass bed that was originally conceived of by collective echoes as an Indigenous garden. There once existed a wooden sculpture representing swimming salmon (vandalized and subsequently removed) near the front of the wave. White salmon spirits are painted on the piles that support the wharf and Science World. These teeming salmon claim the space for a purpose other than tourism. In a sense, they represent the other-than-human public that *systems of sustenance* speaks to.

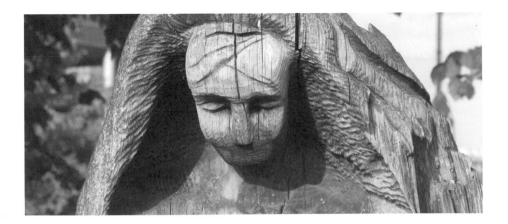

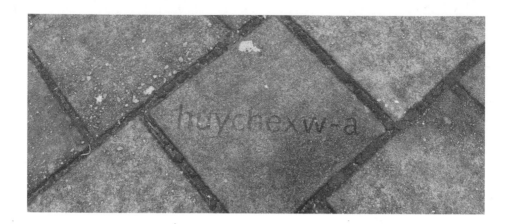

Embedded in the interlocking brick pathway are the words huychewxa, huychexw-a, and həyčxʷq̓a, the Skwxw'u7mesh, Xʷməθkʷəyəm, and Tsleil-Waututh dialects for saying "thank you." As described by the collective, these words of thanks honour the salmon and the streams that once covered several acres of land where the CPR railway was eventually built. In the 2006 exhibition catalogue for this piece they write: "Each year, over 500,000 people walk through this area and although they may not understand the meaning of the words inscribed beneath their feet, through reading, they too will be uttering thanks. Like the salmon, so too does the Coast Salish language return" (36). The fact that the many visitors that pass through Creekside Park can neither pronounce nor understand these words is not, we believe, what is at stake in this public

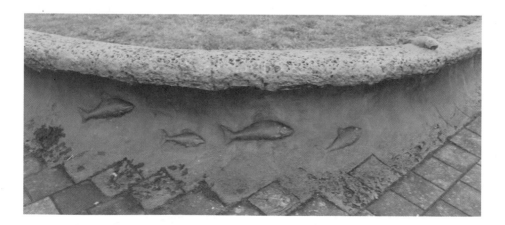

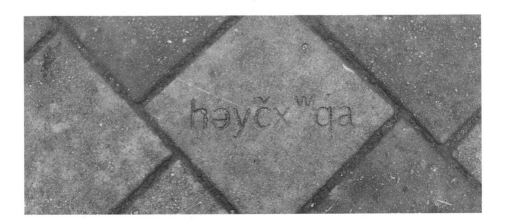

artwork. What matters is the very attempt to read. This act points toward an important recuperation of sovereign visual epistemology. The sense of sight in itself functions as a form of doing, of asserting sovereignty, of expressing thanks. Like the sight of welcome poles or ceremonial objects, these works have the power to call the viewer to participate in an affirmation of sovereignty through vision itself. Sandwiched between the legacy architecture of the Olympic Plaza and Science World (formerly a pavilion and product of Expo '86), *systems of sustenance* models a way of reading history back into the site. These are not words lost in a confusion of natural and industrial English-language descriptors (like *Lookout*), but words that assert their own space, demanding to be read on their own terms.

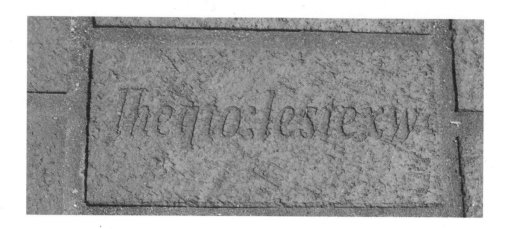

Reading public art and, by extension, interpreting the built urban environment takes many forms. In contrast with *systems of sustenance*, Sheila Hall's *To Connect* (2008) engages viewers in an act of reading that publicly affirms, and contributes to, narratives of neoliberal multiculturalism in Canada. Located in Gastown, a tourist district in Vancouver's Downtown Eastside, Hall's work covers the Columbia Street Pump Station, the front windows (that represent past, present, and future), a courtyard, and the surrounding sidewalk.[11] At the foot of this two-storey brick building are a number of sandblasted paving stones inscribed with the words "to connect" in twenty-two (of the many) languages spoken in Vancouver. Amongst them is the word lheqto:lestexw (additionally translated as "joining together"), which is drawn from the

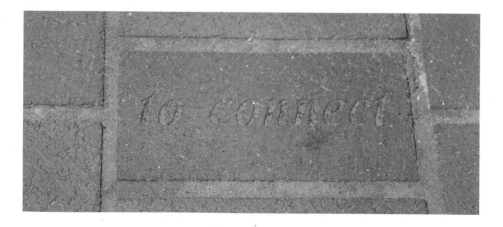

Halq'eméylem language spoken by the Stó:lō peoples who travelled within the area.[12] While Hall's piece recognizes that Vancouver is a multilingual place composed of many voices, this display of different languages in a civic space does not challenge viewers to read beyond equivalency and consider the differences between languages. Like an international market place, the words circulate, supporting the nation-state through a multicultural linguistic ornamentation of the street. Indigenous language competes in this market as one culture among many. *To Connect* thus affirms that Vancouver is today a place of many cultures, of which First Peoples are to be recognized as one part. As such, the piece participates in a process of integration that abrogates First Peoples *sui generis* claims to this territory through the equalization of cultures. Hall's

explicitly stated intention is "to encourage the viewer to rethink what a city is, how its history has been constructed and continues in its metamorphous [sic]." This aim, however, is at odds with the work's re-inscription of multicultural values and histories that in recognizing First Peoples along with other immigrants to Canada as having the same right to belong to place, subsequently disinvests them from their inalienable ancestral rights to their territories.

Located on the north-facing side of False Creek, Henry Tsang's *Welcome to the Land of Light* also works dynamically with translation, but not in ways that support narratives of multicultural citizenship through a profusion of languages. Instead, *Welcome to the Land of Light* misuses translation, rendering the language of settlement unintelligible. The 100-metre

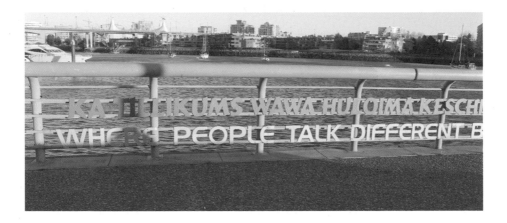

long artwork, made of aluminum and fiber-optic cable wire and installed along the seawall handrail, is composed of two parallel texts. The sentences running along the top are Chinook Jargon, which Tsang describes as "an intercultural pidgin used extensively along the [North] West Coast during the 19th century."[13] The sentences along the bottom re-translate that Jargon back into English. The texts we read are borrowed from early 1990s marketing advertisements for the condominiums that line False Creek, and like other advertising they illuminate the city at night. The '90s was a period of extensive upmarket development of the Yaletown neighbourhood by Hong Kong-owned developer Concord Pacific. (The very same developer whose property was occupied by Olympic Tent Village on West Hastings Street.) The creation of Concord Pacific Place in Yaletown is "one of the largest

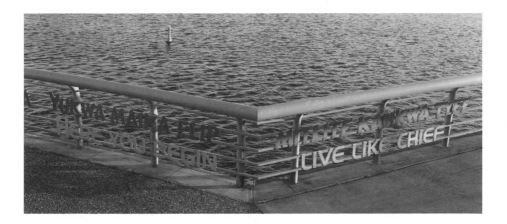

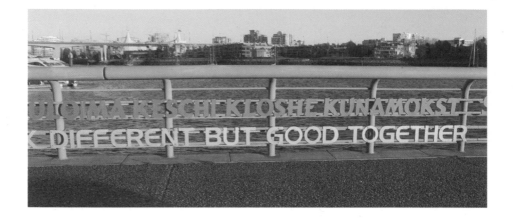

urban mega-projects in North America" (Lowry and McCann 182). It was
not planned for an urban community already in Vancouver but a popula-
tion of ethnic Chinese immigrants (largely from Hong Kong) who had yet
to arrive.[14] According to sociologist Jay Scherer, this real estate boom sig-
naled "a profound expression of the globalization of Vancouver's economy
and the incursion of Asian capital into local commercial and residential
property markets" (5). The marketing jargon that facilitated the success of
this urban settlement is divorced here from its grammatical and rhetorical
logic. The artwork includes statements like:

"Here you begin live like chief"
"You have same like electric eye and heart mind and talk sound"

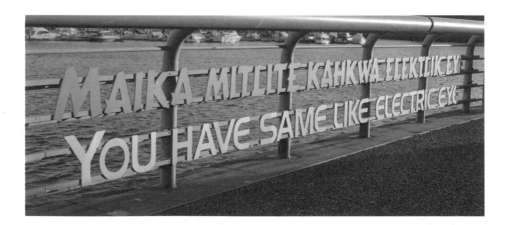

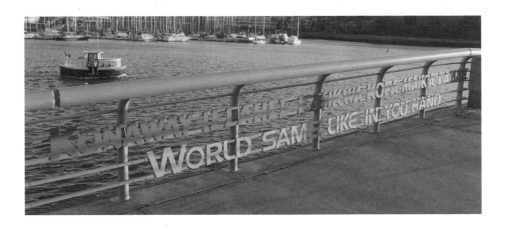

Tsang's sentences produce a series of textual puzzles that cannot be understood by "simply" reading them. This is because readers are confronted by at least three irreconcilable languages and worldviews. The first, the Chinook Jargon, is primarily a language of trade. Its presence here combats the frontier nostalgia identified in the other public artworks along False Creek. In place of a pre-colonial landscape that is settled by the external forces of mass industry and nation, the visual presence of Chinook Jargon reminds us that the success of empire always depended on the interconnected routes of intercultural trade.

The second irreconcilable language is, mischievously, English. Displayed along the handrails, we fail to connect to what is written here because what we are reading belongs to a historical elsewhere. The modern

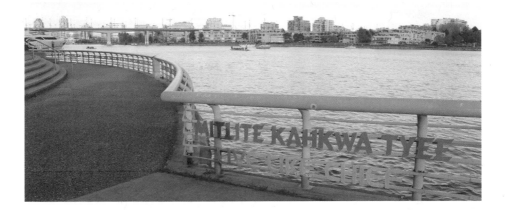

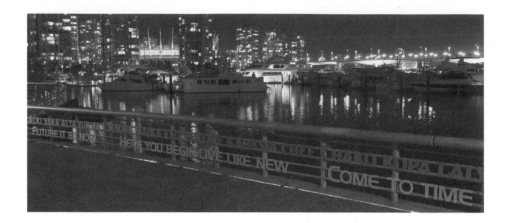

Chinook Jargon is used to "translate" the English marketing jargon. The English language we read possesses the organizational structure of a historical worldview that proves to be untranslatable. This act of defamiliarization eschews the key principle of neoliberal multiculturalism: that other languages and cultures can be known, related to, and therefore consumed.

Finally, real estate marketing jargon is also a language of trade, and like Chinook Jargon it brings with it a culturally specific set of perspectives and values. When colonized by Chinook Jargon, the rhetoric of marketing copy (its fantasy scenarios of a wealthy cosmopolitan lifestyle) must bend, or reconcile itself to, an insupportable worldview. How, for example, might we "live like chief" in Vancouver today? Tsang's piece stretches the history of investor traffic and capital accumulation back, beyond the

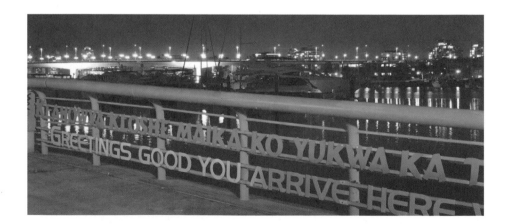

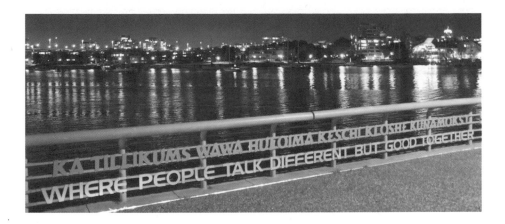

origin of the glass towers in Yaletown, to a time of intercultural trade and colonial land expropriation. His installation makes the transnational history of place visible in a city that continually imagines itself as new—a place for mostly investor-class newcomers—and young—a "teenage" city. This outlook is irreconcilable with the Indigenous and marginalized poor who carry the historical burden of displacement as they agitate for the City to plan and make adequate place(s) for them in Vancouver. This kind of equitable vision cannot be easily summarized by sales campaigns and marketable images of the city.

Digital Natives (2011), curated by Lorna Brown and Clint Burnham, also asserts a text-based record that does not bend to familiar national and market-driven narratives. The lack of public acknowledgement that

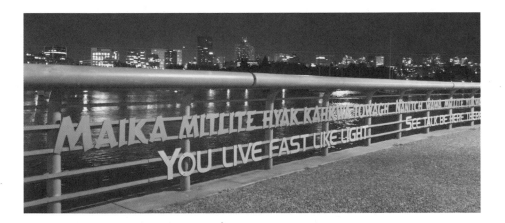

In 1913, all traces of the original village were burned to the ground...

digitalnatives.co @diginativ

Vancouver is built upon unceded Coast Salish territory is contested in this collaborative digital project. *Digital Natives* runs counter to the multi-cultural mosaic framework, which relativizes Indigenous history and culture as merely one fragment among many, and in doing so elides inherent Xʷməθkʷəyəm, Skwxwu7mesh, and Tsleil-Waututh rights to the territory upon which Vancouver stands.

In April 2011, an electronic billboard broadcast text-based messages, in Indigenous languages and English, lasting 10 seconds between commercial advertisements. The 140-character long messages were generated by a range of Indigenous and settler artists, poets, and curators (sixty in total) and ran for four weeks. The project coincided with Vancouver's 125th anniversary as an incorporated municipality. Messages took the form of social media tweets, some of which named the Coast Salish history of the site that

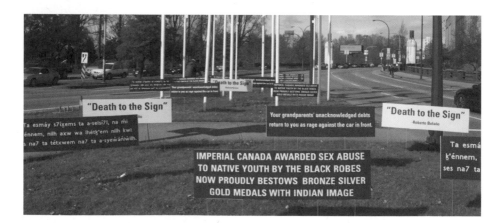

Na yelhyúlh ti úxwumixw-chet, na7 ta 1913.

digitalnatives.co @diginativ

Burrard Street bridge currently occupies. This included making visible the violent unsettlement that unfolded on the site: "In 1913, all traces of the original village were burned to the ground…" In other cases, statements dealt with present day injustices. Most prominently, Edgar Heap of Birds's message took issue with the hypocrisy between the simultaneous affirmation of Indigenous culture and amnesia around Indigenous history that prevailed during the 2010 Olympic Games: "IMPERIAL CANADA AWARDED SEX ABUSE TO NATIVE YOUTH BY THE BLACK ROBES NOW PROUDLY BESTOWS BRONZE SILVER GOLD MEDALS WITH INDIAN IMAGE" (uppercase in original). Despite the fact that Heap of Birds's message was censored by Astral Media (the owners of the billboard),[15] *Digital Natives* placed this and other censored statements as temporary lawn signs upon a City-owned piece of land in front of the bridge. This unannounced intervention occurred

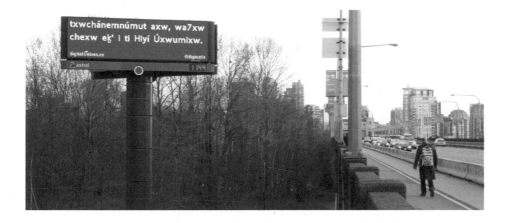

> **On the 1st day of class, a boy left a bar of soap on her desk. With sadness, she remembers his name & the brand of soap #indianact**
>
> digitalnatives.co @diginativ

on the day of the Vancouver Marathon, when 10,000 runners crossed the bridge as part of the marathon route. Pointedly, Heap of Birds's message refused to participate in the "truce" established by the Olympic narrative and displayed in the Olympic Village Plaza. Instead, he named Canada's long history of Indian Residential Schools run by priests and nuns, "the black robes." His text addressed the contradiction between the Canadian government's public acknowledgement of First Peoples' artistic contributions against their continued abdication of responsibility to publicly make restitution for the more than hundred-year history of prohibition and eradication of cultural practices that the Residential Schools attempted to effect. As an interruption of the city billboard's regular commercial programming, *Digital Natives* explicitly destabilized narratives of Canada's benevolent origins through messages that announced: "It's all unceded land, is it not?"[16]

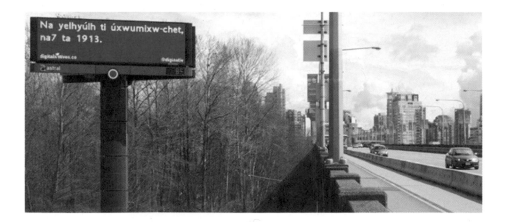

Conclusion

> Without massive restitution made to Indigenous peoples, collectively and as indi-
> viduals ... reconciliation will permanently absolve colonial injustices and is itself a
> further injustice. —TAIAIAKE ALFRED, "RESTITUTION," 181.

As we write this, the City of Vancouver has made two near simultaneous announcements: on June 17th, 2014, it tabled a motion to become "the world's first city of reconciliation";[17] days later, on June 25th, City Council unanimously acknowledged that Vancouver is located on unceded Coast Salish territories.[18] This motion cannot influence land claims currently under dispute, rather its purpose is "to invite representatives from the Musqueam, Squamish and Tsleil-Waututh First Nations to work with the Mayor to develop appropriate protocols for the City of Vancouver to use in conducting City business that respect the traditions of welcome, blessing, and acknowledgement of the territory" (Motion 6). This important step on the municipal level toward historical redress returns us to the question of who benefits from governmental recognition. What tangible benefits will First Nations secure from the subsequent development of protocols with the City of Vancouver? To what extent will future welcoming ceremonies, blessings, and acknowledgements rub up against the limits of the motion because they are not accompanied by material restitution?

As Alfred makes clear in the statement above, reconciliation should not mollify or absolve the nation-state of its wrongs. For reconciliation to result in restitution, the acknowledgement of historical and ongoing injustices against First Peoples must first have a place in the collective memory of non-Indigenous Canadians. The integrationist framework that weaves First Nations culture into the fabric of official multiculturalism must be dismantled and replaced by a discourse of historical redress. An alternative vision of acknowledgement as redress would include the prominent and public naming of national origins founded on forced migration, potlatch bans, the 60s and 70s scoop, the forced removal of children from their families, and the abuse of many of these children while in residential schools.

The Truth and Reconciliation Commission has generated the beginnings of a public memory around the Indian Residential Schools. However, significant work remains to make these accounts part of the larger historical record and Canadian imaginary. These accounts have a place in our urban texts, where they can be witnessed (along with the histories of First Peoples' achievements) daily as markers in the built environment. While the works discussed in this photo essay, such as *systems of sustenance* and *Digital Natives*, challenge us to shift public memory toward intergenerational responsibility for Canada's national injustices, this is only a first step. To develop a civic infrastructure of redress means to develop a corresponding model for urban planning that acknowledges Vancouver's location on unceded Coast Salish territory through the city's very form, from its sidewalks to its signs and from its public art to its uses by the urban Aboriginal public in asserting their rights to sovereign space.

NOTES

1. Both of these designs are by artist Susan Point. The storm drain covers, designed with her daughter Kelly Cannell, represent the lifecycle of frogs (from egg to tadpole to frog). These covers have gradually proliferated across the city in new developments and in the replacement of older storm drain covers. The Vancouver Police thunderbird design was given as a gift in 2006 from the Musqueam Band. Importantly, the description of the design on the Vancouver police website acknowledges the history of Vancouver as unceded Coast Salish territory:

 > The land on which the City of Vancouver is established has been the territory of the Coast Salish peoples for thousands of years. Over the last century-and-a-half others have come and built their homes and businesses on this land. This was done without a treaty or ceding of land by the Coast Salish. Today we share their land as the treaty process moves forward.
 >
 > The Vancouver Police acknowledge the traditional ownership of this land and the history of colonization through displaying the Coast Salish thunderbird motif on marked police cars. This display is a statement of mutual respect and friendship. ("The Thunderbird")

2. See Elizabeth Povinelli, *The Cunning of Recognition*; Glen Coulthard, "Subjects of Empire"; and Eva Mackey, *The House of Difference*.

3. In *The Practice of Everyday Life*, de Certeau devotes a section within Part IV: The Uses of Language to reading entitled "Reading as Poaching" (165-76). See also Part III: Spatial Practices and "Walking in the City" (91-110) for how everyday practices like walking can temporarily suspend an urban dweller's "proper" relationship to

the city—a relationship all too frequently defined by unremitting consumption, urban development, and police surveillance.

4. In addition to Corrine Hunt's Olympic Truce piece, the Olympic Village is host to a second First Nations work, Skwxw'u7mesh artist Wade Baker's *Canada's North Star,* a stainless steel Canadian Maple Leaf with a Coast Salish north star engraved within the leaf. More information about Baker's work and other Aboriginal art commissioned for the Vancouver 2010 Winter Games can be found in the catalogue, *O Siyam.* Scattered throughout the plaza are Susan Point and Kelly Cannell's storm drain covers.

5. See Sullivan, "Activists Threaten to Turn Vancouver Olympic Village into 'Tent City'" and "Poverty Activists Satirize Condo King, Vancouver Mayor" (CTV News, May 15, 2011). For information about the Olympic Tent Village, and their mandate to end homelessness in Vancouver, visit their blog, www.olympictentvillage.wordpress.com.

6. See Kun, "Raising the Roof: Housing Activism in Vancouver's Downtown Eastside," a roundtable conducted by Kun in the lead-up to the Games. The problems remain after the Games. In the 2013 City of Vancouver homeless count, First Nations were said to make up thirty percent of the homeless population, yet only two percent of the overall population (which is, according to Patrick Stewart, chairperson of the City's Aboriginal Homeless Steering Committee, a severe "undercount") (Howell).

7. Barman uses this phrase to refer to the totem poles erected in Stanley Park in 1923 that were placed there after the forced removal of the last Indigenous residents of the area. We believe the phrase is equally applicable to some of the Olympic commissions that now occupy the city in place of the less-desirable history of displacement, and actual presence of urban Aboriginal people.

8. The importing of work from other nations to be situated upon Skwxw'u7mesh and Xʷməθkʷəyəm territory is far from unique. Throughout the history of Vancouver as a modern city, Haida and Kwakwaka'wakw peoples' artwork has often been placed within Coast Salish territories due to Western tastes that deemed it the most aesthetically advanced form of Pacific Northwest Indigenous art.

9. At the time of writing, there are currently 60 First Nations participating in the BC treaty process. Because some First Nations negotiate in shared treaty processes, there are a total of forty-nine negotiations underway at this time. For details regarding the stages of these negotiation processes, see the BC Treaty Commission website.

10. See the catalogue exhibition of this four-year project edited by two of the project leaders, Simon M. Levin and Henry Tsang, titled *collective echoes: projects for public space.* Participants also included Skwxw'u7mesh ethnobotanist Cease Wyss, Dana Thorne (Cowichan), Elisha Sidlar, Crystal Lee Clark, Kristine Germann, and Dan Bushnell.

11. In the media release for *To Connect,* the City of Vancouver notes that the front windows that face the street:

> represent a different time period: the past, the present and the future. The "past" window has a historic aerial photograph of Gastown. The "present" window has

three liquid crystal display or LCD windows that show a live video feed of Burrard Inlet from cameras mounted on the top of the building. The "future" window displays a story written by children about water as a resource. It is partly obscured since we don't know what the future will hold. (Metro Vancouver media release)

12. While Halq'eméylem-speaking Stó:lō peoples have always maintained a presence in Vancouver, it is strange that Sheila Hall does not use a Hun'qumi'num dialect spoken by those whose territories are directly within the area now occupied by the city. According to Hun'qumi'num language specialist, Patricia Shaw, the availability of Halq'eméylem language materials preceded Hun'qumi'num resources, which may have led to their more frequent use. However, such earlier availability of Halq'eméylem resources may also have led to the mistaken assumption that Halq'eméylem was the parent language of Hun'qumi'num. According to Shaw, while Hun'qumi'num-speaking Xʷməθkʷəyəm peoples may recognize the Halq'eméylem word lheqto:lewtexw as "to connect," they may equally recognize the misplacement of another nation's dialect upon their territory (Conversation with Patricia Shaw, May 22, 2014, UBC).

13. In "Asia in the Mix: Hong Kong, Vancouver, Dubai," Glen Lowry and Eugene McCann show how Tsang's fiber-optic piece in Concord Pacific Place is indicative of Vancouver's bonds to multiple elsewheres that include Hong Kong, China, and Dubai. The authors provide a fulsome definition of Chinook Jargon and note that it was the

> lingua franca up and down the coast from Oregon to Alaska. Chinook Jargon ... was a pidgin of indigenous Wawashan dialects mixed with English and French, as well as other sources. Named after the Chinookan (Chinuk or Tsinuk) people of the lower and middle Columbia River basin, but based loosely on the aboriginal language, it was structured on the principle of inserting words and phrases from different linguistic sources into basic syntactic or grammatical units. Chinook Jargon was readily adaptable and portable, capable of facilitating exchanges among diverse cultural-linguistic groups and accommodating disparate regional demographics ... Chinook lexicon reflects the use of Kannaksis (from Hawaii), Chinese, and Norwegian, in addition to Chinook, Nootkan, English, and French. In some regions, it became a creole and was spoken as a first language. (187-88)

14. Glen Lowry and Eugene McCann explain that: "In the wake of Tiananmen and in the lead-up to 1997 [handover of sovereignty from the UK to China], Vancouver became a safe haven for affluent, middle-class investors from Hong Kong who were looking for a place to which to move their families and business interests" (183).

15. While it faced censorship on Astral Media's billboards, Heap of Birds's message was displayed indoors as part of the Vancouver Art Gallery's WE: Vancouver (2011) exhibit, which was held concurrently with the Digital Natives project. For more information about the project see Brown and Burnham's exhibition catalogue, Digital Natives.

16. This was a contribution to Digital Natives made by a member of the public for the WE: Vancouver exhibit. The project also hosted a Twitter feed, Facebook page, and blog.

17. For a summary of Vancouver's "year of reconciliation" see City of Vancouver, "City and Aboriginal Leaders Celebrate Year of Reconciliation." The motion "Designating Vancouver a City of Reconciliation" was passed on July 8, 2014. Public art played a pivotal role in materializing (and openly questioning) the City's reconciliatory status through the display of publicly commissioned temporary artworks on bus shelters, the Vancouver Public Library central branch, video screens, and other sites. For more information see City of Vancouver, "Platforms: Art Marking Vancouver's Year of Reconciliation."

18. The motion officially states that "the modern city of Vancouver was founded on the traditional territories of the Musqueam, Squamish and Tsleil-Waututh First Nations and that these territories were never ceded through treaty, war or surrender" (City of Vancouver, "Motion 6").

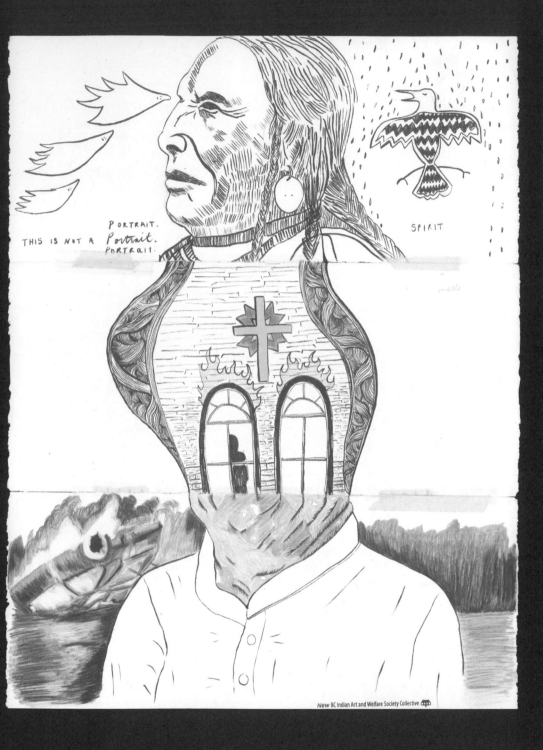

unreconciling public art

The New BC Indian Art and Welfare Society Collective

In 2014, four drawings by us, The New BC Indian Art and Welfare Society Collective (NBCIAWSC), were selected by the City of Vancouver to be exhibited in bus shelters across the city as a part of the "Year of Reconciliation" public art program. Entitled *Underlying States*, the series was made in the style of the exquisite corpse, or *cadavre exquis*, a method made popular by the Surrealists in the 1920s. André Breton describes the exquisite corpse in the *Dictionnaire abrégé du surréalisme*: "A game with folded paper. Every participant makes a drawing without knowing what his predecessor has drawn, because the predecessor's contribution is concealed by the folded part of the paper" (Breton and Eluard 93). One of the reasons this technique appealed to us is our understanding of the formative impact Indigenous arts and artists from Turtle Island had on Breton, Max Ernst, Kurt Seligmann, Wolfgang Paalen, and other members of the Surrealist movement.[1] The NBCIAWSC's version of the exquisite corpse involved cutting the pieces of paper and sending them by mail to the members—some of whom live in northern communities or on their home reserves—who then drew on the paper and mailed their pieces back to be taped together. The following manifesto is similarly written in the style of the exquisite corpse, showing clearly the places where our thoughts coincide as well as the places they diverge.

"When children are sick, the fathers or mothers dream for them..."

—FROM *THE JESUIT RELATIONS AND ALLIED DOCUMENTS: TRAVELS AND EXPLORATIONS OF THE JESUIT MISSIONARIES IN NEW FRANCE 1610-1791.*

Underlying States examines the Christian concept of hypostasis, which speaks to the underlying substance, or state, of all things. According to the Oxford Dictionary, the word hypostasis means "an underlying reality or substance, as opposed to attributes or that which lacks substance." This foundation allows for the shared existence of spiritual and or corporal entities in one body, as in the Holy Trinity. We propose that Indigenous story, dreaming, and history are the foundation of all cities in Canada. Artists explore these concepts of shared existence and the Indigenous foundations of place through dreamlike imagery. The power of dreams can be seen in the early attempts to colonize and Christianize Indigenous peoples. Many entries in *The Jesuit Relations*, early accounts written by missionaries documenting their work in the field, point to the challenges to Christianization posed by the Indigenous belief in dreams. In making this work, we think about the children who dreamed of their families, of better worlds, of speaking their language to their grandmothers; maybe their dreams helped end the residential school.

The Inkameep drawings, made by children from the Inkameep Day School near Oliver, BC, between 1932 and 1942, illustrate the power of dreaming and creativity that at times surfaced in residential schools in Canada. A unique instructor, Anthony Walsh, encouraged the children to express themselves and their culture through art. When he left, his replacement burned all the drawings and announced that Walsh's practice was detrimental to "civilizing the children." Some of these drawings were saved in collections and later exhibited. Inspired by the art of these children, the beauty of their resistance, we draw and we dream for the children who attended residential school.

Challenging Western ideas of the individual artist as stand-alone genius or master, we, the New BC Indian Art and Welfare Society Collective, work collectively. We are beginning to unlearn Western art traditions through this visual reconciliation. The viewer also plays a role in this process: the

unlikely spaces left in-between the artists' concepts, lines, and expressions are open to interpretation, allowing room for the viewer to insert their own ideas and reveal their own thoughts about this "shared existence."

Working from different geographic areas, the members of our collective are located both on-reserve and off, in both urban and rural contexts. We are status and non-status Indians, we are interested in decolonizing our lands, our minds, and our art through experimental art practices.

Underlying States is meant to invoke a dream-like state of parallel and possibly contradictory meanings, which in relation to each other become whole. What holds all of these disparate images, ideas, and texts together is an idea of a "shared existence" in which even the most distinct fragments contribute to a whole. This idea of distinct ideas, spirits, and concepts contributing to a whole comes from teachings from the land; we posit that the land is our starting point, the underlying state(s) of our existence, and reconciliation starts here.

The cut paper, the heavy tape, the lines that don't match up, these gestures work differently from the way that the Surrealists' exquisite corpse drawings hid the individual artist's identity in favor of a collective anonymous one. Rather, the *Underlying States* drawings emphasize the ruptures between us as much as they do our collectivity. It is the disjunctive spaces in the drawings that are the most active, that hold the most possibility.

This practice of disjunctive collectivity is especially important in the context of talk about reconciliation. Reconciliation as a concept is problematic in many ways, not the least of which are the implied goals of putting our divisions behind us and working towards closure and a unified nation. Dissent, difference, and contestation drive the constant formation and reformation of our shared existence, our shared space—whether that space is the reserve, the neighbourhood, the city, or the country. The goal of a unified public whole positions that dissent and difference as a negative rather than positive force, as something to put behind us.

The *unsettled* state or condition of a colonial nation like Canada has been a source of anxiety and fear for many successive Canadian governments,

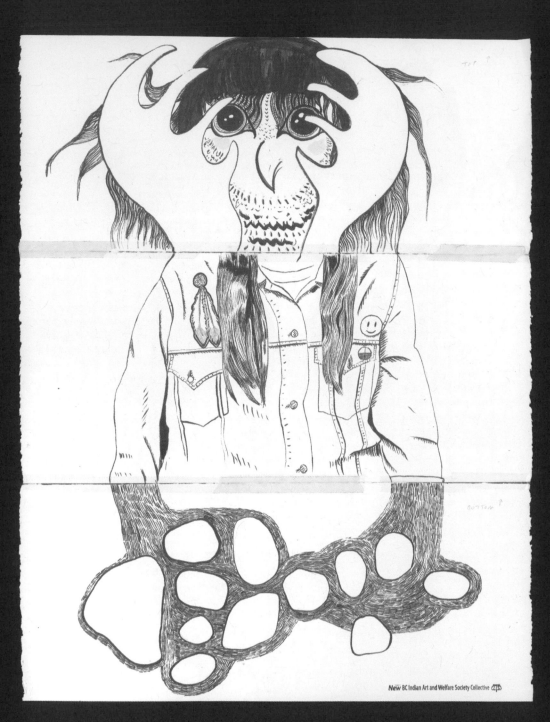

New BC Indian Art and Welfare Society Collective

all of whom sought to terminate the "Indian problem" in the name of na-
tional unity and closure. The discourse of reconciliation—especially as
it attempts to narrow down the horrors of colonization to the residential
school experience and neglects to address the restitution of land and po-
litical power to Indigenous peoples—falls into this category of policies of
termination. However, the unsettled nature of the Canadian nation, the
fact that it is a project that remains unfinished, is a place of potency and
possibility much like the moments of disjuncture in the *Underlying States*
drawings. It is the incompleteness of the colonial project that allows for
room to reimagine what our shared existence might look like.

In "Always Beginning," the final chapter in this book, Allison Hargreaves
and David Jefferess write of the transformative potential that exists for
settlers in renewing how they look at Indigenous blockades. They write
that "[a]t sites of seemingly irreconcilable conflict between Indigenous
and non-Indigenous communities, the barricade is mistaken in the main-
stream as the violent embodiment of this impasse rather than an oppor-
tunity for its transcendence" (209). They point out that a barricade is
not inherently violent, that it could be seen as an "opening onto a dif-
ferent relationship to land and to one another—one that both acknowl-
edges the violence of settlement and resource extraction, and that affirms
shared obligations to care-take the land for the wellbeing of future gen-
erations" (210). The places where our drawings don't match up, the
tape, the gestures of disjuncture, can in this sense be seen as Indigenous
blockades, insisting that this space is not settled and offering the pos-
sibility of working together to reimagine and reforge our shared space
through struggle.

Participating in the City of Vancouver's public art programming for the
"Year of Reconciliation" was not an easy decision for all the members of
the New BC Indian Art and Welfare Society Collective. One of the many
reasons for reluctance was the sense that public art in Vancouver often
works against Indigenous people, marketing unceded territory as a dy-
namic investment opportunity. As Miwon Kwon writes in *One Place After
Another: Site-Specific Art and Locational Identity*, at a time when places

are losing their distinctive qualities to generic big box stores and increasingly migrant populations, marketing the unique identity of a city becomes "a matter of product differentiation" (55). The authentic experience of a community, in this case, is transformed into the increased market-value of their location, which can ultimately lead to that community's displacement.

Artists often get caught up in city development schemes that result in increased spending on the arts on the one hand, and cuts to social housing and programming on the other. Benefitting at first from neoliberal policies that increase public arts funding to make the city a more attractive investment opportunity, we are eventually faced with a loss of the affordable spaces and working-class neighborhoods that have long been the home of vanguard arts movements. As Indigenous artists, we also must consider the risk of lending our images to an urban development scheme that scatters and displaces the city's Indigenous communities—our families—and encourages further encroachment on unceded Indigenous lands.

Disheartened then, we think about what Indigenous public art *can do* in a city and a system where it is almost always co-opted by capital to work against the interests of Indigenous people. To begin with, Indigenous art and artists can and should resist working in collaboration with urban development that pushes people out of public space and affordable neighbourhoods. Secondly, Indigenous public art can claim the city as a space where Aboriginal bodies belong.

This is no small thing, though it might seem like one at first. Even when on our own territory, Indigenous people in the city are always constructed as "out of place." This concept of Indigenous people as not suited for modernity or urban living is linked to and reinforced by many aspects of the colonial system. At the most basic level, it is a continuation of the myth of the "vanishing Indian," a person defeated by colonialism, disease, and the temptations of the white world. The image of Indigenous people as unable to succeed or thrive in the city is an outgrowth of this myth and it is one that benefits urban development and colonial powers. Sherene Razack points out that the modern city is deeply invested in "rendering Aboriginal bodies out of place" ("Memorializing" 910). She writes that

while "Aboriginal bodies haunt settlers, a too present reminder that the land is indeed stolen, they must also serve to remind them of their own modernity and entitlement to the land" (910).

While the construction of Indigenous people as "out of place" in the city justifies the theft of traditional lands and displacement of urban Indigenous communities, it is also an idea that has severe lived consequences on the bodies of Indigenous people. Indigenous people on city streets are targets of daily police harassment, criminalization, and race-based violence. In Saskatoon, the police have a well-documented practice of driving Indigenous men outside the city limits and leaving them there, often in the middle of winter, sometimes with the consequence of death. Even middle-class Indigenous people experience spatial policing when they are ignored in banks, followed around by security in malls, or otherwise shown in a thousand little ways that their presence in urban spaces is suspicious and undesirable.

The exquisite corpse is first of all a body, and the *Underlying States* exquisite corpses are exquisite Indigenous bodies, standing on the city streets, waiting at bus stops, larger than life, reflecting our own bodies back at us. The drawings mark urban space as belonging to Indigenous bodies; they remind all that see them of our presence, our beauty, and our strength.

> Across the room from where we sit a pile of wood shavings forms beneath a pencil sharpener; near it lies a shredded paper figure curled up into a fetal position on the floor. In the corner hangs rags dipped into a patch of white plaster relief, on them are the names of confrontations between First Nations and government authorities: Oka, Burnt Church, Ipperwash, and Saskatoon. On the far wall tiny souvenir Canadian flags are arranged to resemble the profile of the American Indian from the United States Nickel. Fluttering in a fan-propelled wind, the diminutive flags shed their nationalist identity.
> —DOT TUER, "PERFORMING MEMORY: THE ART OF STORYTELLING IN THE WORK OF REBECCA BELMORE," 35.

Underlying States are named by the New BC Indian Art and Welfare Society Collective. These named states are placed in direct view, backlit in bus shelters. These states are the places in which the three drawings meet.

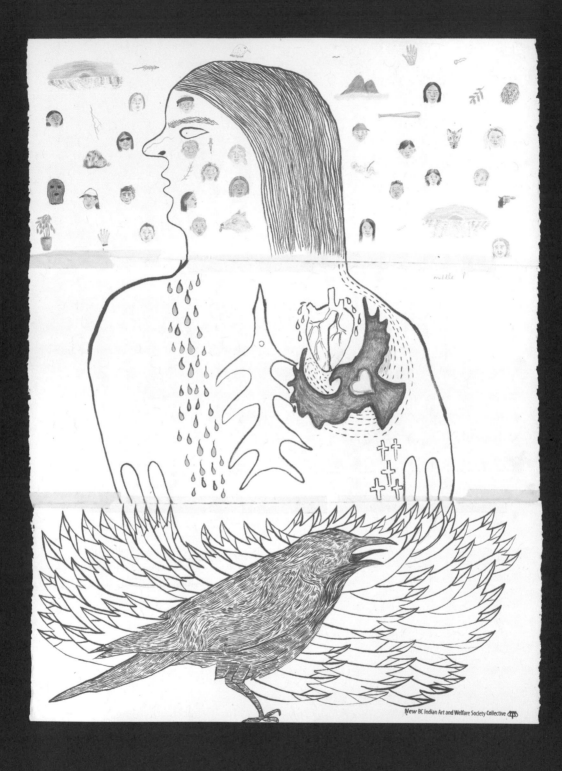

New BC Indian Art and Welfare Society Collective

Underlying States: A year of reconciliation, A program of reconciliation, A city, A mayor's speech, a National identity crisis (perhaps), and still a Nation-to-Nation dialogue. Underlying states are heartbeats, drawn like a bird's wing and dangerous as a bullet.

Recently, there was a chance to drive around the city to see the artwork. We wanted to see the bus shelters that featured the Underlying States drawings.
There was a map involved.
And a cell phone.
And perhaps there was also this year of reconciliation, perhaps that was along for the ride as well. Perhaps we should also name this: "a year of bus shelters which feature art that are also comfortable enough for people to sleep in."
The search was intriguing, this act of looking for our artwork.
This art is about articulating the act of looking and how we understand what collaboration does for reconciliation.
The work of artists
ideas of reconciliation
the lapse of identity politics
the birth of nationhood politics
reconciliation is still a nation-to-nation conversation (if you're up for it … that is).
Performance. The placing of Band-Aids on the back of our hands.
Reconciliation is the movement through spaces,
thinking about architecture and control.
Reconciliation is a pretty artwork.

The unstated assumptions of our mass media tell people what is "normal." The language of their discourse with us conveys messages about "reality" as well as objective information. The media is largely supported by commercial or state interests, dedicated to influencing audiences, attitudes, and action. This bias is commonly accepted without question (Riddington 243). Boom. Robin Riddington tells us the truth. 1990s truth. Invested statements that shape reality. Perhaps this Reconciliation is just a drive-by idea. Indigenous artists are taking the time to reflect. We write

or draw the spirit of the meeting places on the land. These meeting places are the places where important business takes place. Our questions are, "Is reconciliation normal?" and "Do we accept and understand the goals of reconciliation?"

Back in the car, driving around the city, we find the first bus shelter. I'm ecstatic. I'm an artist who practices in the western art history system, in this moment, deeply in my bones. I live to see my artwork exhibited. We decide to move to another site. The car. The cellphones. The gps. The radio. I start to rationalize this moment, as Indigenous people living and moving on the land. But this rationalization is weak. What we are experiencing is the movement through difficult political landscapes and histories. The invitation to consider what reconciliation is, by a city that is concerned with developing a distinct life, a life apart from other city narratives. This search for *Underlying States* is about the design of spaces, it shows the lines we cross, don't cross, and don't want to believe exist. We don't need bus shelters for shelter. We get to go home or to our hotels for the evening. We get to eat in restaurants. We get to move through privilege and drive to bus shelters to look at art. The architecture of this experience reflects the city and reflects the line where the city meets the land, Indigenous land, Coast Salish land—I choose to write both here, as named states, because one is about discourse and one is about reality. The designs of city spaces are lines that meet and don't meet, and effectively are focused on the moving of people through spaces. *Underlying States* is not afraid to draw these lines. Ideas of reconciliation, telling the Indigenous land story, and the introduction of our connection to difficult political histories, is only a drawn line, and yet, that drawing has the ability to interrupt movement and make a space for land.

The sign is more for visitors to the wilderness park than for Iskut audiences. Perhaps the sign's creators meant to add some Aboriginal colour to the camp and to authenticate the Native experience for hikers from Vancouver or Seattle. For such adventurers, the story is an expression of Iskut identity and local history—elements of being didene—in a form that sounds like a myth. It describes a seemingly fantastic event, the transformation of a man, dog, and goat into a rock, and it

is visible to non-natives. Park visitors, like the guests at reunion camp, might expect to encounter this kind of Native Lore, since the website for the park acknowledges Native connections to the place.

—THOMAS MCILLWRAITH, *"WE ARE STILL DIDENE": STORIES OF HUNTING AND HISTORY FROM NORTHERN BRITISH COLUMBIA*, 119.

There are handcuffs in the Secwepemc Museum. Unmarked, cold, post-industrial restraint system; post-colonial restraint. They look like another set of handcuffs I have seen … children's handcuffs. We find it hard to imagine the existence of children's handcuffs.

There are more of these handcuffs for children surfacing. Allegedly used in the residential school period, we have read about them on social media, read about their horrible size, for small wrists. We want the children to be like a great Houdini, making a daring escape from colonialism.

"They tell the story of who paid the price for us to be here now."

—MARY ANNETTE PEMBER, "TINY HORRORS: A CHILLING REMINDER OF HOW CRUEL ASSIMILATION WAS—AND IS."

Who paid the price and who is still paying?
Can art ever come close to acknowledging, healing, or enlightening us in the face of trauma and injustice?

Nicholas Galanin, Tlingit artist, carved a pair of children's handcuffs—He liberated these objects, inscribed them, and in doing so saved souls. That might be naïvely poetic, but I can feel it—those cuffs have a power, a power we need to take back. The realm of spirit is not something easy to give voice to, to discuss in papers, to expose in art, and I am often hesitant, and I think I need to unschool myself in that regard. But this space, talking about the artwork that we made together, writing about it together, can be that space. I felt the power of those restraints, holding back our children's minds, bodies, hearts, and spirits.

With *Underlying States*, however, we did not want to give people the crying Indian, the headline horrors. These things happened, they are real, their essence sealed in objects like those child-size handcuffs. *Underlying States* was more about how we move through personal, familial experiences and

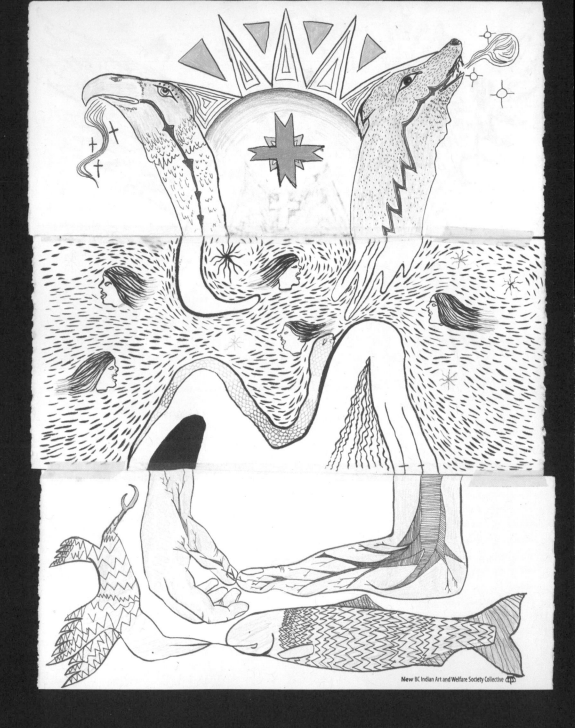

New BC Indian Art and Welfare Society Collective

inter-generational stories without exploiting them. We embarked on these drawings to give voice to these concepts but not necessarily to educate people, nor to give them a didactic account or a penetrating portrait. This was for us, to make our escape. This project did not take much account of the parameters for the work, suggestions of ways in which the work might function. It was chance, it was spirit … it was fun. *Underlying States* was not about unsettling the viewer, or the artist, it was about unsettling expectations that art about residential school should be any particular way, that it needs to be haunting, or direct, or political, or spiritual. I love artwork that can be any or all of these things, but conceptually, this work sought to enliven the dreamscape, unsettling the surface of expectation and perception. There are no crying Indians here for you, no screaming children, no horror to consume. All of that exists, but these drawings were about freedom. Freedom to work collaboratively, to experiment, to draw, to sigh, to overcome, to assert possibilities not outcomes.

I think the secret to Houdini's escape was in part that his handcuffs were not child sized.

NOTES

1. See Marie Mauzé's "Totemic Landscapes and Vanishing Cultures: Through the Eyes of Wolfgang Paalen and Kurt Seligmann" and Dawn Ades's *The Colour of My Dreams: The Surrealist Revolution in Art.*

PART TWO

"PLEASE CHECK AGAINST DELIVERY":

THE APOLOGY UNLOCKED

PLEASE CHECK AGAINST DELIVERY

Jordan Abel

"Please check against delivery" was constructed entirely from Stephen Harper's June 2008 apology for the Indian Residential Schools system. The speech, for me, was a starting place in thinking through Truth and Reconciliation, and seemed to be freely available for repositioning, reconstruction, and reimagining. As a collaborative piece—Stephen Harper delivered the speech and I reconfigured it using the words provided—the process was unfortunately unidirectional. I divided the speech into clusters of three to five words, and randomly rearranged those clusters until they started to reveal meanings that resemble the truth. The transcription of the speech, however, starts with the imperative "PLEASE CHECK AGAINST DELIVERY"; this phrase was the only part of the speech I felt the need to leave intact.

former students have spoken but as you became
parents, cultural practices were prohibited
federal partly in order we are now
joining you on this journey. Most schools
families, strong communities remove and
isolate children A cornerstone of the
Settlement together with a renewed implemen-
tation of the Indian never having
received a full Anglican, Catholic, Pres-
byterian Nous le regrettons new relationship
between and a desire to move forward

 First Nations,
we apologize for failing to now recognize that
in separating sad legacy of

 the Government of Canada system
in which very young children and an
opportunity to recognizes
that it was wrong September 19, 2007. Years
of work communities. In the 1870s, the cultures
and spiritual beliefs were and their separa-
tion and cultures, and to children
from their families, inadequately fed, clothed
understanding that strong to adequately
 own children from suffering powerless
to protect Residential Schools system were
operated as "joint ventures" far too long.
burden is proper that it was wrong to
School contributed to social Indian Residen-
tial Schools policy moving towards healing
that this policy has family members and
communities forward together in partner-
ship a positive step in forging

them into the dominant more than
a century, parents, grandparents neglect
emotional, physical and sexual
we recognize that this policy legacy of
inferior and unequal
Canadians based that the
consequences of the knowledge of our
shared vibrant cultures we apolo-
gize for having done and
government recognizes built an
educational said, "to kill the Indian in the child".
Government sincerely apologizes
sowed the seeds for all Canadians on
the Indian apology caused
great harm, and and to the strength
we undermined the ability are sorry feder-
ally supported schools Stephen
Harper, inadequately controlled, and the abuse
they suffered. It is to healing and reconciliation
asks the forgiveness of the Aboriginal
Inuit and Métis and You have been
working on recovering while attending
residential schools Residential Schools no
place in our country. housed. All were deprived
of the peoples of this country for failing them so
pro- foundly. its obligation to educate their
homes we apologize for you, in this
so The treatment of children suffer these abus- es
as children, children from their families and
many students are and communities, and
we far too often, Therefore, on behalf of the
time and in a very real sense, in these schools.
Tragically the approximately 80,000 sur-
vivors that have come in that gives us a
new a role in the development and this we

are sorry. separate children from rich and cul-
ture. These objectives were based has taken ex-
traordinary located in every province

forcibly removed from their forcibly
remove children from Aboriginal organizations
culminated Truth and care and
nurturing of their of the Govern-
ment and language. While some

courage for the thousands Not
only did you not
with us today died to apologize to

peoples for the attitudes that Schools
Settlement Agreement There
is no place the influence of their homes,
families, presents a unique oppor-
tunity One hundred and thirty-two

these children died

and separated over 150,000 Aboriginal oth-
ers never returned home by tragic accounts
of We now recognize that, their
own children and that absence of in
many communities today. I stand
before reconciliation and resolution the pos-
itively about their experiences of their cultures.
Regrettably, a testament their resilience

these schools. Agreement is the
Indian that it created a void in many

for all of us. The Right Honourable this
experience for a long generation and
has been on your shoulders for

and will contribute to a stronger

as it was infamously at residential
schools, or United Churches. The Govern-
ment on Aboriginal culture, heritage ours
as a Government as central to our life

as a country,　　　The government now recog-
nizes abuse and neglect of helpless stories
far overshadowed　　　　　　　　in the Indian
　　　　　　except　　　　　　　Prime Minis-
ter of Canada　　Aboriginal children, began
　　inspired the Indian Residential homes, often
taken far from their　　　　primary objectives
of the on the assumption　　　　　Aboriginal
profoundly negative living former　　　and all
apologize for having done this.　　The burden
of this　　　　　　　apology has been an im-
pediment　　　　　　　　　This history, a
respect for each Schools system to　　prevail
again. Aboriginal peoples and other problems
　　　　continue to from powerless families and
communities. and vibrant cultures and tradi-
tions of Canada　　Many were a lasting and
ing and damaging impact　institutions　gave
rise to abuse having done this.　　　is a sad
chapter in our history.　　Residential Schools
　　　　forward to speak　publically about
the same experience, and for　assimilation

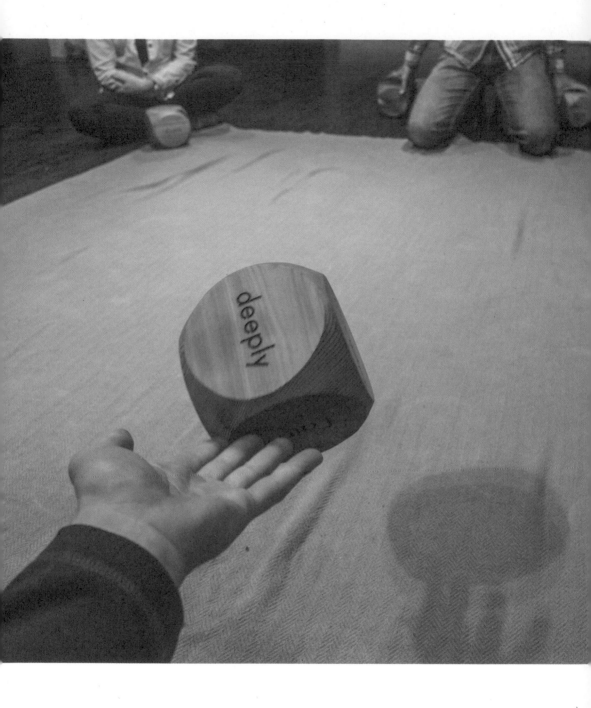

David Garneau and Clement Yeh. *Apology Dice*. 2013. (SHARIF MIRSHAK)

APOLOGY DICE:
COLLABORATION IN PROGRESS

David Garneau and Clement Yeh

Snow and rain. Escaping the slushy, wet darkness, seven people gather in a circle around a generic grey blanket. In the centre are several oversized cedar dice incised with words. The first reads "I am," "you are," "we are," and "they are." The second reads "fairly," "deeply," "very," "so," "not," and "somewhat." The final die has five sides reading "sorry," and one with "tired of this" carved into it. The possibilities and combinations disassemble and reassemble as everyone reaches for the dice to smell and feel their heft, their smooth rounded sides. Clement Yeh begins to speak about their genesis at a residency in Kamloops, BC. These dice, he explains, are a proposition, a provisional answer to the question: given Canada's horrific legacy of Indian Residential Schools, is reconciliation at all possible? More importantly, what is reconciliation, and what forms might it take? He rolls. I am / not / sorry.

Discussion quickly ensues, fueled by questions from participants. Basic information on Aboriginal history and contemporary realities is missing; misconceptions abound. Haven't reparations been made? Does an apology even matter? Still, the participants roll. Speak. Listen. Learn. They are / deeply / tired of this.

— RHONDA L. MEIER, PARTICIPANT/RESPONDENT. DECEMBER 10, 2013. MONTREAL.

Collaborating

Clement Yeh is a maker of things. I make things too, but my objects are mostly paintings and texts, which are less thingy than his sculptures. While I mostly think in pictures and words, I sometimes have tangible ideas but lack the skills to realize them. The appeal of working together began with the selfish hope that a skilled craftsman could materialize my

imaginings, but it soon evolved into a collaborative relationship when I found myself thinking with Clement, having ideas about the physical work that I would not have otherwise had. In that mode, we knew our work would combine my love of words and Clement's love of wood, and that it would be performative—something outside both of our usual practices and comfort zones.

We came to this project shortly after having been part of a month-long residency in Kamloops called *Reconsidering Reconciliation.* Co-sponsored by the Shingwauk Residential Schools Centre at Algoma University, the residency was held on the campus of Thompson Rivers University and hosted by Ashok Mathur during the summer of 2013. It gathered Indigenous and non-Indigenous artists who worked individually and collectively to consider what role art might play in reconciliation.

Prior to this gathering, I was not optimistic about the social engineering called Truth and Reconciliation. When first asked to work in this area more than five years ago by Jonathan Dewar, I rejected the idea. Even before seeing the testimony process firsthand, I felt that the principles of the formal TRC project continue the colonial enterprise. Individual payouts for personal testimony—rather than nation-to-nation settlements—are designed to bypass Treaty relationships, to divide and conquer. While the aggressive assimilation spearheaded by Indian Residential Schools targeted children, it was designed to ruin whole communities, past, present, future. The money, and the public raking up of this pain, has caused a great deal of (mostly unreported) devastation to individuals, families, and communities. I remain convinced that the official Truth and Reconciliation is primarily a non-Indigenous project designed to reconcile settlers with their dark history in order that they might live in this territory more comfortably and exploit these lands more thoroughly.

"Re-conciliation" assumes that Indigenous peoples and settlers once had a conciliatory relationship; that all that is needed is Indigenous absolution for harmony to be restored. But there is no halcyon moment to recover, only the on-going colonial condition to become conscious of and resist. This cannot occur in the TRC bubble of structured empathy, where the pressure on survivors to forgive is enormous. The first line of the TRC's official mandate reads: "There is an emerging and compelling desire to put

the events of the past behind us so that we can work towards a stronger and healthier future" ("Establishment"). Whose compelling desire? The cruelty of this construction is that it places the onus on survivors of these internment institutions to forgive both their absent abusers and the abstract state. Following the familiar colonial script, these people are narrated as obstacles that must be overcome if we are all to move forward "towards a stronger and healthier future." The TRC's emotionalist structure negates resistance, reason, and discourse. The TRC is a pain generator, a testimony and tear-stained tissue collector. The federal focus on Indian Residential Schools is an effort to personalize, cauterize, and distract notice away from larger issues. It aims to direct attention to the display of individual Indigenous suffering bodies, rather than the collective wholes that were betrayed. It attempts to pay off and/or "heal" these folks rather than negotiate with their nations. And it is designed to distract both Indigenous and non-Indigenous folks from larger ongoing issues of Canadian colonization and land (ab)use.

That said, after watching Peter Morin and Ayumi Goto's affectively wrenching *Hair* performance in Kamloops in August of 2013, I felt that one path through to that which is not-quite conciliation might be empathetic and inconclusive aesthetic exchanges across the Indigenous/non-Indigenous divide—particularly with newcomers, folks for whom Indian Residential Schools and Canadian colonialism is a recently adopted burden rather than something that directly entangled their ancestors. The possibilities of this sort of relationship are embodied in a gesture from *Hair*. Responding to Morin's grieving over the suffering endured by Indian Residential School children and their families, Goto cuts her beautiful, long black hair. Her reformation evokes both a shorn First Nation child and a traditional Japanese woman, whose hair/culture is reshaped by Modernism.

The Morin/Goto partnership disrupts the Indigenous/Settler binary that assumes the Settler position to only be occupied by European bodies. This wordless dialogue, between a Tahltan man and a Canadian woman of Japanese descent, occurs in the margins of the colonial script. It has us wonder not only about how similarly and dissimilarly each is formed under their various empires, but also how they empathize, console, counsel, and collaborate with each other beneath empire.

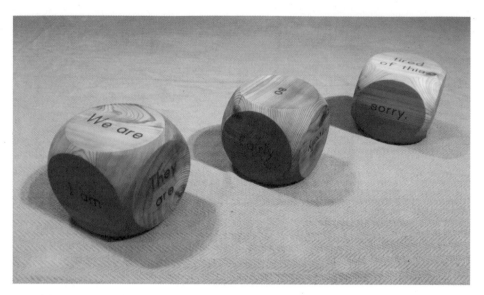

David Garneau and Clement Yeh. *Apology Dice.* 2013. (SHARIF MIRSHAK)

The Limits of Art and Empathy

There is a danger that, much like the Truth and Reconciliation road show, this sort of performance might be consumed as emotional spectacle and may not engender political results. And this is the weakness of all art for those who measure the world according to an instrumental calculus. Art moves us but does not necessarily move us to action. Gestures in the aesthetic realm may symbolically resist the dominant culture, but there is little empirical evidence to show that art leads to direct action or that viewing it makes us better people. And yet some of us do feel changed, and we continue to make and enjoy art *as if* it mattered, *as if* it made a difference. What art does—and what is difficult to measure—is that it changes our individual and collective imaginaries by particles, and the resulting new pictures of the world can influence behavior. Queer pride parades and Idle No More round dances do change how we see and treat each other and ourselves.

The public display of Indigenous and non-Indigenous people working through their parallel constructions under colonialism, relating to each other in novel ways, in difference to dominant scripts, changes our

minds, pictures new ways of being with each other. The strong but weeping Tahltan man asks us to recognize his humanity, and we do, not just in this fictive moment but beyond. Dialogues about the lived experience of colonialism by a group of Indigenous and non-Indigenous people who absurdly gather around three blocks of wood and a blanket are powerful if only because they exist apart from official control, where surprises may occur. To be sure, academic, racial, judicial, tribal, and religious patterns wind their way throughout the conversation. But in the polyphony and the overlay of differences, their structures, limits, and contingencies are laid bare. When, for example, members of an implicated faith group (in the absence of their leaders) talk about the good intentions of past members who designed and worked in Indian Residential Schools, and then are met with Indigenous survivors (in the absence of their leaders) who describe the bad results of those good intentions, it creates an intellectual and empathetic dissonance that cannot be dissolved by argument. Art can be a site of symbolic dissonance where hegemonies are revealed and challenged in fragments. In our case, creative conciliations are not answers but displays of possibility, ways of being other than the proscribed and unhealthy.

Clement identifies as Canadian with Chinese ancestry, his family arriving in 1979. Although he generally feels very much included within our national cultural mosaic, he never forgets that he is a visible minority. That knowledge prevents him from taking this land for granted. I am Métis, with more European than First Nations inheritance. Perhaps precisely because neither of us quite fit the Indigenous and Settler profiles, we wondered if we might be well suited to devise creative ways to stimulate conversation about issues of conciliation among all sorts of people living in these territories. I think of these small, rough, and unofficial gestures as creative conciliation. They are naïve, symbolic, incomplete, emotional, and hopeful person-to-person conciliations.

Apology Dice

In 2008, on behalf of Canada, Prime Minister Harper apologized to former students of Indian Residential Schools for the government policy of aggressive assimilation that separated children from their families, cultures, and

languages in an attempt to "kill the Indian in the child." The reactions of First Nations, Métis, and Inuit people were various. Many were pleased by the recognition of these facts but did not think the Apology and reparations went far enough. The non-Aboriginal Canadian reaction was similarly mixed—when not apathetic or confused. The meanings of the Apology are endless, and this complexity may lead people to feel in suspense or indifferent. *Apology Dice* is a performative moment that endeavours to stir an emotional response, but also to help participants discover and express their feelings about these important issues in public. For ambivalent participants, rolling the dice may prompt more certainty: "I do feel only somewhat sorry." For those who feel well informed and have a strong opinion about apology and reconciliation, play may reinforce their beliefs or perhaps unsettle them a little—especially when they explain their thoughts to First Nations participants. *Apology Dice* is a conversation starter.

Apology Dice consists of participants, three large dice, and a blanket. Each die is cast one at a time, and in order, to form a sentence. The letters of the first die begin with a capital letter. The second die has no punctuation. The word or words of the third die end in a period. "I am / so / sorry." "We are / not / sorry." "They are / very tired / of this."

The participant reads the sentence aloud and responds. Is this how they feel? Is this the opposite of how they feel?

The Indian Residential Schools are a living tragedy for Aboriginal people. This work is not intended to make light of this dark legacy but to be a disarming vehicle to prompt discussion. *Apology Dice* are only to be rolled in an environment of contemplation and conversation. Participants must be willing to share and discuss their thoughts and feelings.

I recently activated the dice with a dozen Shingwauk Residential School survivors at the Art Gallery of Algoma (June 8, 2014). These folks have organized themselves and supported each other for decades. They found surprising nuance in the rolled sentences. "We are so sorry," had them wonder which "they" and "sorry" for what? Sorry about the schools? That they did not work as planned? Sorry to have initiated the TRC process? The sentences became Rorschach tests, allowing participants to raise what issues they pleased. They told and taught rather than confessed. Nearly half the group had been in the Parliament Buildings for the Apology. Some

were moved; others not. One elder said that she purposely stayed away from the ceremony. She did not want to be mollified by the ritual.

I also activated the dice with a mixed group later in the week. Nearly everyone gave it a try. They seemed excited by the opportunity to share their thoughts. Indigenous folks, perhaps since everyone was taking a turn, appeared eager to explain their experience—not at Indian Residential School, but as being Native in a non-Native world. Talk was very much to and with each other, rather than abstractly historical and political.

Apology Dice was an attempt to encourage conversation in a playful setting rather than a didactic one with intentional outcomes. I was concerned that some might find the work not disarming but disrespectful, making a game of tragedy. I was very pleased that the Shingwauk elders appreciated the accessibility of the work, and that it was about whatever those participants needed it to be about. One of the elders, upon picking up a die, said: "It feels so light. I suppose, though, that the more they are used the heavier they will get."

—DAVID GARNEAU

Why I Wanted to Make the *Apology Dice*

Canadians spend so much time patting themselves on the back for their supposed openness to ethnicity, acceptance of gay marriage, history of peacekeeping, socialized medicine, and so many other things, one must wonder why we don't all have sore wrists. Some of these claims are certainly true, and I am proud of them. But there lies an inherent danger: self-congratulation can obscure areas that demand immediate improvement, such as major retractions in our commitment to fighting climate change, and our continuing history of subjugating First Nations people.

For many years I have wanted to make something that expresses my desire to be an ally with Indigenous peoples, but I didn't know how. The problems are so complex. One only has to read the nasty comments under any Aboriginal-themed news article to realize that a huge part of "polite, liberal, open-minded" Canada has written these people off: "What's done is done. Why can't they just get over their problems and conform to the rest of us?" One out of many responses comes to mind: We, settlers,

David Garneau playing *Apology Dice* with members of the Children of Shingwauk Alumni Association at the Art Gallery of Algoma. 2014. (JONATHAN DEWAR)

have attempted to obliterate their cultural identity by decimating most of their lands and traditional ways of life. We kidnapped several generations of their children, and subjected them to sexual and physical abuses, cultural shame, and harsh nutritional experiments. We have relocated their society far from the rest of us, sometimes in very inhospitable conditions, and set up barriers to equal education, employment, political/legal representation, and healthcare. History shows that demolished civilizations don't adapt and rebound overnight. Besides, what is so damn great about our society that they should conform to us? They were here first; maybe we should be the ones conforming to them.

Collaborating with David Garneau has given me a special opportunity to add my skills and empathy to this conversation, hopefully without being another intruder. Thanks to Sophie McCall, Gabrielle Hill, and Ashok Mathur for helping to make this happen. *Apology Dice* is meant to stimulate conversation between people of different backgrounds. While I don't believe complete reconciliation and restitution across this entire nation can ever be achieved, my goal is to use this project to educate myself and others about how we can all move forward to a place of understanding, compassion, and respect.

—CLEMENT YEH

FROM *WHEREAS**

Layli Long Soldier

On a Saturday in December 2009, US President Barack Obama signed *the* Congressional Resolution of Apology to Native Americans. *No tribal leaders or official representatives were invited to witness and receive the Apology on behalf of their tribal nations. President Obama never read the Apology aloud publicly—although, for the record, Senator Brownback later read the Apology to a gathering of five tribal leaders. (Bearing in mind there are 566 federally recognized tribes in the US.) And the Apology was folded into a larger (unrelated) piece of legislation called the* Defense Appropriations Act.

The following is my response to the Apology's delivery, as well as the language, crafting, and arrangement of the written document. Facts as they are, it should be noted that this series is not written to target or attack President Obama, a specific politician, nor any political party; I am not affiliated with a party. I am, however, a citizen of the United States and an enrolled member of the Oglala Sioux Tribe, meaning I am a citizen of the Oglala Lakota Nation—and in this dual citizenship I must work, I must eat, I must art, I must mother, I must friend, I must listen, I must observe, constantly I must live.

* These poems are excerpted from Long Soldier's forthcoming manuscript entitled *Whereas.*

WHEREAS my eyes land on the statement, "Whereas the arrival of Europeans in North America opened a new chapter in the history of Native Peoples." In others, I hate the act

of laughing when hurt injured or in cases of danger. That bitter hiding. My daughter picks up new habits from friends. She'd been running, tripped, slid on knees and palms onto asphalt.

They carried her into the kitchen, *She just fell, she's bleeding!* I winced. Deep red streams down her arms and legs, trails on white tile. I looked at her face. A smile

quivered her. A laugh, a nervous. Doing as her friends do, she braved new behavior— I can't name it but I could spot it. *Stop, my girl. If you're hurting, cry. You must*

show your feelings so that others know, so that we can help. Like that. She let it out, a flood from living room to bathroom. Then a soft water pour I washed

carefully light touch clean cotton to bandage. I faced her I reminded, *In our home in our family we are ourselves, real feelings. You can do this with others, be true.* I sent her

off to the couch with a movie encouraging, *Take it easy.* Yet I'm serious when I say I laugh reading the phrase, "opened a new chapter." I can't help my body. I shake. The sad

realization that it took this phrase to show. My daughter's quiver isn't new— but a deep practice very old she's watching me;

WHEREAS I tire. Of my effort to match the effort of the statement: "Whereas Native Peoples and non-Native settlers engaged in numerous armed conflicts in which unfortunately, both took innocent lives, including those of women and children." I tire

of engaging in numerous conflicts, tire of the word *both*. Both as a woman and a child of that Whereas. Both of words and word-play, hunching over dictionaries. Tire of referencing terms such as *tire*, of understanding weary, weakened, exhausted, reduced in strength from labor. Bored. In Lakota, tire is okita which means to be tired. Should I mention I'm bored. Yet under the entry for okita I find the term wayuh'anhica, meaning to play out to exhaust a horse by not knowing how properly to handle it. Am I okita or do I wayuh'anhica?

In my effort to push and pull language, how much must I labor to concrete here what's real. *Really,* I am 5-foot ten inches. Really, I sleep on the right side of the bed. Really, I wake after eight hours and my eyes hang as slate grey squares. Really, I am blokita

very tired. Really, this is a matter of wayuh'anhica, meaning I exhaust a horse by not knowing how to properly handle it. I climb the backs of languages, ride them into textual conflict—maybe I pull the reins when I mean go. Maybe kick their sides when I want down. Does it matter. Okita, I'm stuck, I want off. From the repetition, my impulse to note: *Beware, a horse isn't a reference to my heritage;*

WHEREAS her birth signaled the responsibility as mother to teach what it is to be Lakota therein the question: what did I know about being Lakota? Signaled panic, blood rush my embarrassment. What did I know of our language but pieces? Would I teach her to be pieces. Until a friend comforted, *Don't worry, you and your daughter will learn together.* Today she stood front and center her pride in the living room to share a song in Diné, her father's language. To sing she motions simultaneously with her hands I watch her *be* in multiple musics. At a ceremony

to honor the Diné Nation's first poet laureate, a speaker explains that each People has been given their own language to reach with. I understand reaching as active, a motion. He offers a prayer and introduction in heritage language. I listen I reach my eyes into my hands, my hands onto my lap, my lap as the quiet page I hold my daughter in. I rock her back, forward, to rise of conversation

about mother tongues versus foster-languages, how to forge belonging. I connect the dots I rock in time with references to Derrida, master language-thinker who thought of his mother too. Mother-to-child and child-to-mother relationships, is that postmodern. As his mother suffered the ill-effects of a stroke he wrote: *I asked if she was in pain (yes) then where? [...she] replies to my question: I have a pain in my mother, as though she were speaking for me, both in my direction and in my place.* His mother, who spoke in his place for his pain and as herself for her own, did this as one-and-the-same. Yet Derrida would propose understanding the word mother by what she is not. Forward, back. I lift my feet

as my toes touch the floor I'm reminded of the linguistic impossibility of identity, as if any of us can be identical ever. To whom, to what? Perhaps to Not. I hold my daughter in comfort saying *iyo-tanchilah mi-chuwintku.* True I don't know how to write our language on the page correctly, the written takes many forms

yet I know she understands through our motion. Rocking, in this country of so many languages national surveys reporting Native languages are dying. Child-speakers and

elder-teachers dwindle, we gather this from public information. But in our home her father and I don't teach in statistics, in this dying I mean. Whereas in speaking we find *defiance*—the closest I can come to *differánce*. Yet I confess

these are numbered hours spent writing to speak to a national document which concerns us, my family. Hours alone to think, without. My hope: my child understands wholeness for what it is, not for what it's not, all of it the pieces;

WHEREAS I sipped winter water cold-steeped in pine needles, I could taste it for days afterwards I taste it now. When I woke alone grey curtains burned in sunrise and down my throat to the pit, a tincture of those green needles changed me. When should I recount detail, when's it too much. When my mother burrows herself, I listen to her. We speak about an envelope for receipts, dark roast coffee and the neighbor's staple gun I want to borrow. In the smallest things I watch the compass needle of conversation register her back to center. What has become of us, mother to her former self. Daughter to mother, present selves. Citizen to country, former and past to present or, is it a matter of *presence*? My daughter wouldn't do it when she was younger but this year she wanted to. For her birthday, an ear piercing. The needle gun hurts only for a moment we assure her. In the old days Grandma held ice on my earlobes then punctured with a sewing needle. You'll have it easier, I encourage. She rushes through the mall to the needle chair, her smile. Eagerness, the emotion-mark of presence. I want to write something kind, as things of country and politic nation and nation-to-nation burn, have tattooed me. Red-enflamed-needle-marked me. Yet in the possibility of ink through a needle, the greater picture arrives through a thousand blood dots. Long ago bones were fashioned into needles. If I had my choosing I'd use this tool here, a bone needle to break the skin. To ink-inject the permanent reminder: *I'm here I'm not / numb to a single dot;*

WHEREAS I read an article in a New York newspaper about the federal sequestration of funds from reservation programs, the cuts. In federal promises and treaties. The article details living conditions on reservations those suicides up to ten times higher than the rest of the country. Therein the story of a 12-year old girl whose mother died she doesn't know her father she bounces home to home to foster home, weary. I regard how plainly the writer imparts her repeated sexual abuse. And for her mental care, unavailable services. There's a clinic that doesn't have money after May, *don't get sick after May* is the important message. As I read I cry I always cry and here I must be clear my crying doesn't indicate sadness. I read a comment posted below the article:

I am a fourteen-year-old girl who recently visited the _____ Reservation
in South Dakota, with my youth group. The conditions the Native American
people were living in were shocking. When I arrived home, I wrote a petition
on whitehouse.gov for the u.s. to formally apologize and pay reparations to the
Native American people. This petition only stays up until July 23rd, so please sign
and share!!! You signing it would really mean a lot to a lot of people. Thank you.

Dear 14-Year Old Girl, I want to write. The government has already "formally
apologized" to Native American people on behalf of the plural *you*, your youth group,
your mother and father, your best friends and their families. You as in all American
citizens. *You* didn't know that, I know. Yet indeed Dear Girl the conditions on
reservations have changed since the Apology. Meaning, the Apology has been followed
by budget sequestration. In common terms sequestration is removal banishment or exile.
In law-speak it means seizure for safe-keeping but changed in federal budgeting to mean
subject to cuts, best as I can understand it. Dear Girl I went to the Indian Health Services
to fix a tooth, a complicated pain. Indian health care is guaranteed by treaty but at the
clinic limited funds don't allow treatment beyond a filling. The solution offered: *Pull it.*
Under pliers masks and clinical lights, a tooth that could've been saved was placed in my
palm to hold after sequestration. I don't share this to belabor suffering, facts are what
they are I share to explain. Dear Girl, I honor your response and action I do. Yet at the
root of reparation is repair. My tooth will not grow back ever. The root, gone.

PART THREE

COLLAB-
ORATION,
CREATIVE
PRACTICE,
AND
LABOUR

WALKING WITH OUR SISTERS IN SAULT STE. MARIE:
THE COMMEMORATION OF MISSING AND MURDERED INDIGENOUS WOMEN AND INDIAN RESIDENTIAL SCHOOL STUDENTS

Jonathan Dewar

Walking With Our Sisters is a commemorative art installation for the Missing and Murdered Indigenous Women of Canada and the United States. In May of 2014, the Shingwauk Residential Schools Centre at Algoma University partnered with Shingwauk Kinoomaage Gamig, an independent culture-based educational institution, to host the installation in Sault Ste. Marie, Ontario. The Shingwauk Auditorium, part of the former Shingwauk Indian Residential School, which now stands as Algoma University's main building, was chosen as the site for the memorial.

> "Over [1200] native women and girls in Canada have been reported missing or have been murdered in the last 30 years. Many vanished without a trace with inadequate inquiry into their disappearance or murders paid by the media, the general public, politicians and even law enforcement. This is a travesty of justice.
>
> Walking With Our Sisters is by all accounts a massive commemorative art installation comprised of 1,763+ pairs of moccasin vamps (tops) plus 108 pairs of children's vamps created and donated by hundreds of caring and concerned individuals to draw attention to this injustice. The large collaborative art piece will be made available to the public through selected galleries and locations. The work exists as a floor installation made up of beaded vamps arranged in a winding path formation on fabric and includes cedar boughs. Viewers remove their shoes to walk on a path of cloth alongside the vamps.
>
> Each pair of vamps (or "uppers" as they are also called) represents one missing or murdered Indigenous woman. The unfinished moccasins represent the unfinished lives of the women whose lives were cut short. The children's vamps are dedicated to children who never returned home from residential schools.

Together the installation represents all these women; paying respect to their lives and existence on this earth. They are not forgotten. They are sisters, mothers, aunties, daughters, cousins, grandmothers, wives and partners. They have been cared for, they have been loved, they are missing and they are not forgotten."
—WALKING WITH OUR SISTERS COLLECTIVE

When Métis artist Christi Belcourt first put the call out on social media in 2012 for interested parties to submit vamps or moccasin tops for a commemorative initiative, she was overwhelmed by the response (Belcourt, Interview). She was further overwhelmed by replies from those individuals

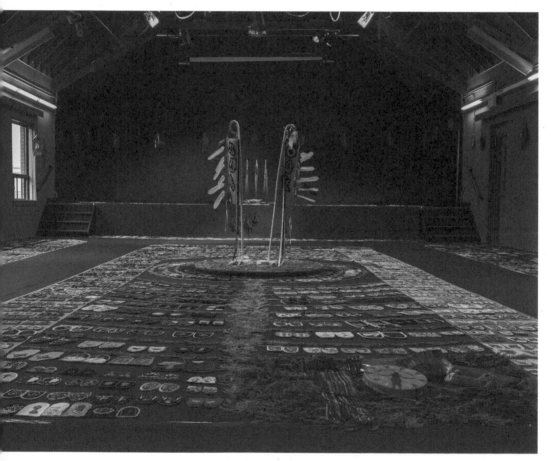

Shingwauk Auditorium, the main building of Algoma University. *Walking With Our Sisters.* 2014. (MELODY McKIVER)

and parties interested in hosting the eventual installation, which Belcourt describes as ceremonial—a memorial, not an exhibit. In fact, I was an early responder to this call and was thrilled to be asked to host the memorial—in 2018!—at Algoma University.

On February 5, 2014, Belcourt visited our campus as a guest speaker invited by our institutional partner, Shingwauk Kinoomaage Gamig, where she floated the idea of Algoma University and Shingwauk Kinoomaage Gamig hosting *Walking With Our Sisters* sooner rather than later due to a cancellation. I glanced over at my Shingwauk colleague and Belcourt's host, Rebecca Beaulne-Steubing, and emphatically nodded to indicate my interest. Within 24 hours it was confirmed; we would host *Walking With Our Sisters* in the former Shingwauk Indian Residential School in twelve short weeks, May 2014.

To give a bit of background on the hosting community, the Shingwauk Residential Schools Centre is a cross-cultural research and educational development project of Algoma University, the Children of Shingwauk Alumni Association, and the National Residential School Survivor Society. Shortly after the closure in 1970 of the Shingwauk Indian Residential School, and in the early years of Algoma University College's relocation to the present site, Residential School Survivors who were connected to the Shingwauk School, along with their families, communities, and allies, became catalysts in the growing Healing Movement. Their efforts culminated in the development of the Shingwauk Project in 1979 and the Shingwauk Reunion in 1981. From these watershed events began the decades-long work of organizing, collecting, displaying, conducting research, and educating the public that led to the establishment of the Children of Shingwauk Alumni Association (CSAA) and the Shingwauk Project, now known as the Shingwauk Residential Schools Centre (SRSC), respectively. The SRSC is a partnership between Algoma University and the CSAA, governed independently by the partners' Heritage Committee, which is majority Survivor-led.

At that point, Rebecca and I began to pore over the lengthy document the Walking With Our Sisters (WWOS) National Collective had prepared for hosts. It was daunting to say the least. But we were in no way cowed by the tasks at hand. The chance to engage in this essential, transformative

memorial was just too meaningful and too great an opportunity for both of our organizations, particularly given the mandate of the Shingwauk Indian Residential Schools Centre, which is "Sharing, Healing, and Learning" with regard to the legacy of Indian Residential Schools and the broader colonial context. And our community *needed* this engagement, too. We knew that all too well.

As wwos is entirely community-based, our first tasks were to bring together the members of the community who would volunteer to fill the essential roles of Elders and Keepers. In each host community, local Elders are asked to provide guidance over the organization and ceremony to honour local protocols and needs. Keepers work closely with the Elders and take up the responsibility of looking after the bundle, ceremony, and protocols. I am indebted to our Elders, Shirley Horn, Barbara Nolan, and Brenda Powley and to our Keepers, Dallas Abitong, Linda Audette, and Rebecca Beaulne-Stuebing, and this photo essay is dedicated to them and to all of our volunteers. We also had a dedicated team of men who volunteered to keep the sacred fire for the full three-week run of the installation, from opening ceremony to closing ceremony. These activities were ably led by Mitch Case, who also shared his pipe, along with others from the community in the various ceremonies we held.

With those key responsibilities taken care of, we were then able to host the first of three Community Conversations. The Community Conversations were open to all and were meant to invite volunteer participation of all sorts, with a special emphasis on the many administrative duties we would take on (finance, scheduling, communications). Everything related to the event had to be done in ceremony, including receiving the installation materials, especially the vamps and sacred bundle; the long, painstaking, deliberate work of installation; and the equally detailed process of take-down, at which time we would close the initiative and send the materials, driven by volunteers, to Flin Flon, Manitoba. Once the memorial arrived at its new destination, both the volunteers and the materials would be welcomed in ceremony.

At our very first meeting we were struck by a challenge: How would we welcome this memorial, this ceremony, into a former Indian Residential

School building? What special considerations were there to think through and act upon? We all knew, without hesitation, that wwos was meant to be here, at this time, and we were ready. We also felt called upon, because of our "expertise" in Indian Residential Schools education and service to the community and Shingwauk Kinoomaage Gamig's culture-based education focus, to be the ones to think through, with the National Collective, just how the issue of Missing and Murdered Indigenous Women and Girls should intersect with the legacies of Residential Schools, which include social and systemic dysfunction that leads to women and girls being put at risk.

At a subsequent meeting, keeper Dallas Abitong asked if special vamps could be made to honour the children who never returned home from Residential School. There was unanimous agreement that this was, in fact, a beautiful, meaningful, and profound way to honour these children and the Survivors who would be our hosts, by virtue of their decades of work on the issue, starting with the 1979 Shingwauk Project and culminating in the present day work of the Shingwauk Residential Schools Centre, and to honour the children. Symbolically, the idea of honouring the spirits of these children in ceremony, along with those of the hundreds of missing and murdered Indigenous women we were memorializing, was powerful and we knew it was the right way forward. So a special call for children's or baby vamps went out and 117 new pairs were received and catalogued. It was at this point that the work began in earnest to plan the ceremony that would see these new donated works of art, of sacred items, added to the Sault Ste. Marie iteration of wwos.

Next we had to decide where on campus we would—or even could— host an installation of this size. There was never any doubt that the most meaningful space on campus for Survivors was the historic Shingwauk Auditorium, which sits as an extension of Shingwauk Hall. This building was constructed in 1935 and operated as the Residential School until 1970. Not only was this space the appropriate size, its use would also help us deal with some of the painful elements of working with the issues of Residential Schools and Missing and Murdered Indigenous Women. This is because many Survivors first and foremost remember the Auditorium as a relatively benign space; it is even remembered by some as one, if

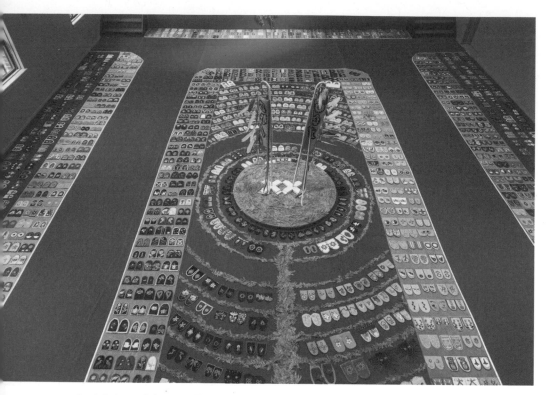

Aerial view of the installation. (MELODY McKIVER)

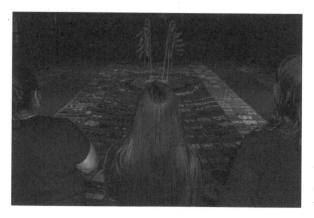

The keepers look on as the opening ceremony is about to start. (MELODY McKIVER)

not the only, space where some positive memories reside. The space was often used, in the experience of living Survivors, as a place of play and also where siblings were permitted, for a few minutes a month, to visit. The Survivors who have sustained the healing and education work of the Shingwauk Project over five decades have also used the space for many powerful events, such as the 1981 Shingwauk Reunion and the many Gatherings that have followed since.

Much thought went into determining how to prepare the space, both physically and spiritually, for the installation. We were armed with excellent advice on the necessary protocols for the project and were hard at work both within and beyond the Community Conversations in determining the new, local protocols that must be added. And so we proceeded to the welcoming ceremony and the other ceremonies that would allow us to enter and to use the space.

Each host community designs its own layout, following some basic teachings. Most importantly, the vamps are placed on the floor, pointing in the direction that visitors walk or stand to contemplate the works. Underneath the vamps and the canvas are sacred medicines. Cedar is placed upon the floor covering the entire floor space and cedar bundles are hung from the walls.

After four long days of installation, photographs were allowed prior to the opening ceremony. In fact the photos that accompany this essay are from this time, courtesy of the talented and committed volunteer Melody McKiver.

Not pictured in this essay are the children's vamps that came out of that special call. And there is good reason for that; a very special ceremony took place days after the official opening to welcome the baby vamps into the sacred bundle.

Pictured here and on the following page, you will see the place of honour reserved for those tiny additions. Led by Elders, Survivors, WWOS Keepers, and Pipe Keepers, these vamps were placed on the floor and welcomed in during a four-hour ceremony. The ceremony culminated in an invitation to each Survivor present—and afterward to each guest—to stand from our place seated in the circle and to approach the vamps, select a pair, and accompany it to the entrance of the room. There the guests

followed a special path of cedar to the centre circle and a place of honour with the Eagle Staffs that had been donated to the project at a previous event. Once laid, the guest returned to their spot and a closing sharing circle was convened. At its close, those leading the ceremony led us from the room and on to a feast.

The children's vamps are now part of the sacred bundle as wwos travels across the country. They will return to Algoma University and the Shingwauk Residential Schools Centre for a permanent memorial installation.

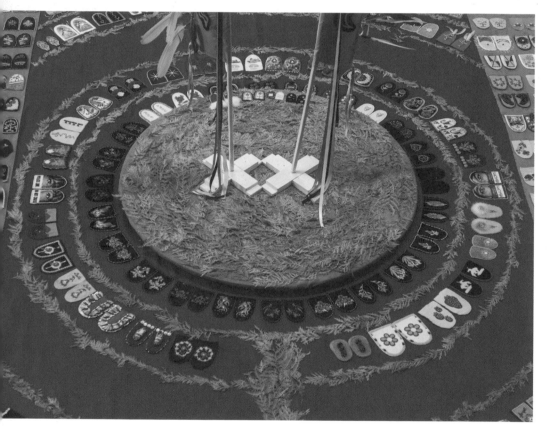

Close up of the centrepiece and Eagle Staffs. (MELODY McKIVER)

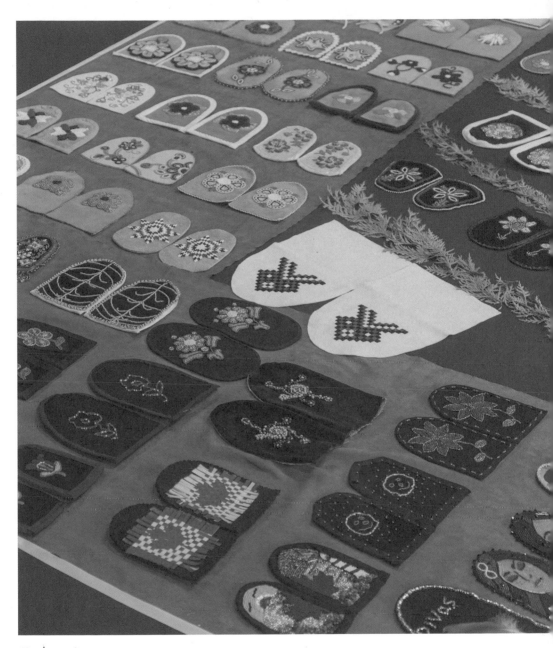

Close up of vamps. (MELODY McKIVER)

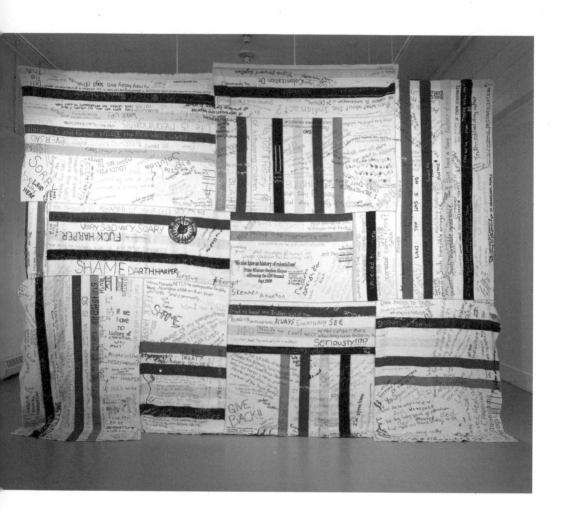

Leah Decter and Jaimie Isaac. *(official denial) trade value in progress.* 2014.
(JORDAN BLACKBURN)

REFLECTIONS ON UNSETTLING NARRATIVES OF DENIAL

Leah Decter and Jaimie Isaac

In September of 2009, just over a year after issuing an official "Statement of apology to former students of Indian Residential Schools," Prime Minister Harper, in the course of answering a question at the G20 Summit in Pittsburg, publicly stated in reference to Canada, "we also have no history of colonialism."[1] *(official denial) trade value in progress* is an art project that asks members of the public to contribute written and sewn responses to Harper's G20 statement through a series of participatory events. Leah Decter initiated the project in 2009. Jaimie Isaac's involvement began when, after being introduced to Decter's work during a studio visit, she expressed interest in curating the project as part of the exhibition component of the inaugural Truth and Reconciliation Commission (TRC) event held in Winnipeg in June of 2010. Committed to including the work of non-Indigenous artists alongside work by Indigenous artists in the TRC conversation, Isaac played a key role in launching the project; her engagement has expanded and, since 2011, Decter and Isaac have collaborated to activate the project across the country. Their collaboration has had a significant impact on how the project unfolded as they brought it to art galleries, high schools, conferences, inner city community organizations, friendship centres, universities, colleges, First Nations communities, research centres, and private homes from Vancouver Island to Halifax. The project has engaged with participants and viewers across age, experience, and cultural background in encounters that have been eye opening, emotional, and deeply thought provoking. With hundreds of sewn and written responses contributed over the last four years, the piece has become a public record of sorts, giving evidence of both the connections

and the difficult divides to be considered in the process of forging a future of "peaceful co-existence" (Alfred, *Wasáse* 23).

The following essays contextualize *(official denial) trade value in progress* through each of our particular positional lenses, our respective art and curatorial practices, and through our experiences co-activating the project over the last four years. Initially written for publication in *West Coast Line*'s 2012 *Reconcile This!* issue, these essays have been revised to reflect the evolution of the project, and our understandings of it, as it has continued in the interim. As Indigenous person and white settler, curator and artist, researchers with related but distinct interests, and collaborators, we in some ways experience, understand, and articulate aspects of this project differently, while in other ways our conceptions of it converge. We chose to construct this piece of writing in the form of separate narratives as a way of making visible both our unique frames of reference as well as the overlap in our relationships to the project.

The texts interspersed throughout both of our writings are responses to Prime Minister Harper's denial from individuals who have participated in this project. The responses form the backbone of the project. We felt it was important to convey and honour the voices of those who have been involved by highlighting their statements within the context of our narratives. We take this opportunity to thank those who shared their thoughts and experiences through their participation in the project and to invite the reader to visit the project website to view more responses, as they are all relevant and important to this work in progress. We would also like to thank the project's funders: the Winnipeg Arts Council, the Manitoba Arts Council, and the Shingwauk Residential Schools Centre, as well as the generous hosts and others who have supported our travel and the spirit of this project.

LEAH:

(official denial) trade value in progress places Prime Minister Harper's statement "we also have no history of colonialism" squarely in the spotlight by inviting Canadians to respond to it. This statement can be seen to encompass the disavowal of a comprehensive set of colonial truths. As Jennifer Henderson and Pauline Wakeham contend, Harper's G20

Leah Decter and Jaimie Isaac. *(official denial) trade value in progress.* 2014.
(JORDAN BLACKBURN)

the picture on his passport. He made a home in Saskatchewan and eventually ran a general store in the small town of Kinistino, where he lived until his death in 1983.

My grandfather's story can be seen as emblematic of those commandeered to construct dominant conceptions of Canadian identity in relation to immigrant narratives of precarity, refuge, and advancement that occlude correlations with the nation's settler colonial systems and ideologies. Such characterizations invalidate the impact that policies and practices of immigration as a form of settlement have had on the economic, political, and cultural lives of Indigenous people, communities, and nations. In truth, when our ancestors found home in these territories, and relief from *their* dislocation, they became part of a settler colonial system that precipitated Indigenous dispossession and oppression with legacies that stretch to the present. Obscuring the full picture of this history, and by extension the reality of current conditions, these narratives, along with other dominant conceptions of Canadian nationhood and identity, have

calcified into reductive mythologies that substantiate colonial claims of entitlement and superiority. Framing understandings of the Canadian nation-state and its population in this way works to eclipse Indigenous histories and voices, devalue Indigenous knowledge, and perpetuate dichotomous settler colonial relations and systems in which inequities are entrenched.

"If we can't honestly examine our mutual histories, oppressed becoming oppressors, then imperialism continues and remains obscured."

"Canada is a beacon of peace around the world: Lies my teacher told me."

"Everybody has the right to know and have a history."

The work I undertook exploring aspects of dis/location and migration relating to my grandfather's story led me to confront the violence of Indigenous dispossession that is intrinsically tied to Canadian immigration policies and narratives, which serve colonial logics of settler emplacement into the present. Extending this inquiry, my ongoing body of work, *trade value*, of which *(official denial) trade value in progress* is part, seeks to disrupt mainstream historical accounts and enduring national mythologies, and examine both contemporary systems of settler colonialism and current initiatives of reconciliation and decolonization. I engage with these issues through a critical and ongoing analysis of my position as a white settler in the context of the historical and contemporary settler colonial logics and racist ideologies that undergird Canada as a nation-state. The works in *trade value* build on my practice of embodied insertions into land, land*scape*, and public space, and calculated tampering with iconic elements of Canadian visual and material culture, in this case the HBC Point Blanket. Incorporated in this work in multiple forms, the HBC Point Blanket invokes trade as an economic, political, and social interchange; one that is fraught, yet potentially recuperative.

Working with the HBC blankets through material, relational, and dialogic strategies, the *trade value* works, and *(official denial) trade value in progress* in particular, frame the economic, political, and social factors inherent in notions of trade as intersecting features of contemporary settler colonial inequities. With its near monopoly on the fur trade and

considerable land holdings, the Hudson's Bay Company was an instru-
mental economic pillar of the settler colonial project in the early forma-
tion of the Canadian state. The imposition of European trade practices
set a pattern of European dominance by privileging Western models of
capitalism and ownership in disregard of Indigenous practices and belief
systems. The HBC's influence extends from resource exploitation associ-
ated with the fur trade to land dis/possession enacted through colonially
embedded practices of acquisition and re/distribution. As such, the HBC
contributed significantly to the fashioning of colonial attitudes and struc-
tures that work to instill European dominance in cultural, political, and
economic spheres across the territories now known as Canada.

The HBC's Point Blanket has both historical and contemporary reso-
nance. It is a highly charged symbol of Canada's inception through its role
as a colonial currency in the fur trade, and its implication in the spread
of smallpox to Aboriginal communities. Its contemporary significance is
solidified through its invocation as a nationalist symbol. The multi-stripe
version in particular—which is the one used in *(official denial) trade value
in progress*—has come to be a Canadian icon and an expensive luxury
item. Enduring as hallmarks in the HBC's retail product line, the multi-
stripe blanket and its numerous variations (bikinis, upholstery, kitchen
ware, chocolate boxes, dog beds, and so on) are increasingly prevalent
in home décor, fashion, and as Canadiana. With this position in main-
stream consumer culture, the difficult history of the blankets has largely
been expunged. I am interested in working with this icon of Canadian
visual culture because of its complex genealogy and the way its contem-
porary mainstream reception mirrors the erasure of colonial violence in
the dominant national imaginary. The *trade value* works redeploy the
blanket and its contentious social history through transfiguration, recon-
textualization, and relational activation to foreground historical counter-
narratives, contemporary conditions, and future possibilities. As this body
of work has progressed, I have become increasingly interested in concepts
and practices of trade that challenge Western capitalist assumptions, and
can be activated as tactics of collaborative pedagogy towards equitable
inter/change. *(official denial) trade value in progress* marks a foray into
these considerations.

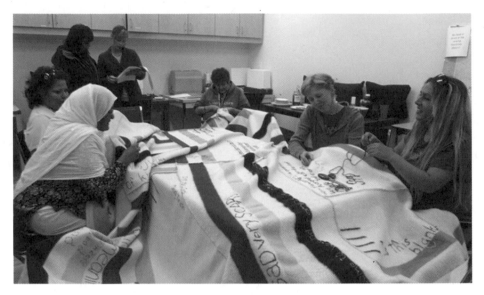

Sewing action at the West Central Women's Resource Center, Winnipeg, 2011.

"What a thing to do to a Hudson Bay blanket."

"My grandfather shared his blanket with NWMP
(Northwest Mounted Police)—who became
known as Chief Walking Blanket."

"We need to change the way we treat
each other and the way we treat the land."

This work is framed in the context of practices that seek to develop just paradigms for Indigenous-non-Indigenous relations. As such it functions in dialogue with the work of Indigenous artists, cultural workers, activists, and theorists engaging in strategies of critical reconciliation, conciliation,[2] and Indigenization. The work is informed by Indigenous knowledges, Indigenous resistance, and Indigenous sovereignty movements, as well as the critical work of non-Indigenous thinkers and artists that aligns with Indigenous frameworks of decolonization. Further, it operates in consort with increasing calls for white settlers and non-Indigenous people of colour in settler states to confront their differential positions and responsibilities with respect to historical and ongoing settler colonial conditions, and to actively engage in ethical and effective opposition

to settler colonial systems and beliefs. If, as Brian Rice and Anna Snyder state, "Reconciliation is about healing relationships, building trust and working out differences," then non-Indigenous engagement is clearly necessary (47). Mohawk scholar Taiaiake Alfred argues that decolonizing movements "must have the support and co-operation of allies in settler society" (*Wasáse* 64), while Métis academic Joyce Greene asserts the importance of mobilizing non-Indigenous Canadians to recognize their inherent privilege within colonial structures and take the responsibility of dismantling the persistent mythologies that support colonial logics and mindsets. Writing from white settler perspectives, Paulette Regan suggests that settlers must undertake the work of decolonizing themselves as a step in decolonizing the settler colonial regime that underpins the nation state of Canada, and Victoria Freeman stresses the importance of decolonizing the minds of settler people and the need for all to decolonize in order to be able to "live with integrity" (Christian and Freeman 386).

At the same time as non-Indigenous people are called upon to act, such agency is regarded with justifiable skepticism. Advancing the activation of decolonial interventions from artists of various positionalities, Margot Francis invokes the state of a "double haunting," a condition in which the "trauma of nation-building ... haunt(s) those excluded from national belonging and those at the center of national hegemonies," but also cautions that non-Indigenous artists risk reinscribing the colonial forms they seek to disrupt (6). While recognizing these risks, Australian settler scholars Alissa Macoun and Elizabeth Strakosch point out that the foreclosure of non-Indigenous resistance can be commensurate with the evasion of responsibility and thus the perpetuation of Indigenous dispossession. This suggests the need for non-Indigenous approaches to be informed, self-reflexive, and activated—to involve cultivating comprehensive understandings of the impacts of colonial logics, both historically and in contemporary contexts, acknowledging one's accountability within these conditions and taking steps to interrupt embedded colonial paradigms, perceptions, and assumptions.

For me this entails, in addition to work I produce individually, critical public engagement and collaborations. I approach collaborations as sustained relationships productive of reciprocal learning processes that

ply both difference and common interests. I also seek out opportunities to
bring together a range of participants towards a shared subject or question
that may be complicated by divergent experience. I endeavour to make de-
liberate, informed decisions regarding all aspects of the work, and am also
well aware that in some ways when operating within the colonial context
that we inhabit it is not possible to escape its inflection.

*"Is an apology that is refuted worse
than no apology at all?"*

*"We as white Canadians need to know the truth
of why we have and continue to
discriminate against those who lived
here first and still live here."*

*"How do we move forward?
What can I do to contribute?"*

In such a landscape it seems essential to take calculated risks; to be
aware of the generative potential inherent in the instability of relinquish-
ing power, control, and authority, the unease of challenging the ingrained
colonial beliefs of our settler communities, and the uncertainty of engag-
ing in new ways across cultural divides. Just as risk resides in personal,
political, and social change, discomfort can be seen as a notable compo-
nent of its methodology. Paulette Regan advocates for a "pedagogy of
discomfort" and the practice of "stepping outside of one's comfort zones"
as instrumental to transformative change in the decolonizing work of
settlers (*Unsettling* 52). Discomfort is also invoked in Roger Simon's de-
scription of "difficult knowledge" as entailing material that complicates
received narratives, interrupts presuppositions, and fundamentally chal-
lenges the way individuals think about themselves and their interactions,
particularly in relation to the "other" ("Afterword"). Andre Lepecki de-
scribes the "zones of discomfort" that artist William Pope.L "creates with
and for his audience" in his performances as "allow(ing) for ... trans-
formation into generative zones of dialogue and relationality" (90). In
these cases the careful channeling of discomfort is understood to inten-
sify critical engagement with contentious issues without the type of de-
structive confrontation that reaffirms barriers. The discord produced by

such interventions can be highly productive of unsettling provocations. Practices of cultural production, in particular rigorous dialogic and relational approaches, hold the capacity to translate such carefully considered discomfort into problematizing, restorative, and intensively investigative spaces of resistance.

Holding a tension between familiarity and discomfort, *(official denial) trade value in progress* was conceived in the spirit of creating such spaces as unsettled zones in the face of prevailing enmity towards decolonizing agendas. The individuals who engage with the project are responsible for the dialogue it manifests. Through their written and sewn responses, materialized in the textile and the books, the breadth of Harper's G20 statement is brought into focus and a process of witnessing is both activated and made conspicuous. The intersections of object and encounter create a space for an unfolding narrative—narrative as personal account, and in terms of "communicative, performative action" (Bhabha 34), "something which inter-ests, which lies between people and … can relate and bind them together" (Arendt, qtd. in Bhabha 34). That which "relates and binds" can range from the solace of intimate kinship to the difficult terrain within divergent experiences of shared histories and presents. "Interest" and the "communicative act of narrative" speak to what happens between people and, importantly, what does not. Cree spiritual leader, teacher, and activist Stan McKay points out, "We all have stories to tell and in order to grow in … understanding we have to listen to the stories of others" (105). The inter-narratives in the pages of the project's books and on the blanket itself (whether in the form of opinion, fact, appeal, or testimony) represent the opportunity to tell and to listen—to enact a vital utterance. Moreover, it enables that utterance to be witnessed.

> "I guess the Prime minister is teaching me humility.
> I have never been so ashamed of Canada before."
>
> "This event has been an amazing and personal
> moment for an Aboriginal woman."
>
> "We have blood on our hands like every other country."

The Truth and Reconciliation Commission is also rooted in practices of telling and listening—of testimony and witnessing. Processes of giving and witnessing testimony enacted through such official reconciliation practices have been soundly interrogated with regards to their intended and actual outcomes. Many have expressed that the Canadian TRC has initiated a profound healing process for individuals and communities, focused unprecedented public attention on Indigenous-non-Indigenous relations by foregrounding the imperative of reconciliation, and, through public education, highlighted the egregious injustices and lasting effects of the Indian Residential School (IRS) system. However, these official public reconciliation discourses and practices have also been criticized for re-inscribing colonial relations. It is suggested that the TRC stages a form of witnessing that applies a preponderance of emotional labour to IRS and intergenerational survivors and engages non-Indigenous Canadians in the detached, passive consumption of painful Indigenous experience, thereby distancing them from their roles in the perpetuation of colonial constructs and allowing them to "feel good about feeling bad" (Regan, *Unsettling* 22). Further, survivor and inter-generational experience is predominantly attached to the state's *historical* wrongdoing, thus perpetuating fantasies of innocence for both non-Indigenous Canadians and the contemporary Canadian government. Together, such approaches to testimony and witnessing risk advancing an imminent and premature closure rather than opening the dialogue to decolonization, as called for by those focused on a future of Indigenous sovereignty and just relations.

As the first major presentation of *(official denial) trade value in progress*, the TRC National Event in Winnipeg was its de facto launch. Yet the processes of witnessing and testimony engendered through the project can be seen to diverge significantly from official TRC programs. During the TRC event, over one hundred responses to the G20 statement were recorded in the project books, representing a range of Indigenous and non-Indigenous perspectives. Although it is a diverse collection, these responses foreground the counter-narratives of survivors of Indian Residential Schools, and those who experience inter-generational effects, and thus can be understood as a form of testimony. Over the intervening four years, testimonies continue to be contributed to the project. Much of the early and ongoing

testimony functions in direct resistance to the G20 statement and is ac-
companied by emphatic assertions questioning the integrity of the state
and the efficacy of its actions in relation to a range of colonial realities.
These responses resist a discourse that seeks to confine Canada's colonial
policies to the Indian Residential School system and close the book on
such practices by defining them as merely, to quote the Apology, "a sad
chapter in our history" (Statement of Apology). Rather than replicating
and perpetuating the Apology's "fram[ing] in a nationalist narrative that
dispels real accountability" (Loft 45), these testimonies are self-activating:
they explicitly situate the recounting of IRS experience and effects within
the larger context of the *ongoing* colonial and racist logics in which such
policies are embedded. Further, some of these statements include criti-
cal reflections on the potential and efficacy of the TRC in particular, and
current Canadian discourses of reconciliation in general. Such testimo-
nies have both propelled and been propelled *by* other responses contrib-
uted to the project. Subsequent expressions of outrage, shame, resistance,
and conviction, together with the first-person testimony, weave an open
counter-narrative that places the G20 statement fully into context vis-a-
vis current colonial conditions.

> *"The past is not something we can choose
> to forget or accept on our convenience.
> It is always with us. In the ground we stand on
> and in the blood in our veins.
> Denial is no shield from it."*

Processes of witnessing are both problematized and activated through
the embodied encounters within the project's solitary and collective spaces
of viewing, reading, and sewing, and through the project's material plat-
forms—the books and textile. As an authoritative convention, the book
form imbues a formal dimension to its content, mobilizing the counter-
narratives unfolding in its pages as a restorying of the national imaginary.
Those contributing to the books are palpably present as individuals, not
only through the measure of their words, but also in such intimate de-
tails as the pressure of a pen on paper, the size and shape of text, and its

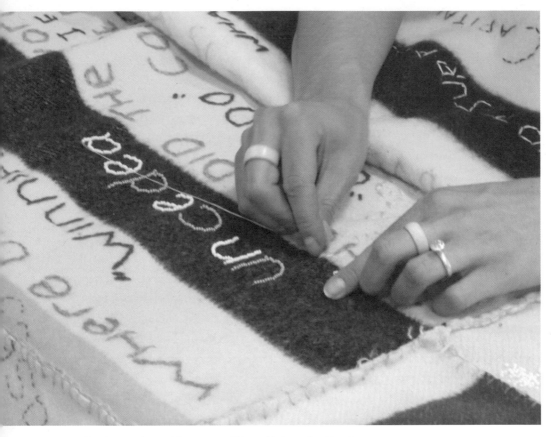

Sewing action at Thompson Rivers University, Kamloops, 2013.

placement on the page. The order of the book form, which might otherwise work to contain or tame the stories within it, is counter-pointed by the translation of texts from written to sewn manifestations, from the page to the composite of blankets. The HBC blankets on which the sewn texts reside embed them implicitly in a larger context of colonial policies that intersect with economics, land, culture, and sovereignty.

"Is it possible he didn't mean to say that?"

"Canada does not have a history of de-colonization."

"CAN'T EVEN WRITE! TOO ANGRY!"

"Denial: Helping politicians sleep at night."

Echoing the written text in the books, the sewn iterations on the blanket convey the presence of the sewer through distinctive idiosyncratic stitching and the visceral sensation of text rendered in thread. The blanket is an anomalous, unruly archive. Its dialogue is unresolved, ever changing, and without a predictable compositional logic. The sewn texts, which are applied to the blanket in a clamour of colours, angles, sizes, and textures, must be navigated physically, sometimes to a point of discomfort. Unlike reified, static historical or archival records, this text has no pre-inscribed order, and therefore each viewer's meandering path through it will result in a unique account. With a myriad of voices present, no one narrative is prescribed to dominate, and thus proprietary assumptions are also diffused. The complexity of the collection of statements surrounding any given text sewn on the blanket unsettles compulsions towards simplistic or vicarious identification and disrupts moral centralities. The statements *in relation* exist in a candid, messy, and often uneasy conversation that complicates colonially constructed Indigenous-settler dichotomies. What may be missing is as important as that which is present. The lacunas encountered reject the passivity of neatly packaged, superficially resolved narratives such as those underscored by the reconciliation discourses that dominate the Canadian mainstream.

The back of the blanket reiterates these infringements on simple representation. As the project has progressed, the back has become an unexpectedly resonant counter-point. An unselfconscious echo of the narratives reflected in sewn responses on the front, it further reinforces the productive weight of difficult apprehension. A cacophony of knots, tangles, threads, and stitches, it speaks to that which cannot be easily or fully voiced, understood, rationalized, or communicated. Forming a type of asemic text, these unbidden, yet demonstrably poetic, markings conjoin what is hidden, avoided, and unuttered with the emphatic articulations sewn on the front. Redolent of the underbelly of process—of the mistakes, misgivings and contingencies implicit in efforts of actualization—the markings on the back appeal for rigour in the act of witnessing, a movement from affect to re/cognition called for in critiques of passive witnessing.[3]

Witnessing is also nuanced through the embodied engagements of the project. The blanket's haptic materiality opens reflective and affective

portals that incite associations with the social and cultural particularity of the HBC blankets, and with the notion of blanket as generalizing, obscuring, *and* comforting. One is aware of the idiosyncratic characteristics of the second-hand blankets from which the object is made. Patterns and degrees of wear, imperfections, and even the lingering odours evoke familiar utility and the nearness of unknown inter-narratives; the bodies they warmed or concealed and the hands that folded and washed them. Sewing on the blanket expands this embodied relation as a material act both inherently relatable and demonstrably political. As a speech act it re/iterates the sampler which, having begun as a means of indoctrination, was retooled as a tactic of resistance. Situated in the everyday and bearing compelling connections to labour, industry, construction, restoration, and emancipation, sewing operates "as a means of linking the social, the political and the personal" (Shueing and Bachmann 17). The act of sewing recasts the viewer as participant, bringing them into closer proximity with the blankets, other sewers, the G20 statement, and the responses.

"There has to be justice and healing for the true Canadian people, the Aboriginal people."

"My ancestors arrived here in the early years of the 20th century and I know that the Canada they came to was and is an artifact of colonialism."

"Consequences of inconsequential words. Language forces us to consider who we are in relation to others."

While people write their own response in the books, the responses sewn onto the blanket are a result of a joint effort between the person who writes *in* the book and the sewer who chooses a response *from* the book. In choosing to sew a response onto the blanket, the sewer is making someone *else's* contribution visible. This act of remote collaboration is engendered with both agency and responsibility. Participants in the project have expressed a range of motivations for choosing the responses they sew. Some gravitate to a response that reinforces their own perspective. Others are moved to make visible a response with which they strongly disagree, but nonetheless feel should be seen. Some are drawn to responses that are

clearly contributed by someone who shares the basis of their positionality, while others cross lines of cultural and experiential contiguity. Without the nuances of content, depiction, reception, relation, context, and activation embedded in the project's design, these choices could fall headlong into the replication of colonial patterns. Even so, this project—like many endeavours carried out in the context of, and in resistance to, such deeply ingrained colonial systems—cannot completely avoid their reverberations. However, this approach to the embodied act of sewing works to resist and problematize rather than to reproduce colonial relations and the contours of appropriative, consumptive, and passive empathy.

Passive empathy can be circumvented through the slow, meditative, embodied processes entailed in sewing in this project. The extended time it takes to sew a given response has the effect of deepening the act of witnessing or "listening." The process of looking through the responses in the books is injected with a heightened regard when one is looking for a response in which to invest the time it takes to sew. As the blanket becomes more densely packed with sewn texts, the vacant territory decreases. Decisions about where to locate a sewn text—how it will function in conversation with or interrupt the tangled dialogue between responses already sewn—require increasing attention and consideration. Through these contemplative actions—performed in the company of an array of sewn and written voices—the act of sewing someone else's statement can resist a mirroring in which empathy is engendered only through a reflection of the self. Instead of "stealing the pain of others," this process can highlight the call to continually question "who benefits from the production of empathy" (Razack, "Stealing" 390).

"Although my family immigrated relatively recently, my white Canadian life is still built on a foundation of Aboriginal pain, suffering, trauma, poverty and betrayal."

"It's time for a change and change has to come from all of us speaking out."

"Don't think you can be an innocent bystander."

The project's exchanges both embody and trouble notions of response, responsibility, solidarity, and shared experience. Its encounters and collaborations not only form the objects, but also bring into view historical and contemporary divisions that are entrenched within the conditions of the settler colonial state. In staging remote and intimate proximities, the project foregrounds the potential of coming to know one another despite being encumbered by disconnections. At the same time, it underscores the complexities inherent within such endeavours. Although the project features a range of voices from a variety of locations, it is marked by social, economic, cultural, and geographical challenges to access. It follows that although the project is open to anyone and includes many voices, from my perspective it cannot and does not claim a *balance* of representation in terms of participants' positionalities and viewpoints. This, I think, does not diminish the project's resonance but, rather, firmly locates it as operating within, and in resistance to, the limitation of its time and place. Upon reflection over the extended time span of the project, it is clear that these

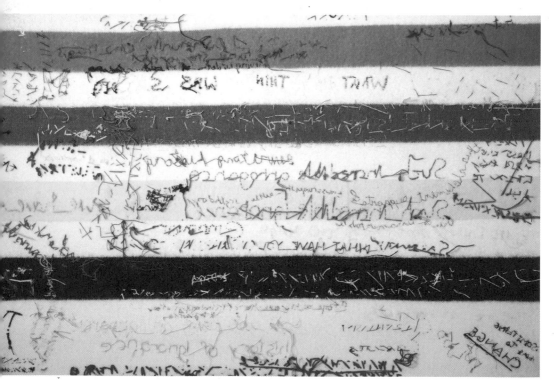

The back of the blanket. *(official denial) trade value in progress.* 2014. (JORDAN BLACKBURN)

limitations or barriers are slowly moving and shifting. Conversations about the state of relations in Canada and in other settler states have evolved considerably in the four years since this project began, and the dialogues in the project have mirrored these developments. Indeed, many of the voices reflected in the project are representative of such evolutions.

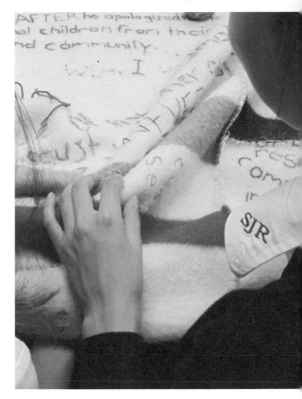

Sewing action at St. John's-Ravenscourt School, Winnipeg, 2011.

Although it has clearly been impacted by its presentation at TRC events, *(official denial) trade value in progress* began, and remains, an independent art project. As such, rather than operating through the widespread visibility and restrictive narratives of official state-sponsored proceedings, it functions in the rhyzomic territory of the *unofficial*. What started as an impulse to engage Canadians in critical reflection on personal and political accountability—a way of holding a mirror to denial and desire in relation to the very real history and present of settler colonialism in Canada—has evolved as a process of critical, multi-layered engagement and collaboration spanning geography, time, and culture. The residue of such encounters, as it moves out into the world through the embodied experience and knowledge of those who engage, has the potential of making a crucial contribution to reforming the damaged relationships that mark our contemporary times. Unfolding in reaction to Harper's G20 statement, the responses and the experience of participating in the events—the dialogue created by the project—enacts a critical restorying. As its name suggests, the project is inherently "in progress," with its impact and resonance activated through a confluence of personal reflections of anger, shame, pain, loss, fear, resistance, ignorance, impatience, humility, respect, humour, and denial.

JAIMIE:

First, it is necessary to position myself as an artist/curator/researcher in the context of this ongoing project, my collaboration with Leah Decter, and beyond. The matriarchal side of my family is Anishnabe from Sagkeeng First Nation, Treaty 1 territory, and the patriarchal side of my family hails from Britain and the Isle of Mann. My cultural and political dichotomy has shaped, influenced, and informed my curatorial/artistic sensibilities and perspectives on decolonization and reconciliation. My matriarchal family and community are survivors of the colonial legacy as documented in *Broken Circle: The Dark Legacy of Indian Residential Schools: A Memoir*, written by a relative, Theodore Fontaine. For a long time, my family didn't talk about their school experiences. I believe this was to protect the younger generations from the atrocities they had endured; however, this silence left gaps in understanding why many of our Peoples suffer severe and systemic social, economic, inter-personal, and educational disadvantages in Canada. Drawing from my experience, education, and mixed cultural background, I feel I have a role in bridging and connecting settler-Indigenous relations through my curatorial and artistic pursuits. I practice decolonizing and indigenizing methods within an activist research framework, one that contributes to an interdisciplinary dialogue and de-naturalizes dominant whitestream knowledge. Essentialist and discipline-based knowledge has been wholly inadequate in understanding the complexities of history, art, and culture, in social, spiritual, and political domains.

"It's not easy sitting on both sides of the fence ..."

My collaboration with Leah has significant beginnings. In June 2010, I coordinated the visual arts component at the inaugural Truth and Reconciliation Commission (TRC) event in Winnipeg, Manitoba. The TRC's mandate was to contribute to truth, healing, and reconciliation. The national events held across Canada were meant to commemorate survivors of the Indian Residential School legacy, educate the public, and provide opportunities for people affected and impacted to share their experiences.

* The terms First Nations, Aboriginal, and Indigenous are used interchangeably, and include Métis, Inuit, Status, and non-Status peoples.

Within the scope of work at the TRC event in Winnipeg in 2010, with only two months to research and plan, I organized visual artwork and curatorial pursuits that pertained to the Indian Residential School history in Canada with a responsibility to educate, commemorate, and disseminate this history to a broad audience. The breadth of work by Indigenous and non-Indigenous artists within this domain remains abundant. Some of the projects were inherited upon my hire, and others I was able to select and propose to a committee authority, which ultimately made the final decisions on what would be accepted for exhibitions. It was challenging at times because there were many works by artists that I felt were significant and relevant, but that weren't selected for reasons I was not privy to. With this opportunity and challenge, I felt a considerable amount of responsibility to convey the issues with utmost respect and sensitivity. Still, working within a federal governmental system presented limitations in regards to transparency and artistic/curatorial agency. After my contract was finished, I submitted the following recommendations for the TRC visual arts component:

> It is important to hear and see perspectives of both First Nation Peoples and settlers of Canada as the IRS is our shared history and it is a valuable step in reconciliation. Consider balanced representation symbolically and fiscally. Aboriginal artists in Canada are still getting compensated 28% less than other artists in Canada (according to Hill's Strategies Research).[4] In Aboriginal art history and in contemporary Aboriginal art, artists have contributed many relevant artworks that conceptualize the IRS experience—direct or indirect, survivor or intergenerational.
>
> It is vital to recognize these works in the process of research and program development [....] It would be valuable for the coordinator to identify a core audience for each exhibition and prepare for the expected outcome in reaction/response (i.e. providing access to Elders, health care workers, counselors, traditional medicine, tissues, possible trigger warnings etc.). The visual arts coordinator should meet and consult with representatives from local galleries, artists, community arts and survivors. This would be effective outreach to gauge art

projects, create meaningful programming and locate artists regionally. The visual arts would benefit from a transparent vetting process that outlined selection parameters.

Overall, I worked on six visual arts components for this event. Depending on the exhibition's content, there were assigned therapists, comment books, opportunities for community interaction and engagement with the artworks, and private areas to contemplate and read. The visual arts component of the event was largely pedagogical in nature, appealing to diverse audiences and various demographics: survivors, intergenerational survivors, non-Indigenous people, settlers, children, adults, youth, and the elderly. The educational method was vital in working towards healing and reconciling, guided by the idea that people must first confront the truth of the IRS history, empathetically consider the trauma, understand the impacts, and unpack the causality.

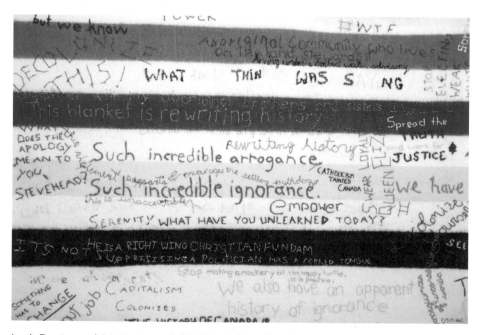

Leah Decter and Jaimie Isaac. *(official denial) trade value in progress.* 2014.
(JORDAN BLACKBURN)

Among the six exhibitions I worked on for the TRC was Leah Decter's *(official denial)*. It was incontestable to include the work of Indigenous artists, survivors, and intergenerational survivors, but I also felt it was important to include non-Indigenous artists and their perspectives on this matter, as this legacy pertains to and has affected all Canadians on multiple levels. It was powerful to collect responses at the first Canadian TRC event because the very notion of truth and reconciliation was scrutinized by a diverse and affected audience. After sharing/hearing the trauma endured and then facing the *(official denial)* statement on the blanket, people were able to critically engage the political deceptions and implications, and could respond in an uncensored manner. In learning about Prime Minister Harper's contrary statement following his official apology, people's responses were disparate. For many people, this was the first time they faced their country's true history of colonial violence. Indeed, the Hudson's Bay blanket served as a symbolic reminder of the history of disease epidemics and the physical-social-psychological-spiritual suffering delivered by "Euro-arrival" trade.

> "This wasn't something I learned in either Canadian or Mennonite history class in high school. Clearly there are stories we don't tell. So not so much a long history of amentia as a history of cultivated, partial ignorance."
>
> "Violent words to deny violent reality."
>
> "It is not surprising a politician has a forked tongue!!"
>
> "You dishonor me, my family and my country."
>
> "Now I'm confused, what is our history."

Other responses mnemonically allude to further oppressive colonial realities. The residential school legacy was only one part of the larger colonial machine that affected Indigenous people's ability to have equal standing and respect in society and violated First Nation peoples' basic human rights on many levels. Colonial government policies excused and legitimized land/resource theft and exploitation, the spread of small pox through trade agreements (and HBC blankets in particular), the tactics of social control (such as the pass system, which restricted people from

leaving their reserves unless permitted), disenfranchisement, jury discrimination, the sixties scoop, the sterilization of women, nutrition experiments, and scorched earth practices (which denied Indigenous people's access to traditional foods and forced reliance on unhealthy, processed food commodities), contributing to the prevalence of diabetes (LaDuke 194). Some of these policies are alluded to on the blankets and in the response books.

"Robbed of my language and culture!!"

"No, just a history of kidnapping children."

"My family is so screwed up because of a long history of alcoholism!"

"The ongoing abuse of Aboriginal Women is a legacy of colonialism in Canada."

Indian Residential Schools were in operation for over 150 years, yet the general public wasn't aware of this history and the severe intergenerational consequences the school system had on Indigenous people's social, economic, spiritual, and political existence. The first responses collected at the TRC from the *official denial* blanket reflected the shock, reckoning, and embarrassment many non-Indigenous people were feeling. On a national level, I had hoped the TRC's events would challenge people to transform their normalized racist perspectives towards Indigenous peoples. However, it is quite evident in today's headlines and First Nations' realities that historical and existing colonial systems continue to affect generations of Indigenous peoples. In the child and family welfare system alone, there is an overrepresentation and maltreatment of Aboriginal children and youth in out-of-home care. Indeed, there may be three times more Aboriginal children in the care of child welfare authorities now than were placed in residential schools at the height of IRS operations (Blackstock 12).

How can a nation consider reconciliation and a path towards healing if only a fraction of the truth is known? In 2014 CBC News released results from a poll that showed a prevalent intolerance towards Indigenous people, especially in the provinces of Alberta, Manitoba, and Saskatchewan (Levasseur). Niigaanwewidam James Sinclair states, "starting from the residential school era, Canadians have been taught, as much as Indigenous

people in those schools, that [Indigenous people] were inferior and savage."[5] The disturbingly high rates of Indigenous people that are homeless, incarcerated, missing and murdered, and committing suicide as youth, demonstrate the effects of current colonial conditions and racism. As Jeff Thomas, the curator of the *Where Are the Children* exhibit has said, "We only have to look around the streets of any major city in Canada and see the effects of this ethnocide" (19). Until recently, this history was not taught in schools; it was only after Indigenous leaders' lobbying efforts, the Indian Residential Schools Settlement Agreement, and the TRC that residential school history became part of curriculum in *most* but not all schools in Canada.

> "I am teaching my children about our country's colonial past ... and present. Together with my aboriginal brothers and sisters I will spread the truth and work for justice."

> "Colonialism shaped the world and Canada is not different."

Even though the IRS legacy (alone) embodies the definition of genocide, the federal government has refused it. When the Canadian Museum for Human Rights opened its doors in September 2014, it followed the federal government's direction by not acknowledging this history as genocide. This Canadian truth needs to be validated and endorsed as history on multiple levels and by multiple systems of knowledge, such as education, law, philosophy, media, and perhaps most effectively, the arts, as knowledge can be entrenched in the spirit and psyche within people from all cultures. Addressing colonialism is not meant to negate or compare any other cultural groups' experiences of oppression or trauma across the globe and through history. However, there have been some instances where people have felt compelled to compare other countries' situations as worse and have been dismissive of the Indigenous colonial experience in Canada.

> "Was Apartheid not inspired by the Canadian segregation system??"

> "The holocaust happened. Colonialism in Canada happened."

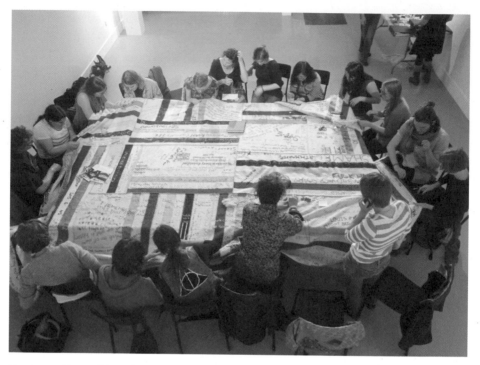

Sewing action at Nova Scotia University of Art and Design, Halifax, 2014.

It is important for newcomers to Canada to fully understand the colonial history and the impacts on the First Peoples of the country they now call home. Racialized discrimination can inform all social relations, including those between immigrants and Aboriginal People. However, as one newcomer states, "from my perspective as an immigrant coming from the imperial centre, there was no disputing that Indigenous peoples all over Canada had been subjected to the outright theft of their lands and resources. I found this shameful, and my sense of indignation motivated me to learn as much as I could about Canada's colonial history" (Chambers 209).

The *(official denial)* project has enjoyed a multicultural and diverse audience, which has made the project more complex and productive. Learning the truth about colonialism in Canada gives people the opportunity to cultivate empathy and compassion, and can also work to dispel preconceived prejudices and constructed myths instilled by dominant

culture. The project has generated much discourse among sewing action participants, some of whom were uninformed of the historical truths of racism, land theft, displacement, subjugation, and degradation.

Debuting the *(official denial)* work at the Truth and Reconciliation event and then working together over a period of time and over a significant area of land has been an incredible journey. There are many benefits to working with a longue durée project; the length of time and depth of involvement in this project underpin its strength. Leah and I are both very thankful for the encouragement and support of all the participants, the organizers who invite and host the project, the funders and other key people that have been vital to the success of this project from the beginning. Since 2013 the Shingwauk Residential School Centre has helped fund our travel, for which we are immensely grateful as it has expanded the possibilities and opportunities to make more connections across the nation. The artists, curators, and academics included in this volume have contributed to the ongoing dialogue. We have visited and engaged audiences in many different spaces and communities, where we have experienced meaningful exchanges with people from the very beginning to now. The durational element of the project—and of our collaboration—has been powerful. For instance, people who were involved in an early sewing action in 2011 participated again three years later; they were intent on searching to see if their written response was chosen, as well as looking for their sewn statement. They were also intrigued to note the statements that had formed around their own, like a conversation over time. Survivors at the first TRC event in Winnipeg and the TRC event in Edmonton four years later expressed the need for this kind of project as it provided a unique opportunity for them to share their knowledge and experiences in ways that didn't feel coerced by government design; they felt they could be open with their stories in a more participatory and empowered manner.

> "History is written by the victors.
> This blanket is rewriting history."

This project involves facilitating participatory action methods, utilizing a relational and dialogic approach that brings people together to activate their agency, their voice, and their unique perspectives. The responsibility

to share knowledge is integral to the decolonizing process. In this way, the blanket functions to share the knowledge of everyone involved. As Dana Claxton writes, "the art community has helped lead the decolonization process in the exhibition space," which "is the site where the most radical and polemic critiques of Canadian society have taken place" (17). Settler and Indigenous participation in decolonization-driven projects—such as the collaboration between Leah and me—demonstrates that Indigenous and settler people can work together to adjust their worldviews, to acknowledge the colonial effect, and to recognize equal standing. *(official denial)* destabilizes the settler-Indigenous division by drawing connections among diverse groups of people and instigating dialogue about the history of colonial power in Canada as we know it and view it now.

> "Decolonize yourself."
>
> "Denial is the easy way out.
> Canada needs to own up to its history
> and the effects of colonialism."

I follow the advice of Skawennati Fragnito in her essay "Five Suggestions for Better Living." Suggestion #4 states that "Native curators should include non-Native artists in their practices," recalling her curatorial work in the exhibitions *Blanket Statements* and *Cyber Pow Wow* 2K (234). The risks of essentialism and insularism are more likely to be eluded if we advance the work of both Indigenous and non-Indigenous scholars on topics of decolonization and reconciliation, if we recognize and celebrate projects by non-Indigenous people that work in the area of decolonization.

(official denial) privileges uncensored, cross-cultural, intergenerational dialogue and critical exchange between diverse individuals on the issues of colonialism, reconciliation, denial, and truth. As it evolves, the blanket has become a public record revealing a myriad of perspectives, bridging unlikely communities through a mediated dialogue and through an activist initiative. The diffusion of the project to a broad audience has summoned varying and often conflicting responses, some of which are provocative. On a personal level, it sometimes feels like an occupational hazard when a response evokes a feeling of vulnerability in me because of familial internalizations. When we give presentations and conduct sewing actions, even

though I know racism still exists, I am often troubled by people's responses, especially after reading some of the racist or patronizing comments people have written. These responses are never censored because they reflect latent, and often blatant, colonial mindsets; however, another participant's role can help to bring about greater equality through counter-utterances.

"It is because of colonialism that you have the right to speak."

"Get over it."

The blanket is a reflexive aesthetic that invites viewers to think about and consider past and current colonialism, becoming a space for agency and reflection. The blanket acts as a site for inquiry and social critique, and the artist, curator, host, and participants are all interdependent in bringing about this process. Through the process of participation and engagement, the line between artist and object, viewer and object is disrupted, enabling participants to learn and understand the blanket's subject matter on a very personal and tactile level. In considering the notion of reconciliation and healing through the arts, not only is art therapy an established practice but art is also known to transcend the limitations of language, articulation, and utterance by allowing the creator to express or confront feelings and emotions. Artists like Robert Houle with his work *Sandy Bay* and R.G. Miller with his work *Mush Hole Remembered* have expressed the vital role their art practice has played in their process of healing from Indian Residential School trauma. Bearing witness to these bodies of work, one feels the anguish expressed by the artists, as if to behold the hellishness as it is manifested and released on their canvases. The Aboriginal Healing Foundation completed a study on the benefits of creative arts in Aboriginal healing programs throughout Canada. The study presents compelling evidence that the creative arts, culture, and healing are linked. One man interviewed in the study referred to sewing as a creative practice that has meditative and calming qualities:

[W]hen people are doing things with their body, there's a connection between body, mind, and spirit. They're being creative and active. Being fully engaged in a creative thing like sewing, the mind is

engaged, the heart or creativity is engaged on a more spiritual level and they are physically engaged, working with the hands. It allows people to feel more secure, more safe. They're in an almost trance-like state and they go deeper into the issue they are talking about than if they were sitting face to face talking with a counselor. (qtd. in Archibald and Dewar 27)

The varying places we've held sewing actions always present unique experiences and have generated many conversations and connections. The stories and experiences people decide to share while sewing are sometimes funny, painful, touching, shocking, and thought provoking. An exercise we often do in a group to generate dialogue is to ask everyone to state why they chose to sew a statement and how it resonated with them. This method stimulates very interesting exchanges and a sense of awareness of one another. As people sew together in concentration, working with their hands to manifest someone else's statement, a dialogue is drawn out between the writer and sewer. A plurality of voices is activated, creating a dialogue that transcends generations, culture, time, and place. For instance, a white middle-aged person might be sewing what an Indigenous elder or youth from a rural community has written, connecting two people from disparate worlds in a meaningful exchange. A sewing action is a sensory experience: the blanket is itchy, soft, and warm, and its familiar aesthetic triggers memories that are anchored within a particular encounter or relation with the textile.

> *"When you see these blankets for sale in stores still, its insulting, almost mockery."*
>
> *"The stripes on this blanket represent so much..."*
>
> *"That was my most prized possession."*
>
> *"Is this blanket infested too?"*

The HBC blankets are just as emblematic of Canadian nationalism as the beaver; they are just as ingrained and woven into Canadian consciousness. Although the blankets are promoted and sold as luxury commodities, they are also signifiers of colonial hegemony. The (*official denial*) blanket

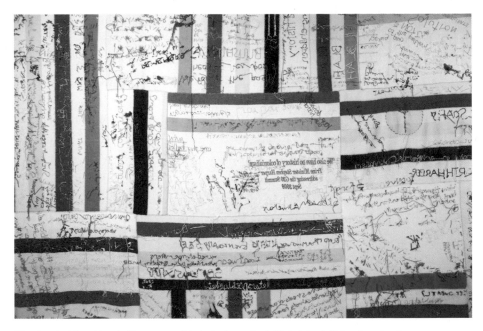

The backside of Leah Decter and Jaimie Isaac's *(official denial) trade value in progress.* 2014. (JORDAN BLACKBURN)

is composed of the well-known white blankets with stripes of green, red, and yellow, sometimes referred to as "chief's blankets." The powerful materiality of *(official denial)* brings to the fore popular Canadian iconography that is inseparable from the darker history of colonial violence and capitalism (yet in no way mentioned in the nationalist narrative constructed by the HBC).[6] The HBC blankets served not only as currency but also as a tool of biological warfare in helping to spread smallpox. In one year alone, in 1882, more than 20,000 First Nations people were exterminated from the disease, demonstrating that the blankets assisted not only in the genocide of many tribes but also in non-First Nations settlement in Canada (Belshaw).

The HBC blankets have no doubt been a stimulus for many prominent Indigenous artists. Anishinaabe artist Rebecca Belmore created an uncanny video installation, *The Blanket* (2011), in which she presents a red four-point blanket as a metaphor to call attention to its horrible history of disease and betrayal (Martin 95). The late Métis artist Bob Boyer

also critiqued Canada's colonial history in his body of work, *Blanket Statements* (1987), which refers to the fur trade era strategy of spreading disease with the blankets. Ojibwe artist Keesic Douglas presented a body of work at Urban Shaman Gallery, entitled *Trade Me* (2011), which exposes the links between colonialism and capitalism. Using photographs that resemble advertisements, Douglas presents images of multicultural models donning the HBC blankets. He also projected a video onto an HBC blanket documenting a personal canoe journey to trade an HBC blanket for his grandfather's pelts. Anishinaabe artist, curator, and educator Robert Houle's body of work, *Palisade* (1999), recalls the history of spreading smallpox through the HBC blankets as a tactic in colonial warfare. Houle vividly documents encounters between Indigenous peoples and colonial settlers on eight large canvases using digital graphic collages. Houle's collages were mounted on a series of billboards across Saskatchewan cities through a collaboration of galleries in 1999.[7] Exhibiting the work in this format made explicit the connection between the capitalist interests of the Hudson's Bay Company and colonial settlement in Canada. The contributions made by these artists trace a Canadian iconographic narrative vital to a critical regionalism. For the *(official denial)* project, the HBC blankets are the carriers of dialogue as the work continues to generate connectivity across the nation.

It is difficult to measure impact or to determine whether people have benefited from education, healing, or reconciliation as it was first framed at the TRC event. Yet based on the experiences of the sewing actions, people have been affected on some level—they have taken the time to sew, reflect, and respond. In connecting a historical colonial object with current political and capitalist oppressions, *(official denial)* vividly represents and collapses the past and present. To truly embrace truth, healing, and reconciliation, it is necessary to first understand denial, pain, and conflict.

Part of the process of decolonizing oneself is to realize and acknowledge the ways we are colonized both individually and collectively. One memory I hold dear is of an Elder who attended one of our sewing actions on Vancouver Island in the summer of 2014. She sat quietly for most of the time, listening to the conversations and reading the blanket. She found both Leah and me separately afterwards and, with tears in her eyes, she

thanked us for coming to her community, for our collaboration. I think that kind of exchange is what motivates us and commits us to continue.

All My Relations.

We would like to thank and honour all the voices reflected in this project, and the generous participation that drives it.

thank you/chi miigwetch,
JAIMIE ISAAC AND LEAH DECTER

NOTES

1. David Ljunggren, "Every G20 Nation Wants to Be Canadian, Insists PM," Reuters, September 25, 2009.

2. See David Garneau, "Imaginary Spaces of Conciliation of Reconciliation."

3. See Trudy Govier, "What Is Acknowledgement and Why Is It Important?"; Paulette Regan, *Unsettling the Settler Within*; and Simon Roger, "Worrying Together."

4. Hill Strategies Research is a Canadian company that specializes in applying social science research methods to the arts sector. See www.hillstrategies.com.

5. See John Levasseur, "People on the Prairies Less Tolerant," CBC News, November 16, 2014.

6. See the HBC Heritage website: www2.hbc.com/hbcheritage/history/blanket/history/.

7. See the Tribe Inc. website: www.tribeinc.org/exhibitions/robert-houle-palisade/.

CALL AND RESPONSE

Leah Decter and Ayumi Goto

"Call and Response" is a dialogue between two projects that disturbs formally imposed reconciliation storylines in the interest of reimagining Indigenous-settler relationships. Bringing our individual works, *castor canadensis: provokas* and *in sonorous shadows of Nishiyuu*, into critical conversation, this piece proposes an unfolding counter-narrative that contends from our respective positions as white and racialized settlers with intersections between histories of colonization, Indigenous histories, decolonizing imperatives, and relationships with the land.

castor canadensis: provokas enlists the beaver as a reference to Canada's inception, trade, and economy, and mythologized settler subjectivity/ies. While the beaver's iconic status originated through a pivotal role in the fur trade, its resilience is connected to notions of labour. Anthropomorphic characterizations of its industrious habits, deployed as early as the 1600s through natural history allegories, equated the beaver with European work ethics to bolster and justify the occupation and "settlement" of Indigenous land. Enduring invocations of diligence and hard work embedded in the Canadian psyche continue to reaffirm the colonial project's model of accruing settler emplacement, in part through the enactment of labour. A week-long durational performance, *castor canadensis: provokas* considers these intersections of labour, land, and "settlement" through Decter's appropriation of the residual material from the beavers' alterations to the land/scape—the tree stumps left behind when they build their lodges. Several hundred stumps were cut down and relocated, then reconfigured in a rectangular form as an intervention into an open field that recalls the lingering demarcations of colonial invasion. This work traverses visible

and unseen evidence to mark, enact, and disrupt as a way of speaking to individual and collective action and complicity, and the role of labour in colonial place-making, as well as processes of *un*making.

Likewise in *in sonorous shadows of Nishiyuu*, Goto explored her relationship to the land as she ran to the music of Cree singer-songwriter and multi-media artist Cheryl L'Hirondelle and to the music of those who also offered their songs. Inspired by L'Hirondelle's description of creating songlines to sonorously map the land, Goto strapped on three speakers that emitted music from her body as she ran across various landscapes, in locations where L'Hirondelle and others had composed, collaborated, and performed. The distance covered, 1568.5 km, was the exact length that the Nishiyuu walkers—a group of six Cree youth between the ages 16 to 21 led by elder-guide Isaac Kawapit—traveled during the middle of winter 2012-2013. Their original mission was multi-purposeful. First, they wished to contemplate their own lives, bereave losses. They also aimed to support, through walking, the Idle No More movement. Finally, through their steps forward, they petitioned an audience with the Prime Minister. Goto hoped that in covering their distance physically and through visual and textual reflections, she would begin to reconfigure her own relationship to the land as a settler. Building upon the works of Jeanette Armstrong and Vanessa Dion Fletcher, who respectively explicate and demonstrate how language emerges from the land, Goto attempted through creative practice to contemplate Japanese and Indigenous relations, while decentralizing Eurocentric worldviews.

Understood in conversation, Decter and Goto's works consider the colonial entanglements of Indigenous, settler, and immigrant histories. Both attempt to carefully intervene so as to resonate with intensive embodied labour, and each in their distinctive way speaks out into space through movement. Their respective projects present critical engagements with the land and its histories through personally situated strategies that unravel settler-colonial logics of possession. Evoking the convergences, intersections, and departures in Decter and Goto's approaches, "Call and Response" is an interwoven narrative. At times it reflects their individual voices, while at others the two converge as a way of intervening in static notions of categorically distinct settler experiences.

reimagining reconciliation
what becomes of variegated experiences of difference
in the everyday

should confluences and creative divergences
of settlement unsettlement
inspire, resuscitate
more respectful states of affairs upon the land

interchanges form anew relationships
analyses of what is
never settled
ambiguity in the constancy of the guest
preoccupied with

space time dis/possession

forestalls truthful recognition in utter occupation
exaltations of the self
cleaving wholes resuturing
one, two, and the many need be
spirited

re/calls across land (and) intensions
de/stilling de/stalled
quiet interjections
insistent

 in solitude public measures
 repeat past future past present
 remembers the past is past and present

 in this moment

 cycles and gestures
 the body heightened
 breath given and taken

 presence absence

 mapping historied lines
 crossed shadowing
 marking relation

 undershadows
 reciprocal doing/s
 seepage through generations

 reckoning repeat

solitary performance
witnessed through the residue of reflected action
exertions of flesh and breath

tooth hewn stump
remains from the demands of the animal body
disturbing the land/scape in making home

 tracing the labours of human and animal
 being
 enlisted in naming the standards of nation
 building

 held fast

 cut down, dislocations interfering
 with everyplace entitlement
 terra nullius

uncanny parallels angle toward this
a path that lifts the geographical plane
provokas
 unsettled

 bodily presence still life still

back and forth in temporal resistance

 across passing disregard
 denial by omission and design
 naturalizing to

the titling of the land

 quarter section, property lines
 grid of the city

 echoing

 colonial instruments that carve
 depth into dominion
 ground to resource

stockade sinking
foundering in burdened tomes
grass extends to conceal the site of puncture

 sharpened ends
 remain

 protruding

call and response

interruptions twist what is over/familiar
recognizing the smallness of actions
as an act unto itself
unto others

cognitions
awakened

call upon
call to accounts
account for

negotiating
ethical attachments
suspending colonial desire

trouble the addiction to willful forgetting, excision, occupation

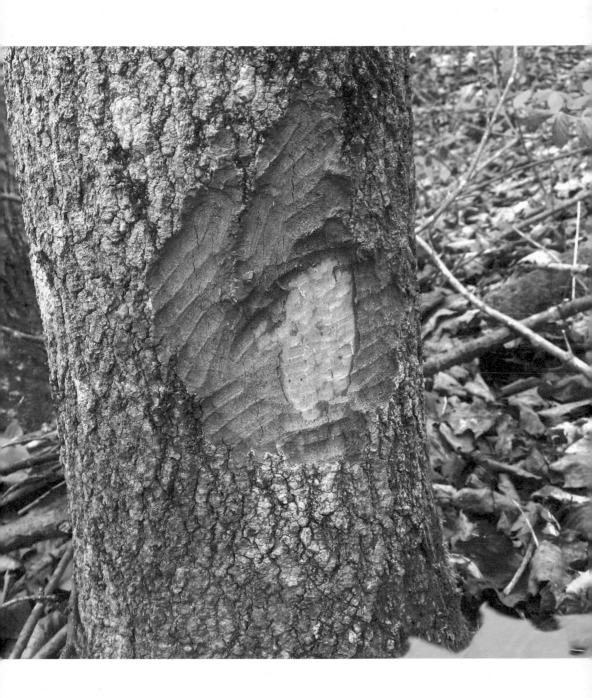

the land
witnessing shadow growths
elongates movement across straight roads

her voice steeps
into skin water air molecular
reverberations

compelling steps forward

here in response
evacuating from attenuated
alliance
overwrought with order
yield uncertainties

voluptuous chaos
to engender

boundless relations

acts surpass intention
enacted habits
embark on global shifts
what comes to the body mind

provoking terra firma
in each step

witnessing enfolds space

 clearing topsy turvy
 decolonial intentions
 withdraw discordant passivities

actioning cognitive recourse
as collaborative form

 who enacts whose will
 to form
 the mandate of the human witness

 wild life traces
 crossing settler lines
 of habitation

 witness in relation
 extends beyond the act

intervene on unfounded settlement

recognition and curiosity
quietly disrupt
spiraling estrangements

actions speak louder

shadowing endeavours
not to overrule
all those composed

enact un/knowing
gathered through breath and
footfalls
extension of the terrain inhabited

recognitions
residues

resisting

the workings of systems
that ground the longevity of a presupposed ethical act
untenable relations

racing
deracinating turbulent knowledge

foot notes
thread subterranean entanglements that
sustain
while surpassing compulsing
self-ligations

reconfigure social conventions
in cite new tracts
assured in the means to include all one
in the many

what remains behind
but the residues of those affiliations
borne of witness
breath beyond the subjective edge

standing with

INSURGENT PEDAGOGIES, AFFECTIVE PERFORMANCES, *UNBOUNDED CREATIONS*

WRITING *TOUCH ME*

Skeena Reece and Sandra Semchuk

Sandra:

Thank you for agreeing to participate in this
performance. I have always wanted to bathe a
Matriarch for something. The images I have had over
the years touch me deeply. You may not know, but my
mother was raised in a convent and in foster homes for
ten years starting at age 8. She was the eldest girl of 9.

When Dana Claxton asked me if I was interested in a
Residential School themed show for the Belkin Gallery
I was honored, apprehensive and it brought up a lot of
thoughts and feelings that I had around this phenomena.
I could only guess what it was like for my mother as
she was very distant about her upbringing. The few
stories that we did hear felt cold, sad and nothing of
value happened that she felt was worth sharing with us.
Although, we four children always wanted to know
what happened. My mother stopped touching me when
I was 8 years old. There was a disconnection, a loss of
intimacy, which we never regained. She recoiled at
touch and when it was forced it was awkward. The pain
of losing intimacy and trust with my mother still hurts.

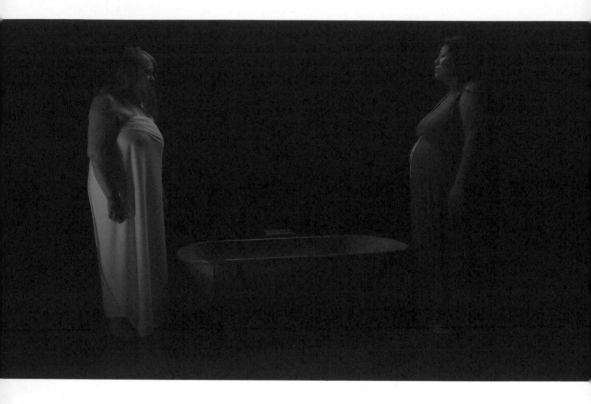

Skeena Reece. *Touch Me*. 2013. (IAN BARBOUR, STILLS FROM VIDEO)

My brother shared a story with me about my father,, who passed away in October of 2010. My brother had held a grudge against him for years, "from the moment" or "because" he stopped being a Father for reasons I can't go into at this time. Even when he took us up again as dependents, those two years we lost were the most deeply cut wounds he left on my brother's trust for our Dad. My brother told me that the night before his surgery, the night before my father passed, that he bathed my father. He said in those few moments he looked at my father in a new light. Not as a man who held such great power and the key to his forgiveness, but a small, delicate man who had come back to his childlike need for care, intimacy, touch, and trust. He forgave all of the years of my father's misgivings and, broken promises and realized that my father did the best he could, as a man who was raised by two Residential School survivors who did the best that *they* could. He saw that he was just a man, not the powerful holder of his emotional freedom. Just a vulnerable human being who was receding and proceeding back to spirit. This gesture of care, of bathing, changed him. It helped him—them both.

You see, in my family, in my community there is a lack of trust and intimacy... in fact intimacy is almost forbidden. I've seen people push away those they love, test them, push them down, hurt, harm, and ultimately break the people they are supposed to have great intimacy and trust with. I've also seen the opposite, the community building, the support, the trust building, and the intimacy forged in order to connect and find a semblance of family again.

Gabrielle Hill 7/30/2014 1:29 PM
Deleted: . My Father

Sophie McCall 8/2/2014 2:48 PM
Deleted: with

Sophie McCall 8/2/2014 2:48 PM
Deleted: d

Gabrielle Hill 7/30/2014 1:30 PM
Deleted: when he

Gabrielle Hill 2/21/2015 10:30 PM
Comment [8]: Mistakes? Faults?

Gabrielle Hill 7/30/2014 1:43 PM
Deleted: ,

Gabrielle Hill 7/30/2014 2:17 PM
Deleted: he

Gabrielle Hill 7/30/2014 2:18 PM
Deleted: A

Gabrielle Hill 7/30/2014 2:20 PM
Deleted: however forced

Forgiveness. This is what is needed. Regaining the sight of seeing each other as human beings. Vulnerable. In need of intimacy and trust.

Let us witness this gesture. Complete the cycles of life in our own lifetimes and not waste another one in a debilitating cycle of fear, violence, self-hatred, and lashing out that overwhelms these survivors. Let's gain something good, let's feel there is hope that we can overcome the damage that's been done to our communities, our selves.

I figure I can wrap you in a soft cotton opaque cloth, would that be okay? Can I take off the wrapping to wash your back? We'll make sure there is only nude shoulders, arms, perhaps some knee down shots.

I will have a sound guy, two camera guys, and whoever else you would like to invite. Just to let you know, I am making the video exclusively for the Belkin Gallery to display for their exhibition starting in September. I will give you all of the details as soon as I can.

The shoot is located at Video In Studios. I have this space from 2-6. If you can, be there by 3:00 for make up, hair, and wardrobe. I hope to have your segment wrapped by 5:30PM at the latest. This way we can have tea and go over the shoot.

Skeena

Sophie McCall 2/21/2015 10:30 PM
Comment [9]: ability to see?

Gabrielle Hill 2/21/2015 10:30 PM
Comment [10]: Can you explain what you mean here by completing the cycles of life?

Sophie McCall 8/2/2014 10:38 PM
Deleted: on the

Gabrielle Hill 2/21/2015 10:30 PM
Comment [10]: "us as survivors"? I suggest this change because I think that this cycle affects those of us who are intergenerational survivors as well.

Gabrielle Hill 7/30/2014 2:26 PM
Deleted: feel the ability to

Gabrielle Hill 7/30/2014 2:26 PM
Deleted: give us

Gabrielle Hill 7/30/2014 2:26 PM
Deleted: House keeping:

Sophie McCall 8/2/2014 10:40 AM
Deleted: m

Gabrielle Hill 7/30/2014 2:30 PM
Deleted: T

Gabrielle Hill 2/21/2015 10:30 PM
Comment [12]: Is this weird now that we are featuring the video in the book too?

Gabrielle Hill 7/30/2014 2:30 PM
Deleted: a

Gabrielle Hill 7/30/2014 2:31 PM
Deleted: can

Gabrielle Hill 7/30/2014 2:39 PM
Deleted: Unfortunately your friend may not shoot while we are as it requires sound and any movement in the background may deviate from the intimacy of the video. Of course she can come and bring her camera, but know that when we need to shoot she will have to be a witness. I'd like the vibe in the studio to be free of distraction and get it all in one shot without stopping to direct anything.

Gabrielle Hill 2/21/2015 10:30 PM
Comment [13]: Sign off here – so the reader is reminded that they are reading a letter.

PS.

If you change your mind about participating I will not fault you for this. I want you to feel safe about your depiction and participation. I want you to feel that you are the object of care and of love. There is no other meaning than this. As a "white" matriarch you are my subject of intimacy and trust. That is all. Please share any questions or thoughts you have. I apologize if I have over-shared or made you think about something you didn't want to think about.

**

Hi Skeena...very powerful what you have written here and so important, to acknowledge the lateral violence that occurs as a result of children being taken away from the touch of family. and yes, the seeing of one another is so important. and human.

i am happy to participate in this healing gesture towards reconciliation. as someone who is aware of the profound costs of residential school and who has lived and continues to live with the effects of those state-sanctioned violences, i am honored to be myself within the circumstance. from my point of view, having a camera on my face as well - as an articulation of lived experience - may be useful and may break down the idea that i am a representation of a white matriarch.

is that useful?

warmly, Sandra

Margin comments:

Sophie McCall 8/2/2014 10:41 AM
Deleted: have

Sophie McCall 8/2/2014 10:41 AM
Deleted: d

Gabrielle Hill 7/30/2014 2:43 PM
Deleted: Sandra response to gratitude

Gabrielle Hill 7/30/2014 2:46 PM
Deleted: occurred

Gabrielle Hill 7/30/2014 2:47 PM
Deleted: in

Sophie McCall 2/21/2015 10:30 PM
Comment [14]: Small case s?

Gabrielle Hill 7/30/2014 2:50 PM
Deleted: warmly

Gabrielle Hill 7/30/2014 3:01 PM
Deleted: sandra

**

Gabrielle Hill 7/30/2014 2:50 PM
Deleted: Call time for Sandra

Hi,

Sorry if I've alarmed you by not connecting by phone
yet. We have organized the shoot for tomorrow at 2-6
and your call time is 3-3:15. Please know this is relaxed.
There is no performance. It's a gesture. I pray we can
surrender and show love. I still have to find and bring

Gabrielle Hill 7/30/2014 2:50 PM
Deleted: ,

Gabrielle Hill 7/30/2014 2:50 PM
Deleted: i

Sophie McCall 8/2/2014 2:49 PM
Deleted: ur

your cloth wrap. If you have a neutral coloured bathing
suit where the straps can be hidden, great. Or give me
your size and I can find one. I am not worried.
Everything is as it should be. Let's just be in the
moment and trust the simple sincerity. I will call in the
morning. Perhaps we can meet earlier? Wherever
you're at with it I'm okay and I'll be okay. Just let me
know if this process is okay.

Love,

Sophie McCall 8/2/2014 2:49 PM
Deleted: s

Skeena

**

Gabrielle Hill 7/30/2014 2:51 PM
Deleted: Sandra's response to
call time

it all sounds loving, Skeena. i trust the process will
enfold with substance.

warmly sandra

ps, size 12 bathing suit. i will be there for just before 3.

Gabrielle Hill 8/6/2014 10:08 PM
Formatted: Font:(Default) Times
New Roman, Not Highlight

**

Gabrielle Hill 7/30/2014 2:51 PM
Deleted: Skeenas response

Thank you. I am so glad it's you. Gives me confidence.

**

() hug

**

Hi,

Gabe Hill is publishing a book and would like us to contribute our thoughts on the Touch Me project as it relates to collaboration.

I will forward her proposal to you.

And Hello Ms. Lady

I am on a phone as I write this, but tomorrow at a computer!

Will send you pictures and updates:)

s

Hi

I really like your text Skeena.

You did what you wanted to do and something else happened. Tell me about your tears. That is where I am in the story.

I am in Saskatchewan near North Battleford. Have just installed an exhibition of collaborations and dialogues called Love Stories, listening and seeing as gestures towards reconciliation. It is opening in concert with an exhibition on residential school called Honor the Child.

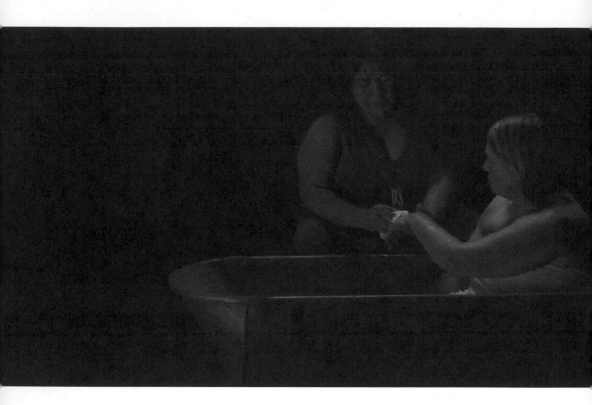

Skeena Reece. *Touch Me*. 2013. (IAN BARBOUR, STILLS FROM VIDEO)

Look forward to getting the attachment. I don't have internet either.

Hope you are enjoying Port Alberni and your dear sweet children.

Love. Sandra

Sandra,

I was raised by two residential school survivors who were raised by two residential school survivors. I know how gentle you have to be in order not to re-traumatize. You can make a huge difference with smallest gestures. Like with this piece—the act of bathing you—I didn't want to make broad sweeping gestures into a community that was already traumatized.

One of my biggest fears is that my children will be taken away... it is such a sadness... being a parent. That fear was passed on.

I am honored to be given the gift of children. I work to get to the heart of what vexes me in order to get to being a mom, a mother's love. That is the teaching.

I need a community.

(Victor's words: "Hold it. Hold it. Hold it.".)

Who was I?

Gabrielle Hill 7/30/2014 3:06 PM
Deleted: port

Gabrielle Hill 7/30/2014 3:06 PM
Deleted: albeit

Gabrielle Hill 7/30/2014 3:06 PM
Deleted: A

Gabrielle Hill 2/21/2015 10:30 PM
Comment [18]: Skeena – can we reframe this as another email? Or would that be too false? I find it a little confusing as is… I am going to write in my suggested framing of this part and see what you think.

Sophie McCall 2/21/2015 10:30 PM
Comment [19]: I find this section a bit disruptive. delete or put somewhere else?

Gabrielle Hill 7/30/2014 3:08 PM
Deleted: Skeena:¶

Gabrielle Hill 7/30/2014 3:13 PM
Deleted: .

Gabrielle Hill 7/30/2014 3:13 PM
Deleted: M

Gabrielle Hill 11/17/2014 10:37 PM
Formatted: Line spacing: double

Gabrielle Hill 11/17/2014 10:35 PM
Deleted: ¶

Sophie McCall 2/21/2015 10:30 PM
Comment [20]: I am not sure what this is referring to? Delete?

Gabrielle Hill 11/17/2014 10:35 PM
Deleted: ¶

Gabrielle Hill 11/17/2014 10:35 PM
Deleted: ¶

I was my brother bathing my father. My Dad.

Gabrielle Hill 7/30/2014 3:14 PM
Deleted: ¶

Forgiveness is important. I was in a caregiving role to those who care,,giving back to those who need care across nations and colors.

Sophie McCall 8/2/2014 10:57 AM
Deleted: Touch me:

OUR CAREGIVERS WERE TAKEN AWAY AND TRANSFORMED.

Gabrielle Hill 7/30/2014 3:14 PM
Deleted: ¶
¶

My Mom stopped touching me at the age of eight, the age when she was taken away.

The Audience:

Sophie McCall 2/21/2015 10:30 PM
Comment [21]: Delete?

Gabrielle Hill 11/17/2014 10:35 PM
Deleted: ¶

I can't know why each person in the audience cried. Everybody had their own reasons to cry.

Gabrielle Hill 8/6/2014 10:08 PM
Formatted: Font:(Default) Times New Roman, Not Highlight

It was a lesson place.

The piece was a place of respite, a dark corner in the exhibition. The challenge for those in the audience was to find peace with it all.

I have found a kind of peace and I am healing. It gave survivors license to find peace, hopefully. And, it gave white people a chance to grieve.

In this context the video was something that people didn't expect; they expected to feel guilty or to experience unresolved resentment.

I don't think my piece was resentful.

They could relax. When a piece is telling a traumatizing story, people, especially settlers, will feel guilt, as personal reaction.

Your vulnerability:

I hoped you would say, "yes."

You were still in a position of power. I was the caregiver.

At the heart of this work is my respect for wisdom, respecting senior artists and honoring elders.

I knew your work with James. (speak about that). With James you were able to talk about these things... explore them from the outside. It is a privilege and rich to talk with someone who understands. Usually audiences, including native people, don't have access to these conversations.

The key was to create a safe space where there could be trust between us and with the audience.

I didn't know what you felt. Thank you for telling me. There are times when we make something and then walk away.

Skeena,

Thank you for taking such beautiful notes...you sure are so present... it's peaceful to be around people who are aware, in their bodies... responding to what's happening now... I feel safe, seen, heard, understood, respected, and loved... honored.

Gratitude:

I see you really value that in your work. That is the kind of space that you created for Touch Me, Skeena. I felt that as soon as I walked into Video In. How did you learn, as an artist, how to create a space where you can be open and vulnerable and so present? It does pull the audience into a place of belonging and longing at the same time. A kind of contradiction that makes sense.

Touch Me:

The opening of Witnesses at the Belkin was a social event, people were talking to one another. "Touch Me", your video, Skeena, was in a darkened corner. In the video I am being bathed by you. There are two people sitting there quietly, each intently watching the video. One of them, a woman, cannot control her tears.

I get caught in the twists and turns of art created within life, and learn despite myself. It is the summer of 2014, two years after working with you. The exhibition of my collaborations, Love Stories, Listening and Seeing as Gestures Towards Reconciliation has just had a joint reception with an exhibition, Honor the Children, artworks on Residential Schools by artists from North Battleford and area in Saskatchewan. That night we created a talking circle with the help of elders. There were survivors of Residential Schools, descendants of settlers and immigrants who told their stories, each one aching for a just society. Talking truthfully, in the midst of the artworks, gave hope, they said.

You knew James, my late husband, a Cree writer, actor and government liaison for the Nisichawayasihk Cree Nation. None of the video or photographic works that he and I did in the name of reconciliation for fifteen years ever seemed to sit still. I would think we were doing one thing and, unexpectedly, the work would turn upside down. I remember James and I talking about generosity with an elder at a Waterhen Lake Cree Nation. I understood then that white government people turned things upside down by making themselves the generous ones. Generosity and power are so connected. I asked James if he could teach me how to say, in Cree, thank you for sharing the land. He responded, "You don't understand. Sharing is the Law. The land owns itself."

You would not let my shame come between us.

Skeena, I was honored by your thoughtful invitation to collaborate. I have respect for the rawness and integrity of your art practice. Honored too, because of your respect for elders. Dana Claxton had encouraged you in your wish to talk to me. My one concern was that I did not want to be a stereotypical white colonialist woman such as the one powerfully created in Tracey Moffat's work, Laudanum... the haunting images of black servant, white mistress. Would I become the white mistress? Worse, was I the white mistress? You addressed that concern by pointing out the complexity of your specific understory and spoke about how your capacity for intimacy and for touch in your own familial experiences had been affected by residential schools and structures of colonization.

Sophie McCall 2/21/2015 10:30 PM
Comment [27]: Italics or quotation marks?

Sophie McCall 8/2/2014 11:02 PM
Deleted: artist,

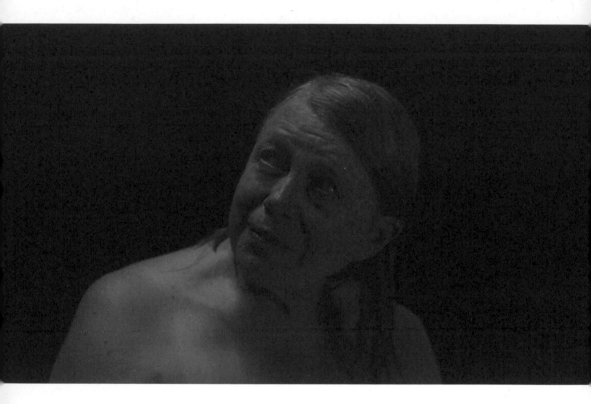

Skeena Reece. *Touch Me*. 2013. (IAN BARBOUR, STILLS FROM VIDEO)

(I remembered my own mother's difficulties in being touched. Her mother who had come from war-torn Poland had difficulties with intimacy, with the affectionate touching of her children. I remembered, too, James and I doing a work called Becoming Mom. He was taken from his mom at the age of eight to go to Residential School. He was happy when he could mother me.)

> **Gabrielle Hill 7/30/2014 3:30 PM**
> Deleted:

> **Sophie McCall 2/21/2015 10:30 PM**
> **Comment [28]:** Italics or quotation marks?

> **Gabrielle Hill 7/30/2014 3:31 PM**
> Deleted: ,

> **Gabrielle Hill 7/30/2014 3:31 PM**
> Deleted: M

Skeena, you offered to pay me for the work to be done in front of the camera. That act set boundaries in terms of the collaboration. This was your work.

> **Sophie McCall 2/21/2015 10:30 PM**
> **Comment [29]:** Delete parentheses?

You had taken such care to take care of me. You bought a turquoise blue housecoat to keep me warm, a big towel to dry me and white swaddling cloth to wrap me.

To protect me.

I didn't want to be naked. Were you the mother or was I?

The Ukrainian serf and poet, Taras Shevchenko, admonished his own people to cleanse themselves in the poem, "To the Dead, the Living and the Unborn." James replaced parts of the Ukrainian text with Cree in a video work we did. He and I sat many times in the Sweat Lodge together. Both of us—cleansing, cleansing, cleansing. The intergenerational trauma, the loss of culture, of language, the dislocation, relocation: the hurt, the sorrow, the anger, the lateral damages, the mistakes...

> **Sophie McCall 2/21/2015 10:30 PM**
> **Comment [30]:** Gabe: I think you need the comma here so I put it back in ☺

> **Sophie McCall 2/21/2015 10:30 PM**
> **Comment [31]:** I took out "the loss" to cut down on repetition

> **Sophie McCall 8/2/2014 11:05 AM**
> Deleted: the loss,

We both made them. But we could fall into one another's arms. Hold and be held.

Generations of colonization, of serfdom, of the internment of Ukrainians in Canada during WWI, of Residential Schools and reservations fell away for moments and moments.

And there you were, Skeena, five years after James's death, doing this work, holding out a blue blue housecoat, to me, for me. Blue like the sky. Blue like transparency. Like honesty. That is how James would have put it. When the Canadian Government handed out red tunics to the Chiefs signing the Treaties in the 1870s, a blue coat was asked for by one of the Chiefs. The change of color was refused.

We created a love story for an audience. Nettie Wild said to me, "True reconciliation and true compassion is about true love. And it is earned. It is our future in Canada if we want it.

I want it. I want it for my grandchildren and their children. I want it even while I am being complicit in maintaining the status quo.

It was James who reminded me what it is to be human. It is what we share. "Pim ma tis si win," he said, "life itself is the most important thing." Is it true that we can do in good conscience to those who are not in our own group what we could never do to those to those in our own group? (Bert Hellinger, *Love's Symmetry*)

James would also say, "You are not white." Another twist. "You are not white," Canadians told Ukrainians during WWI when more than 5000 were put behind barbed wire and forced to labour. It is because of racism that so many Ukrainians have worked hard to become white in Canada.

Is the trickster always in the house?

We are in the darkened studio at Video In. Two sensitive young men are videoing. You, Skeena, are pregnant, in the last trimester, when this video is made. Graceful. Beautiful, beautiful, beautiful. I feel I should be supporting you yet it is you who supports me as I step into the tub and sit, legs extended. I feel that I am my own Baba, my grandmother. You get a pitcher of water and begin the task of pouring the water over me, my head, my shoulders, my back.

The water is not too cold, not too hot. My mother found it difficult to touch me.

I remember my Baba heating the water on the wood stove and bathing me, so gently, in a galvanized tub. Unconditional love—that is what my Baba knew how to give. All the little children were forced to leave their grandmothers behind when they went to Residential School. One grandmother's love, one grandfather's love can change a generation.

Skeena, we were both present to one another. I could hear your breath. Imagine the child-within's breath. Silently, you took the bar of soap and began to wash me. Silently, tears fell from your eyes.

"Sorrow liberates," James said. "When will the final sorrow liberating come?" he asked. "When will the cold and numbness end?"

Skeena, did you see my imperfections, vulnerabilities, frailties?

Silently, I reach up to touch your forehead, the way my beloved Baba, my grandmother, would touch mine.

You flinch ever so slightly.

(There were moments James created in me the conditions that—had he been able to feel them himself, instead of being numbed—he would not have needed to recreate. One time the pain was unbearable. I asked him, could this be how your mother felt when you, your brothers and sisters were taken away to go to Residential School? It was easier not to do that to each other after we spoke about it.)

When you have finished bathing me, you help me gently out of the bathtub, cover me with the towel. We thank each other, hug heart to heart.

You ask me if I like the blue housecoat. "It is a gift for you," you say. Yes, I think, blue is the color of hope.

Margin comments (tracked changes):

Gabrielle Hill 8/6/2014 10:08 PM
Formatted: Font:(Default) Times New Roman, Not Highlight

Sophie McCall 8/2/2014 11:09 AM
Deleted: e

Gabrielle Hill 8/6/2014 10:08 PM
Formatted: Font:(Default) Times New Roman, Not Highlight

Gabrielle Hill 7/30/2014 3:36 PM
Deleted: ,

Sophie McCall 2/21/2015 10:30 PM
Comment [33]: hurt each other?

Sophie McCall 2/21/2015 10:30 PM
Comment [34]: Delete parentheses?

Gabrielle Hill 8/6/2014 10:08 PM
Formatted: Font:(Default) Times New Roman, Not Highlight

Gabrielle Hill 10/14/2014 6:05 PM
Formatted: Font:(Default) Times New Roman, Font color: Custom Color(RGB)26,26,26)), Pattern: Clear

Hi Skeena and Sandra,

The writing is beautiful—thank you so much! You will find many more comments and suggestions on the attached text, but there is one thing I forgot to ask—is there a title for this writing?

Thank you both so much,

Gabe

**

I like "writing touch me."

Sandra

**

I like the glitchiness and transparency of your suggested revisions... keep it like that... the audience can see through it with us...

I am excited to respond to it all... got an idea... stay tuned...

COOL YOUR HEELS SANDY... I got this

love,

s

**

here i am sitting on the floor of my living room and reflecting on something that happened over a year ago...

Gabrielle Hill 10/14/2014 6:08 PM
Formatted: Font:(Default) Times New Roman, 12 pt, Font color: Custom Color(RGB)26,26,26)), Pattern: Clear

Gabrielle Hill 11/17/2014 10:37 PM
Formatted: Space After: 0 pt, Line spacing: double

Gabrielle Hill 10/14/2014 6:38 PM
Deleted:

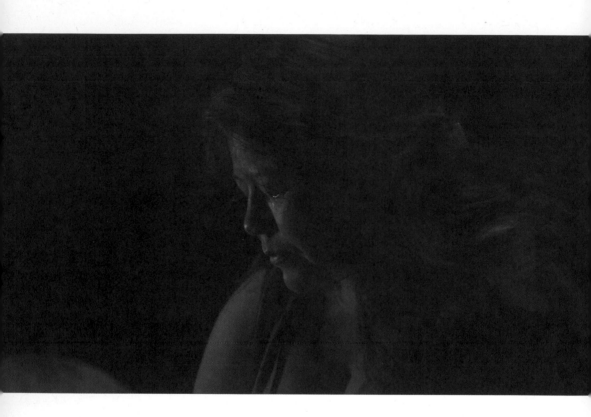

Skeena Reece. *Touch Me*. 2013. (IAN BARBOUR, STILLS FROM VIDEO)

after hearing the many reflections from the exhibition witnesses, from the belkin staff, colleagues and second hand reflections from the viewers of the show...

i wanted it to be quiet, gentle, deliberate, intimate... for the viewer to witness touch, care, love... and to have this moment to reflect on their experience(s) with residential school... in the context of the witnesses show...artists of the 1st and 2nd generation.

i was over 8 months pregnant with my second child at the time the video "touch me" was shot. i was emotional... in spirit... in and out of my body due to the context of the show and my contribution to it, and just in and out of my body due to the context of my life as a mother, a partner, a community member, and an artist.

the vision i had for this video was very clear...it came in and out of clarity over the course of about 2 years and settled into this project the belkin gallery proposed... pre second baby and post fathers passing (2010). my dad... i was in a hyper reflective space, on my art practice, my community involvement, my role as daughter, mother... this light was bright, exposing every detail of my awareness and disassociations throughout my life.

every nuance of my art practice is (was) influenced by colonial contact, more the guilt and shame of being a "by product" and feeling like my art practice is (was) derivative of this POV and working under this belief...

Gabrielle Hill 10/14/2014 6:40 PM
Deleted: ..

Gabrielle Hill 10/14/2014 6:57 PM
Deleted: ..

Gabrielle Hill 10/14/2014 6:41 PM
Deleted: ..

Gabrielle Hill 10/14/2014 6:41 PM
Deleted: ...

Gabrielle Hill 10/14/2014 6:41 PM
Deleted: ...

Gabrielle Hill 10/14/2014 6:42 PM
Deleted:community member.......

Gabrielle Hill 10/14/2014 6:58 PM
Deleted:my dad... i was in a hyper...

Gabrielle Hill 2/21/2015 10:30 PM
Comment [35]: By the?

Gabrielle Hill 10/14/2014 6:45 PM
Deleted: ...

right under it,… was exhausting, i was relieved to be selected to create work with this specific curator's intent, and afraid of the distinct intense feelings brought with it. also, i felt i was being put in my place… it wasn't enough to be an angry artist and self-named backwards person.

years ago someone said "some artists work their shit out on stage." i took it on, retreated, and bashed myself for being one of those artists. now here was a chance for me to be counted, appropriate, considered and kind of expected to work my shit out on stage… to be in a place of colleagues who were savvy to the fact that Yes! the art presented at the witnesses show is(was) raw, undone, dangerous, challenging, vulnerable, relentless, misunderstood, desperate, reaching… everything i am… was… i'm sure there are more verbs, but my self deprecations reign tantamount.

choosing my counterpart, sandra semchuk, was due in part to her performance background, her late partner, James Nicholas, and their collaborative work, her age, race and simply her self awareness, her openness, strength, and her will to have dialogue on these issues… the issues of loss of intimacy, love, trust and elder honouring and care…there's more…

my daughter was born a few weeks before the show's opening, i had little time to consider the video editing— in fact i still haven't watched it, the performance was complete to me... the idea, my muse, the context, spiritual preparations for the show and trust in the video makers put my heart at ease, i've always shied away from videos of performance, but this experience lends another level of safety that i need as an artist doing this kind of work.

i feel like a new era of my work has begun...

anyway, i've said enough...and my monkeys need me. shout out to sandra, my crew: pete hagge, josh olson and ian barbour, the belkin gallery and the curators of the witnesses show and fellow artists...and all of the residential school survivors who choose inflection and self love, awareness, creation in the face of an invisible heinous spiritual attempt to disassemble my people, culture, and that which makes us relevant contributors to wisdom in this universe and beyond.

No I don't remember watching the terminator series at your house...thanks for inviting me to write about this video Gabe... looking forward to seeing your (edit[ing]) lol

Love,

s

Gabrielle Hill 10/14/2014 6:05 PM
Formatted

Gabrielle Hill 10/14/2014 6:52 PM
Deleted: ...

Gabrielle Hill 10/14/2014 6:05 PM
Formatted

Gabrielle Hill 10/14/2014 6:53 PM
Deleted: ..

Gabrielle Hill 10/14/2014 6:53 PM
Deleted: ...

Gabrielle Hill 10/14/2014 6:53 PM
Deleted: ...

Gabrielle Hill 10/14/2014 6:53 PM
Deleted:

Gabrielle Hill 10/14/2014 6:53 PM
Deleted: ..

Gabrielle Hill 10/14/2014 6:53 PM
Deleted: ...

Gabrielle Hill 10/14/2014 6:54 PM
Deleted: ...

Gabrielle Hill 10/14/2014 6:54 PM
Deleted: ..

Gabrielle Hill 10/14/2014 6:54 PM
Deleted: ...

Gabrielle Hill 10/14/2014 6:05 PM
Formatted

Gabrielle Hill 10/14/2014 6:54 PM
Deleted: ...

Gabrielle Hill 10/14/2014 6:05 PM
Formatted

Gabrielle Hill 10/14/2014 6:54 PM
Deleted: ...

Gabrielle Hill 10/14/2014 6:54 PM
Deleted: ..

Gabrielle Hill 2/21/2015 10:30 PM
Comment [37]: This looks good, I love this piece. I mostly left this last section as it was, though I took out many of the ellipses – I think your writing is stronger without them, and you could probably go through and take out even more.

Gabrielle Hill 10/14/2014 6:05 PM
Formatted: Font:(Default) Times New Roman, 12 pt, Font color: Custom Color(RGB(26,26,26))

HAIR

Ayumi Goto and Peter Morin

perhaps it starts with a dream. this intent delivered from the ancestor realm. designed to be experienced. experience supported through the created object and the created space.

there is no easy way to say this. peter wanted to be the scissors. the scissors that cut the hair off the children who were stolen from their families, from their lands. and the performance of the scissors. their act of cutting. the blades' impact with their hair. the space. canvas on the floor.

on the wall, one large drawing of hair. a drawing that was created over thirty days. for several hours a day, peter would meditate on their hair, making rapid gestures to try to capture the feeling of the hair of indigenous children. and body memory connection. indigenous children stolen from their families and forced to attend the residential schools.

a remembrance of a disney cartoon. something like goofy or donald or mickey explaining the value of a million dollars. how a million dollars covered so much surface area that you could make a bridge from one continent to another. paper trails to europe. the cartoon goes on to try and visually explain one billion dollars, how if you stacked one hundred dollar bills into a tower, that tower would reach to the moon and back to earth approximately twenty-eight times. the hours of drawing. the hours of hair. dreaming about how that cut-off hair, laid end to end would cover the entire surface of canada. peter was drawing and thinking about this hair. the hair cut off those stolen children. that stolen hair. the image. the image of this hair laid out cut length to cut length. how this hair would cover all of canada and america. this, a conversation about value.

The photos of Ayumi Goto and Peter Morin's performance, *Hair*, were taken at the Reconsidering Reconciliation Residency, Kamloops, BC, in August 2013, by Ashok Mathur.

the best exchanges oblige a gift, a handmade drum in exchange for cheryl's sonorous presence. a drum that peter has made, interweaving of deer and elk, seemingly irreconcilable skins stitched together to create the echoing boom of witnessing. the drum is witness. to. this. moment. peter has made eight drums in total. all witnesses. a gift to cheryl for presenting her voice, adding her work to the collective and community knowledge. performance begins with acknowledgement. performance always begins with acknowledgment. eight drums made to be witnesses. made to be time portals. made to record ayumi and peter's performance. the drum beats are writing. the drum beats are writing. the drum beats are living witnesses. living memory. writing a glimmer of the performance on their skins.

twenty-eight rocks collected, gathered outward in, land repurposed to help tell the story. the rocks are a weight. meant to remind us all of the trauma caused by the residential school. twenty-eight stones criss-cross wrapped in red strips of cloth. then twenty-eight weights knotted onto peter's body—legs, arms, upper and lower torso—so much as to cut off his connection to the land, excise assemblages from one part of the body to the other, remove our own relationships to our and their bodies, estrangements between self and other.

ayumi ties the rocks to peter's body. and cheryl sings. the rocks are tied. the weight is felt. these rocks are the ground. these rocks are holding peter up. these rocks are holding peter down. ayumi feels the weight. each rock is a grandmother, a grandfather. each rock is a weight. a punishment. a protection.

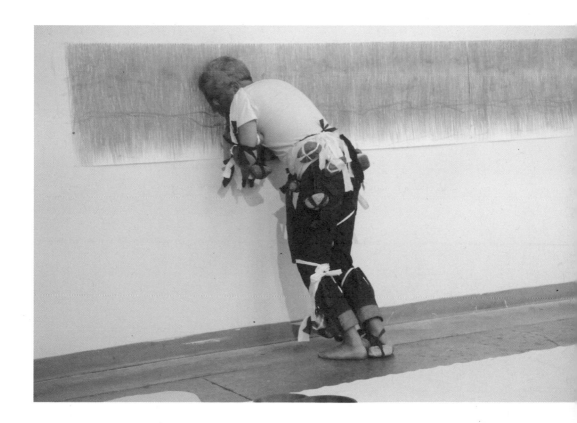

peter wants to be the scissors that cut their hair. peter does not want to be the moment after. not the moment that the hair falls off and hits the ground. stolen. from their bodies. forever. this is about the moment of theft. the scar. the cut. the blood. falling to the ground. there is weight in this moment. nearly immobilized by the burden of knowing all the other bodies that have been forcibly separated from the land, peter is irretrievably transformed in the act. his movement in the performance is now the movement of the scissors. cutting. cutting. cutting. scissors unable to dance through their job. scissors weighted down. heavy. heavy. heavy.

how much hair was cut off? whose hair? who was there to remember? who is here to recollect? in the moment, peter's body invokes the memories of that moment the hair falls off. he remembers that the cutting itself is figurative of the canadian government's genocidal intent behind residential schools. to kill the indian in the child. to tear mother tongues from language. to divide son, daughter, from parent, grandparent, greater kin.

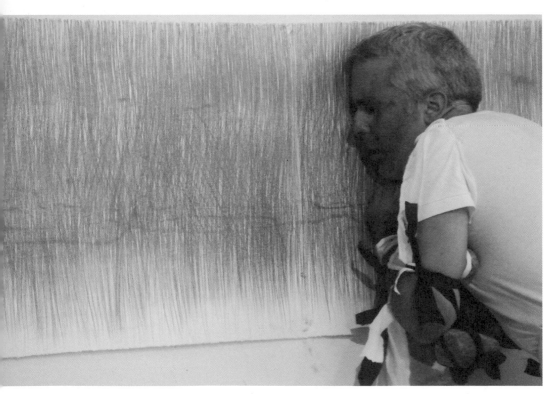

to separate culture from scent, sound, touch, unadulterated knowledges. uninterrupted knowledges.

this hair is a link to the ground. in this moment peter is here to collect the spiritual pain. to gather it up inside of his body. to travel back in time and remove some of that fear from the children. the rocks hold him here. hold his spirit present in this moment. in this reality. rocks. ground. hair. our ground. in the moment that peter becomes the scissors, and the scissors make contact with the hair, the most provocative spaces are invoked. peter rubs his face into the drawings, presses up hard against the paper, pushing ripples into the graphite. the painstakingly measured movements back and forth along the drawings of hair, the symbolic and physical weight of the scissors upon the hair, wears down the integrity of the image, and the drawings come crashing down. hair erratically cut from the body.

hair is cut. hair is cut. hair is cut. hair is cut. hair is cut. hair is cut. hair is cut. hair is cut. hair is cut. hair is cut. their hair is cut. their hair is cut. their hair is cut. canada begins. hair falls. as the hair falls a new map of canada is drawn on the ground. the scissors cease, belaboured. implicated.

their hair is cut and canada begins. canada begins. this is the plan. this is their plan, isn't it? but peter is not merely the eo ipso animation of scissorial transgression. his experience extends into and from his lived body, his corporeality absorbs and rejects post/colonial frames of deference. his body. his creative agency. enacted without regret. these eight drums are witnesses to this transgression. their witnessing takes back this history. transforms it. transforms agency. these drums are creative forces. in the moment, his face covered in raw carbon, the transfer of his act of cutting, the haunting visage of unspeakable experiences, violent ruptures between body and spirit, peter is no longer alive. he slumps to the ground, unable to move following exhaustive labours. the pasts' cutting down of flourishing futures. now the marks of this act are visible to us. we see the physical trace. left on the body. peter's body. an act of canada. there was a plan. and a dream about these residential schools. the government deemed this to be the greater good. from their point of view. the church thought this to be the solution-oriented thinking to address their preoccupations with occupying the land.

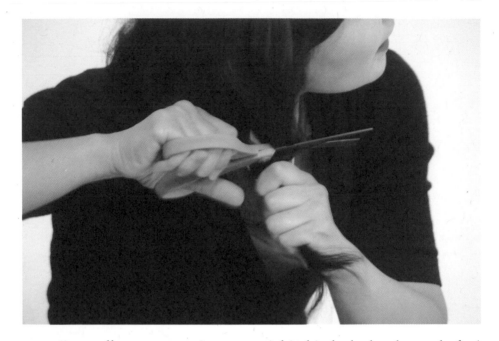

ayumi's corollary presence is ceremonial in kind. she has learned of an oft-forgotten tradition, passed quietly, orally through mother to child, a ritualistic response to egregious acts committed against one's spouse or community. this act is a spiritual gifting, an expression of abidance to recover respectful relations. she is cutting her hair. her beautiful hair. an acknowledgement of their pain. a hard act. considering the depth of spiritual pain that sits inside of canada. this act as a result of these hair cutting actions. ayumi offers solace. she offers witnessing. she offers her ancestors. they stand together to see this grievous act. they stand together to watch canada cut the hair off of the indigenous children for a nation building enterprise. ayumi serenely hums lullabies that her Mother had sung to her in her youth. in tempo to cheryl's soothing songs, lullabies in another tongue, sanguine comforts that evoke memories of stillness that precede the ease of dreamless slumbers. she gently brushes her thick, long, wavy hair, which cascades down mid-spine. ayumi has deep roots. she does not sit alone. ancestors sing in chorus. she is walking with her ancestors. they are acting together. deeply. echoes that are drawn across the water. she is mindful that whatever is emoted and experienced will become steeped into the gift itself. sorrow renders sorrow, composure bestows composure.

she draws her hair together, grouped and tied in five bundles. and one by one, she cuts her hair, washing each bundle in turn, pressing into cloth any excess water caught in the strands. she places the hair into a black wooden box, wrapping it in the most delicate washi paper, criss-cross swathed in fragile red ribbon and a gold seal for good measure. and just as countless women before her cut off their hair to offer it in the face of gross and brutal conduct, ayumi silently walks over to where peter sits, kneels before him, and presents her hair.

peter is stirred. awake. eyes open. there is still so much weight. the eye lids struggle. the hands struggle. the body struggles. she offers him a gift. the memory of the act. this cutting. his body. this act of cutting weighs heavily in the room, has created this burden. peter's hands look like they are made of concrete. he lifts these hardened hands up to receive this gift. cheryl's

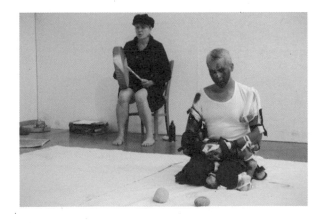

drumming binds and reverberates, the eight drums dispersed amongst others watching, listening, reacting. the rolling thunder of witnessing vibrates skin to skin, beat to beat. something happens in performance. there is so much quiet. overwhelming quiet. the kind of quiet created in the co-constructive interference of infinite relations. this cutting weighs heavily. the act is a presentation of knowledge practices. structures that enable. structures that disturb. interference in the crude colonial narratives of indigenous/settler relations. knowledge is embodied through action and ancestry and land. peter's body and ayumi's body.

in performance, the research is in the same space as the day to day. the performance space becomes the site of engaging with the knowledge of difficult political histories. a visceral awareness of self in relation to history. there is a moment. in the moment that ayumi presents her hair, everything changes. all of the pain, the tangible accrual of injustice as physically, spiritually, and culturally experienced in the every day, in every body, and in peter's body as it is affected and infected by those memories of residential school, just transforms. a catalyst. for when history and present and weight become separated. the performance poses an evocative question about the permeation of spiritual pain. estranged breath.

the drum stops. silent. silent. silent. silent. silent. the silence is like a blanket. peter reaches for the gift, unravels the trimming, softly removes the decorative paper, and opens wide the container, peers at the contents.

he weeps. he clasps a bundle of hair, raising it to his cheek, brushing his face with the wisps entangled in his fingers. he is the scissors who has been offered hair. a moment of transgression. scissors. a westernized innovation coming into contact with the indigenous body. scissors that have served in the misappropriation of. he is the generation forward responding to generations past. and he is one and the same peter who has generously accepted this personal gift from his friend, ayumi. her hair is a catalyst. a reason for change.

ayumi noiselessly sets about snipping off the stones weighing down peter's body until every last one is removed. suddenly there is lightness, cheryl's

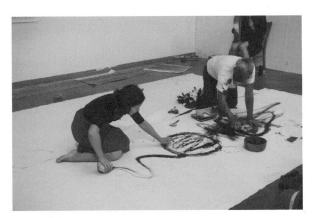

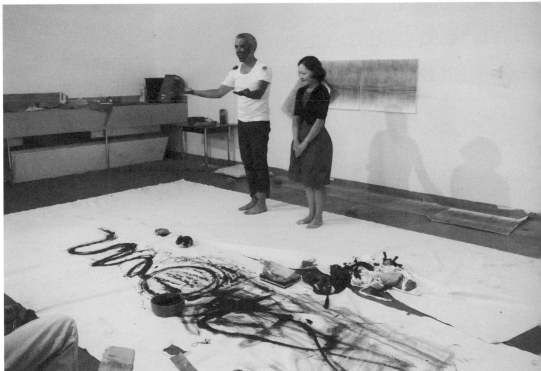

singing resumes. her voice changes in tempo and tenor, her song bounds in the delights of children's play, sonorously floating through the air. she cuts the ties. the rocks fall to the ground. tears. tears. tears. tears. wash away the graphite covering Peter's face. tears become rivers. carving the land. carving away bits of this difficult political history. tears create a new landscape. washing away the previous landscapes of cut-off hair.

they each wrap a bundle of hair around one of the rocks. impromptu paint brushing tools on an equally impromptu canvas. the ground shifts beneath their feet. peter has become a five-year-old boy living in a new land. he feels being seen. his body no longer responding to pain. he reaches across a playground to his new best friend. a five-year-old ayumi. and together they write a new canada. a canada in which ancestors work with us. and beyond any canada in which a person of japanese heritage and a person of tahltan identity work together to address and contribute their voices in the transformation of history, stories forward. restructuring futures. and in witness to the land.

there is levity in the hopscotch leap of ink on cloth. ayumi. peter. transformed into a state of play. they giggle, he egging her on to play harder. just because.

ADRIAN STIMSON

Interview with Jonathan Dewar

JD: When did "reconciliation"—either that word, that concept that we now use—first strike you?

AS: I first started hearing about reconciliation in the '90s when I was in politics in my nation; I was a tribal councillor for my reserve for four terms. It was during that time that South Africa's TRC was also in the news. I can recall having meetings where these kinds of ideas were discussed.

JD: I've yet to hear any of the artists I've interviewed say that they felt that reconciliation was being actively talked about in the early '90s. So my follow-up question is: Was it because you were wearing your politician's hat that you heard about it, or did the conversation extend into the art world as well?

AS: Oh no, that's because I was wearing my politician's hat, most definitely. We were well ahead in terms of negotiations and it all just fell apart, quite simply because every time we would come up with a notion of self-government that suited us, it didn't suit the government. So, then it would just get quashed. I often felt like, "What's the use of trying to negotiate these things when in fact it isn't our processes?" So for me, I think that led me into the art world.

Later, I went to ACAD, which even to this day still struggles with Indigenous representation, particularly within curricula. That's where I first met Ashok Mathur; he was one of my professors and it was there that a lot more activism started happening in the student body. We started an Aboriginal collective and we started to explore a number of these issues, such as appropriation, of non-Native students doing Indigenous-type work.

There was a lot of discussion about that. It was there that I began to come at it more from an artist's perspective, understanding reconciliation a little bit more and what was going on in politics in terms of the future TRC and all of that stuff.

JD: How early would you say you developed that decolonization sensibility? As a child did you have a sense that "There's something not right here with the system, or systems … and there's something that needs to be addressed"?

AS: I think in the residential school. In Gordon's Residential School. I think it was the first time that I was slapped across the face by a bus driver, and having that shock, and then going home and telling my parents, and then seeing my parents be so upset by this; my father going out to find the bus driver to beat the shit out of him (laughs), which he never did. Actually, he went to town and he slapped the bus driver across the face and said, "If you ever do that, not just to my kid, but to any of the kids ever…" So I think I learned from him that idea of standing up for one's self.

JD: Your dad worked at that school.

AS: Yes, Gordon's Residential School. I think my awareness of activism, of not "taking that"—even though I was still very young—was very much instilled. In '75 my father took a position as tribal councillor involved with chief and council. We were a political family, so he would come home and talk about it. As a kid, I just knew that I was different (laughs) to the rest of society, and that there were injustices and we had to make change by standing up and being counted.

JD: The other word that is often connected with reconciliation is truth. Was this concept of truth something you discussed openly as well? It would seem to me, given that your folks were pretty savvy about the residential schools, that there shouldn't have been the same sort of shadow over certain things in your household as other households. But is that true?

AS: I would say yes and no. As I look back now, with what I know now about my father's history in the residential schools, there was probably

some denial about what actually happened within the system. But there was also hope. The stories that I heard from my parents, in particular from my father, were always about wanting to change the system from within, being part of it. Having gone to residential school and having had the experience that he had, and then being employed through it … He never actively went out and sought the work, at Shingwauk or at Fort George or Gordon's, he was always invited.

JD: A job's a job?

AS: Yes, and he got a childcare certificate from the University of Saskatchewan. I just found that out. He went to U of S, just like I did, and that's where he got his childcare certificate, so that allowed him to be a senior boys' supervisor. I think his experience made him want to change the system from within. But then again, how do you still exist and reconcile that? That's one of the questions that I'm asking myself now as I do this research.

JD: So when you mentioned denial, you meant your father, that for him personally there were some elements of denial?

AS: Oh, absolutely, denial in the sense that it's that unresolved trauma.

My parents always said, especially about Shingwauk and Fort George, that it was the best years of their lives. I look back and say, "Well that's kind of an odd statement given the context." But, you see, youth played a big part of it: they were both young people at that time, and usually when you're young, that's the best years of your lives. And then of course there was this beautiful, I would say, innocence about the north at that time, even though the school was there. The life, the actual camping life, and the communities were still very much intact. The whole world of hunting, of fishing, of being outdoors, all of those things really spoke to an idyllic life, even though it was a residential school. Part of my investigation is to decipher and come to an understanding of that reaction.

JD: Were you welcome in the north as a Blackfoot?

AS: Oh yes. When we went to Saskatchewan, in the middle of Cree country —which used to be Blackfoot territory, as I like to remind my Cree friends— many strong friendships were created. The first language I learned was Cree. I don't speak it fluently. I learned it up to Grade 4, and I probably had a pretty good grasp of it, more so than Blackfoot because I wasn't immersed in Blackfoot. When I went back home in '75, that's when I really started to learn my Blackfoot. I've always wanted to do a show as a curator between Cree and Blackfoot artists called "Traditional Enemies, Contemporary Friends" (laughs).

JD: A more general question: The role of art and the artist in truth?

AS: Truth is a hard one because in a lot of my work I look at this idea of construction of narratives, how history is constructed, and of course we know history is told through the bias of time and people and place and interest. But there are stories, and the stories are based on experiences. I guess if the stories are told as they happened, or as they were perceived, it's a truth.

JD: Do you see yourself as revealing a truth that has been hidden— whether about residential schools, or treaties, or those kinds of things that Canadians don't know about?

AS: Well, a lot of my work has dealt with my identity. When I went to ACAD I thought I was going to be a photographer, so a lot of my photographs revolved around my experiences, which also include a lot of Native imagery. But then, when I got into painting, I started to paint things that I knew—like the history of the bison and images of my great-grandfather Heavy Shield. When I started to create works like that, I started hitting up against a wall, because in the critiques the instructors would be able to talk about the painting style, but they had a lot of difficulty with the content. I found I had to do a lot of education with my instructors and my fellow students about Indigenous worldviews and Blackfoot history, and sometimes it would be met with opposition—like, "You should just be an artist. Why do you have to include all this stuff about identity?" I would say, well, that's stupid. Look at every art movement in the world:

there are political issues that drive every single one. So why would it be different for me, a Blackfoot person making art, why wouldn't my identity be a part of it? It was that sort of educative process. It wasn't always confrontational, but there were a few times when it was, and I would get really pissed off and get into arguments (laughs), aesthetic arguments. In many ways I think it expanded the conversation about art-making. Yes, you could be a purist in terms of painting—but you still have an identity, and that identity still comes out in whatever style you choose because that style has a history. Every time that argument would come up, the other students and the instructors couldn't see their own history in terms of their own identity construction. That made me wonder if there is a racist bent here and people are just not admitting it. They just want to cloak it in these art history contexts.

JD: Was there ever a light bulb moment, whether there was a call for submissions or a curator approached you and said, "I want work on this topic," and you said, "Yeah, I can't believe I haven't contemplated that"?

AS: Yes, I think probably in my Masters when I moved into installation and performance art. I started doing research on performance artists like James Luna, Guillermo Gómez-Peña, Rebecca Belmore (who I adore), Dana Claxton, and others. I was also taking a course from Lynn Bell in post-colonial studies. It was during that time that I could see where I fit. I could see where performance art held a bit more of a cachet for me to work.

JD: You're speaking of form and process here, as opposed to like, a theme.

AS: Yes, but also theme though. *Buffalo Boy*, for example. That's when I started looking at history. I started to look at what those histories were all about and then move those histories into the present to see how the present and the past are not so different. It was there that I started to realize how the connection between past and present fit with my Blackfoot worldview and concepts of time. In my Masters work, I started to bump those two things together to see what would happen.

My work has a theoretical and academic background, and my research informs my work. But I also have this ... I don't know, this channel that's

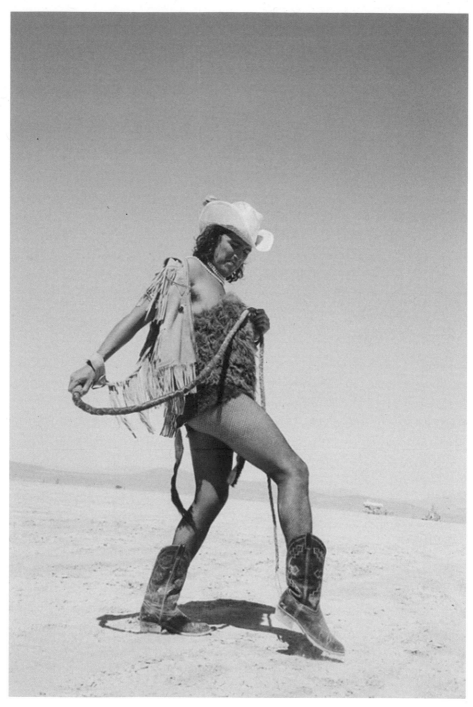

Adrian Stimson. *Buffalo Boy.* 2010.

open. I can be sitting there and I have these waking visions. I'm wide awake and all of a sudden I get this flood of imagery that comes through my mind. I have to be careful to try and write it all down. I usually don't, which is too bad, but it's almost like it's coming to me from the ether. I like to think of myself as an anti-theist. Yet, at the same time, I don't exclude or ignore the fantastic because I have seen stuff that has caused me to wonder.

When I was a child, I used to walk through the hills on my reserve and I used to hear powwow music. I used to hear it for the longest time in my life and then it stopped. I don't know why it stopped, but it stopped, and I've spoken to many people who have had this happen. The song was coming through them to use—I never really realized that then. I see the art-making process in the same way, because I get these visions. All of a sudden I'll just start seeing things in my mind's eye, and I'm like, OK, OK, that's kind of cool. Then I start to wonder how I can use that … What will that be—a painting, performance, or video? What's the best way to get that information out? So part of my process is trusting in the spiritual openness. But I also have a strong background in academics and research. I try to balance them.

I still haven't really understood my process fully. Like *Buffalo Boy*. *Buffalo Boy* first started at Lebret Residential School when my personality as a kid split into two people. It was Adrian who went to school, and then after school Adrian would come home and turn into Adrianne. The signifier was a white pleather fringe jacket. I'd put that on and I'd go out and I'd be Adrianne, Adrian's twin. And then I'd go back to the school and hang out with all the kids as Adrian (laughs).

JD: Many of the artists I've met have said that in the months before the TRC came to be, and as people began to get information about what it might do and the role that art and artists might play in it, they'd never thought of doing work around residential schools. Some of these were survivors, some of them were inter-generationally affected, and some of them weren't personally connected to it. But many of them said that now they felt compelled to approach it. Later on there was a call for artists to be involved, formally. What was your take on that? You didn't need a call from the TRC to bring you to that subject matter.

AS: No, I was already doing it. Residential school was such a part of my experience that it was something that naturally I did, or spoke to. There was always that connection to that history. As the TRC started to develop, I started to recognize that my work had that interest, and perhaps that strengthened ideas around residential schools in my performance, video, and installation work.

This is another weird story. In the late '80s, even before my political career, they were renovating Old Sun Residential School. They took out all the windows and beds and all that sort of stuff and threw it in the dump. I was a bit of a junk collector as a kid, and I'd go trekking and dragging these beds and windows home to my parents' place and put them in the garage. My mom and dad would say, "What are you doing bringing all this junk home?" And I'd say, "I don't know, maybe I might use it someday." It was just stupid (laughs). But maybe there was something else going on

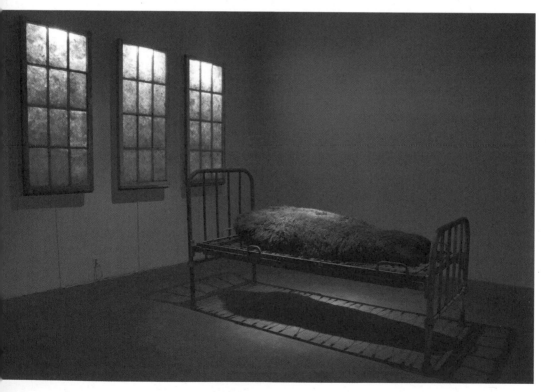

Adrian Stimson. *Sick and Tired.* 2004.

where all these things became parts of installations that I did in my later life, like *Sick and Tired* and *The Bed*.

JD: What role do you see, generally, for art and artists in reconciliation processes? What roles do art and artists play formally, or less formally?

AS: Well, artists are a conduit for the community in many different ways, of the experience that has happened in the community. Traditionally, artists can be looked at as tricksters, as some sort of moral compass, and often they are sought out to help with visioning ideas within the community.

JD: Are you speaking contemporarily?

AS: I think traditionally in the Blackfoot culture we have Napi who is our trickster, we have clowns, we have many contrary characters. If you were to parallel that with the contemporary, it would be performance artists and actors. Now we just call ourselves artists. I think artists have that role, or are charged with that role, within the community to be seers, to mirror back what's going on so that the community can agree or disagree or be confused, or in some weird way have that information transferred to them for them to resolve.

JD: Would that then be, traditionally and more contemporarily, an element of health and wellbeing?

AS: I think so, absolutely. I think the purpose of the clown, the trickster, Napi, is about wellbeing in the community because the community needs to be able to see itself in order to understand itself. At times when the community is sick, mirroring that back is like, uh oh, something's not right here.

JD: What are your thoughts with regard to the idea of healing, and the role of art and artists in healing?

AS: I've always believed that the art object itself cannot heal. For me, the process of creating art is a process of healing for myself. The object itself, the result, is not a healer—but it could be a trigger, a trigger for somebody else to consider their own situation, in their own context.

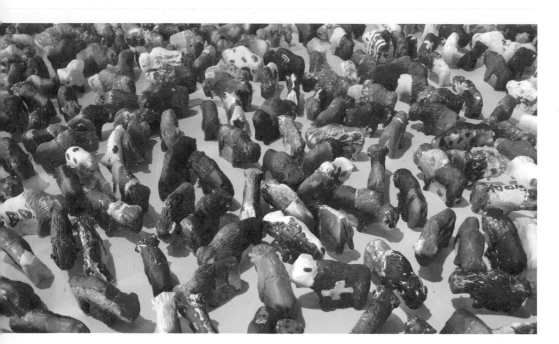

Adrian Stimson. *The Herd*. 2010.

JD: Have you ever engaged in applied arts practice?

AS: I think so. I think of my projects like *The Herd*, and creating the hydro-stone bison, because of my research on the history of the bison and slaughter. I make a deliberate decision that certain projects are educative. I work with all ages, but younger ones in particular, to educate them about the history and to give them a space where they can be activated within it. So with the little hydro-stone bison we had a map. We tell them about the slaughter, and they take these little bison from a pile that looks like a pile of bones, paint it whatever colour they want, and then place it on the map. It is a symbolic repopulation, so at some point the whole map is full of the bison. But it's also a very contemplative, very intimate process. It was at Fort Calgary for almost a year; they just took it down.

I was just there for the *Making Treaty 7* play that I was a part of. I was in the staff room, and on the wall there was this beautiful little letter with all these buffalo on it; I said, "I wonder if that relates to my project."

It was from Germany, and it was from a bunch of kids in Germany who had been over here and participated in that project. It was their understanding of "don't kill the buffalo." It was just beautiful, little poems and stuff. For me it was a beautiful moment of realizing that this project, in a weird way, had spawned this consciousness around the bison and an understanding of the history.

I've been thinking about how art can be transformative, even for people who don't consider themselves artists. I'm trying to consciously develop more projects like *Drawing Treaty*, a project that I created a few weeks ago. I record the treaty and then I play that recording back to a group of people, and they have to sit there and they have to draw the treaty. It's another way of transferring knowledge, but it also speaks to what we hear and what we don't hear and how we interpret what we hear—which relates to the spirit and intent of treaties. I've become more conscious of projects that combine education on a particular issue with subjects that, on the surface, may not seem to have political or educative content.

Drawing by Jeffrey George, participant in Adrian Stimson's *Drawing Treaty*.

JD: In 2010 you were asked to bring work to a TRC event. Is that something you're comfortable talking about?

AS: Oh, absolutely. It was nice having Jaimie Isaac here this last week as she and I were able to have a further discussion and to shed light on what actually occurred. Jaimie contacted me and wanted to have this particular work in there, and so my understanding was that she was the curator. I first thought that she had all the control, and then I started to understand that the work had to go through another committee to be examined and vetted.

JD: Which piece or body of work?

AS: The *Sick and Tired* piece, with the windows, which now is in the collection of the MacKenzie Art Gallery. It's so funny, they see it as significant work for our time. Anyway, Jaimie started indicating that there was trouble, that the committee had vetted it and didn't want it. The excuse was that it was too powerful. I think it was the guy who she was working with, he was the one who emailed me the final sort of, "No, we're not putting it in because it's too powerful." He said that it would cause trauma and stuff like that. And then I said, you know, I appreciate all that, but you need to consider your process. You can't ask a curator to put something together and then turn around and pull the rug out from under her feet and make her vulnerable to the artist, because as curator and artist we create relationships. And saying it's too powerful doesn't make sense to me because isn't art supposed to do that? Isn't it supposed to be a trigger? Then I said, you've negated my experience. I am a residential school survivor, you've negated that. What you've done is really problematic, and you need to think about these things before you embark on these things. I was pretty direct.

JD: The TRC received advice like: If you're going to put out a call for art from residential school survivors, will you ever say no? Can that work be assessed or adjudicated? And if you say no, what's the power of that no? What might it do to an individual?

AS: I think the TRC, or whoever tries to create these kinds of exhibitions, has to know right away that if you're putting out a call, you've got to

accept everything. And what does that mean? And how do you contextualize everything if something comes in and it's so outrageous, you know, how are you going to deal with that? If we want to truly understand our condition as human beings in relation to residential school, there's some pretty awful shit that happened and there are artists who are going to show that. You don't have to look at it if you don't want to, but it's there. It's there.

JD: Do you feel like you have a responsibility to do the kind of work that you do? To your community? To your nation?

AS: We do have a responsibility towards our communities. Within the societal roles in the Blackfoot nation—and I can only speak from the Blackfoot perspective—when you become a member of the Horn Society, you are a parent for your whole tribe. You have a responsibility to be compassionate, to give, to provide for your people. So, yes, from a worldview perspective, absolutely I have a responsibility to my tribe. That bumps up against western notions of art, where you have less responsibility.

JD: The last question is about apologies. As an artist and with your particular kind of practice, you are already engaged in some of these issues. Have we said it all, or is there still more to say?

AS: I watched the apology with Lori Blondeau, and we both shed a few tears. Both of us kept saying to each other, "It's more about this energy we're feeling. We're feeling this collective energy right now—a bit of a release." And yet within a couple of hours, both of us were highly skeptical. We talked about the orchestration of the apology—but at the same time we did not want to dismiss people's reaction, you know. I, too, am a survivor and sometimes I forget that. I start to think that I'm a second-class survivor, I'm not really a survivor, I didn't go through the same things as everybody else. Yeah, I've been in the system and I know it intimately and I know what happened to me.

JD: Well, your experience with the Common Experience Payment (CEP) certainly made you feel that way. You knew going into the CEP process that you were likely to be rejected.

AS: Oh, absolutely.

JD: You weren't one of those survivors who were caught completely unaware.

AS: Absolutely. The reason I applied is because a number of elders encouraged me back home. I knew that I wasn't going to get it. I knew it. But then I talked to my father and he said, "Well, you should put your name in there anyway because you went to residential school, you are a part of the statistics. Shit happened to you, so you have to put your name in." Honestly, I was really reluctant. I don't think I really put it in until the very last minute. But then, from an art perspective, I thought, "Well, you know what, I want to feel this. I want to feel what it's like to be rejected." I deliberately put myself in that vulnerable position to be able to write about it, to be able to talk about it from first-hand experience. I made an educated, deliberate move to do that because I wanted to know what that felt like.

JD: I've heard you refer to your experience and "shit happening." I've heard you use that kind of shorthand a number of times. Do you talk about the shit openly?

AS: Yes, I have actually. I've talked ... yes, I was physically abused, I was sexually abused, from a number of different perspectives, from administration, from senior boys, from people who were involved on the periphery, so both Native and non-Native. I haven't really gone into the actual specifics of any of it yet, but I will, because given my own understanding of my father's experience, and seeing patterns in his life now living out in my life...

JD: You and I have talked about you wanting to explore your father's experience, to help him tell his story, or to tell his story and how your story is obviously involved in his story. What I've seen in your work is that you have a vision of how deeply personal art can be. It can be pedagogical, it can be instructive, it can be transformative.

AS: The *Making Treaty* 7 process was very powerful. I took on these little bundles, and one of them was self-trauma. I spoke a little bit to my

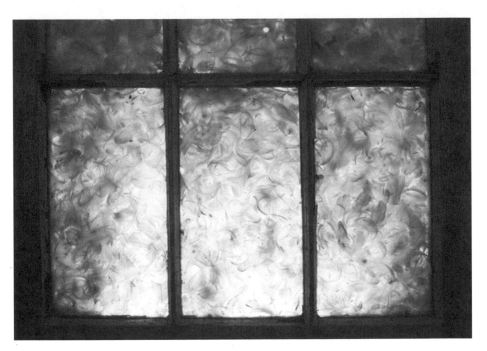

Adrian Stimson. *Sick and Tired.* 2004.

experience to the group, and it was beautiful because within the group we had this real trusting relationship. It was everyone—Blackfoot, non-Native, Black, Asian, just a really interesting group of people. Treaty 7 territory, yeah. The elders, too, were sharing their trauma in a very personal way and all of a sudden I just burst out crying, and it was good because it was very supportive. I think it was really important for those emotions to surface in that context, in that place, because it really fuelled the artistic process. We came out with a pretty special moment in time. That's what everybody was telling us when we presented at Fort Calgary to the elders, and then again the next day to the general public. People walked away feeling like they had been changed. Something hit. I think that's so important because, yes, I believe it, I've seen the power of your own personal truth shared. It can be very transformative.

ALWAYS BEGINNING:
IMAGINING RECONCILIATION BEYOND INCLUSION OR LOSS

Allison Hargreaves and David Jefferess

In mainstream conceptions of reconciliation, and particularly in official discourses in Canada, reconciliation is most often supposed to provide closure—new beginnings, perhaps, but most importantly closure. Reconciliation purports to redress historic suffering and injustice, and in so doing to provide an end to non-Indigenous guilt and responsibility. Formal state apologies don't hide the desire to close chapters, for instance: "they" still need to heal, but that is their work, and by doing so they will finally be fit for inclusion in the "Canadian mosaic." The end product, it is hoped, will be "a stronger Canada for all of us" (House of Commons Apology 337). But what if we understood reconciliation not as a means to secure closure—thus fulfilling Canada's national mythology of progress and inclusion—but rather as a place from which to begin the hard work of rethinking relationships and renegotiating responsibilities?

In the introduction to *Hair: A Performance*, part of the 2013 *Reconsidering Reconciliation* artist residency at Thompson Rivers University, Peter Morin described how when taking up the practice of decolonization, "It always feels like you are on day one." A sentiment such as this might articulate frustration; no matter how much work is done, it always feels like starting over, at the beginning, again. But Morin's statement also offers a powerful counterpoint to the demand for, or hope of, "closure"—a recurring trope in state-authored and institutional discourses of reconciliation and redress. Further, if reconciliation is becoming just another story within Canada's progressive narrative of history as a peaceable and inclusive nation, Morin's comments constitute an intervention into the way the cultural imaginary requires that colonialism be forgotten.

As non-Indigenous scholars we seek to recognize the ways in which our identities, as Canadians, have been affirmed though this forgetting of colonialism. We are learning that to know ourselves as settler subjects, as beneficiaries of an ongoing system of colonialism, we are undertaking a work that is always beginning, and is only ever partial. It is a work for which we often feel we have few tools or models; the roles and responsibilities of settlers in projects of decolonization are often obscured, avoided, or denied—because to think concertedly about the responsibilities of settlers would be to acknowledge our historical and ongoing complicity with colonization. Taiaiake Alfred states that, because "Settlers have serious difficulties thinking thoughts that are outside foundational premises of their imperial background," "we have to do it for them. And for us" ("Opening" 10).

What would it mean for us—as non-Indigenous people—to think seriously about reconciliation in terms of the project of decolonization, a project that serves to acknowledge and undo the foundational premises of our dominant settler myths? How might this work best be done, or begun? Where models for this work already exist—in the creative and critical work of Indigenous thinkers, for instance—how might we engage responsibly with the entry points these models provide? That is, how might we undertake the work of reconciliation as decolonization, something that is "always beginning" and that necessitates our entry into a collaborative process informed by respectful acknowledgement, responsible sharing, and mutual engagement?

We have come to experience this process as a humbling one: in one sense, it requires unlearning those stories that have affirmed our belonging and normalized colonial relations of power; in another it requires us to enter into a relation of sorts with those who have done much of this decolonized thinking "for us." In entering into this relation, we recognize a responsibility not only to acknowledge these influences upon our thinking, but also to engage in a collaborative spirit with this creative and critical work. This entails taking our analytical cues from the work of Indigenous scholars, artists, and activists, while not appropriating this knowledge as our own; it involves speaking from our own subject positions, while understanding the limitations of our worldviews; it means learning to think

and act differently, while not making Indigenous peoples responsible for the re-education this transformation requires.

This work cannot be done alone. Aside from the work of entering into responsible relation with Indigenous thinkers and texts, the more obvious collaboration here is the one that exists between us as settler scholars. For us, collaboration has been a way to practice accountability and critical self-reflection as integral to the process of "always beginning." In formal ways, such work has included fostering community dialogues on decolonization and reconciliation. Informally, our collaboration is a space of ongoing conversation marked by a continual and sometimes anxious working-through of what our responsibilities in this work might entail. We wonder together about how to enter into dialogue with those who have transformed our thinking (and we wonder, via Taiaiake Alfred, whether our thinking has been transformed). We wonder when and how this conversation could be useful to others. Our collaboration is thus a space where we challenge one another, and where we both seek and offer support. It is a continual attempt to enact in practice the kind of relationship we find necessary to unlearning settler belonging.

Our collaboration is reflected in this essay, in the way our two voices at times merge but are mostly distinct, as if speaking to one another. We work against a singular line of thought, or argument, the certainty and closure that Western academic writing typically demands. In so doing, we seek to reflect on the necessary "collaborations" we have with the work of Indigenous scholars, artists, and activists who have offered us ways into this process. And, as settler scholars working in collaboration with one another, we seek ways of affirming rather than lamenting the work of decolonization as necessarily partial, unsettling, and (for now) incomplete. We reflect here on reconciliation as something that might be understood as "always beginning" rather than an end, and as an altered relation rather than a solution to be worked toward.

1990. Jeannette Armstrong asks writers from the dominating culture to imagine what it is like to be Native in the settler colonial state. To imagine the suffering of children in the residential schools. To imagine what

it is like to change, adapt, alter, assimilate—all in hopes of being treated humanly. To imagine what it is like to realize that assimilation is not meant to include you but to destroy you—for the dominating culture is a white supremacist culture. Armstrong is not asking us to imagine as an act of empathy, in the way empathy is taught in school: Now, we will read and listen to their stories so that we can know their suffering, and know that they suffered. So, then we can move on to the next chapter. Instead, she demands: "Imagine how you as writers from the dominant society might turn over some of the rocks in your own garden for examination. Imagine in your literature courageously questioning and examining the values that allow the dehumanizing of peoples through domination and the dispassionate nature of racism inherent in perpetuating such practices. ... Imagine interpreting for us your own people's thinking toward us, instead of interpreting for us, our thinking, our lives and our stories" ("Disempowerment" 143). Such imagining so often seems threatening for non-Indigenous people: "we" don't think of ourselves as part of a dominating culture; that is not who we "are."

2009. Greg Younging says on the topic of reconciliation: "Apart from their relationship with Indigenous peoples, Canadians first need to undergo a type of micro-reconciliation within themselves. In so doing, the present generation of Canadians need to face up to what has been done in their name, and they must own it as being part of who they are. Canadians need to play catch-up in the big reconciliation game, because Indigenous people have already done that. Canadian reconciliation must begin with: 1) throwing out all the historical dissociations and denials, and 2) getting out of the prevailing generation-centric headspace. As we attempt to venture down the road toward reconciliation, Canadians would probably benefit a lot by learning from, and viewing the world like, Indigenous peoples; not vice versa" ("Inherited" 327-28). Published nearly twenty years after Armstrong's call, Younging's instruction to non-Indigenous Canadians is uttered post-apology, post-"Statement of Reconciliation," post-settlement agreement, and post-TRC inauguration. As significant or valuable as each of these initiatives might be, they also seem to turn away from the prospect of "facing up"—positing reconciliation as, primarily,

the means of (finally) including and accommodating Indigenous peoples in the Canadian nation.

These initiatives assume the sovereignty of the settler colonial state as a condition for reconciliation: the state's mechanisms and mythologies structure the terms on which Canadians play the "reconciliation game" as a partial and selective acknowledgement of "past" wrongs for which the present generation need not take lived responsibility. By contrast, Armstrong and Younging suggest that non-Indigenous peoples must begin to understand themselves as implicated in colonial relations of power, as benefitting in material ways from colonial processes of dispossession, and as living these benefits in the present. To come to such an understanding requires a radical renegotiation of the frameworks by which non-Indigenous peoples imagine themselves, and the nation. For instance, it requires understanding history not as a linear series of events but as a layered presence; what lies beneath rocks in our gardens may be hidden or ignored but it is not gone.

To hear the stories of residential school survivors—this is surely a fundamental part of the work of reconciliation. The closing lines to Rita Joe's oft-quoted residential school poem, "I Lost My Talk," seem to issue such an imperative: "So gently I offer my hand and ask,/ Let me find my talk/ So I can teach you about me." But what might it mean to hear this closing as a beginning rather than an end, as it so often seems to be? We might hear embedded in Joe's poem not only a plea to be heard—an entreaty that, once acknowledged with empathetic ears, sees our obligation fulfilled—but also a teaching that forcefully reorients non-Indigenous peoples toward a new and different task: to understand ourselves in relation to this regrettable "past." Joe's speaker offers her hand, and with this profound gesture of conciliation she refigures the project as one of relation—of separate but shared obligation. She makes it possible for us to see that the story of residential schooling in Canada is one not only of direct or inherited suffering from which Indigenous peoples now must heal; it is also a story of perpetrators who inflict colonial violence, and of beneficiaries who actively inherit the effects. It is that story that we, as non-Indigenous people, must find ways to own and to tell. In Patricia

Monture's "white man tell me," the speaker of the poem asserts: "white man/ tell me/ 'I had no idea'/ white man, he,/ tell me." In Joe's poem, we are asked to abandon that comforting refrain, "I had no idea," and with it our dissociations and denials that prevent us from hearing and telling a different story.

To commemorate its first 100 years, the city of Kelowna commissioned a video project that the City ultimately refused to show because of one film. A non-Indigenous artist had filmed members of the Westbank First Nation telling stories of the land, of the first white settlers, of the creation of the reserve, of inter-generational trauma (Salloum). Among other perceived failings, the film was deemed not sufficiently "celebratory." In centennial commemorations of Kelowna's transformation from "a dust-bowl" to an "international destination for business and pleasure" (*Kelowna: The First 100 Years*), there was no space to listen to those voices and to hear those stories. A centennial celebration is no place for turning over these rocks.

When I declare at the front of a classroom, or utter in an opening go-round in a discussion event, "I am a settler," in the moment of their utterance I want to swallow those words, not knowing what the phrase should mean, and anxious that my audience may hear it in a multitude of ways: as an acknowledgement of a social relation, perhaps; as the facile confession of an academic; as a threat to the identity of non-Indigenous participants; as not meaning anything at all. J.M. Coetzee suggests that "one settler, one bullet," a slogan chanted by anti-Apartheid activists, was terrifying to white South Africans not just because of the threat of the gun, but because their belonging was undermined: who they imagined themselves to be never was, never could be, or at least wasn't any longer. To recognize oneself as a settler-subject is to learn to acknowledge this loss. Reconciliation, in this vein, means that I must come to know myself as something other than what I think I am.

I think I can sort of follow the stories and images of Chris Bose's video, *Jesus Coyote Teevee*, at the beginning at least. I don't get the text in N'laka'pamux, but I can read the English. The story of snk'yép, Jesus Coyote, aerial images of mountains, grainy ethnographic film footage

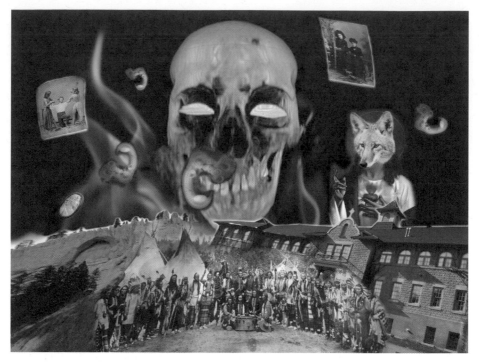

Chris Bose. *Jesus Coyote Burns for Your Sins*. 2008.

("The Shuswap Indians of British Columbia"), urban traffic in the evening. The promise of a saved soul scrolling across the screen as Prime Minister Harper stutters the apology, trying to close the chapter. Drumming and singing I don't understand. The hope of understanding the histories and perspectives Bose layers one upon another. Understand history as layered rather than linear. Images, ideas, words drowned out by others, selected or ignored. I try to attend to it all. Posing priests. Maps of North America narrowing to Canada narrowing to British Columbia. Harper's reading voice. The images, layers, perspectives, histories slowly proliferate. I can't follow the scrolling diary entries. The music gets louder, more aggressive. I can't keep up. I can't understand. In the opening to the video, I am startled by a clap of thunder, a gun shot. It gets my attention. Its closing overwhelms my knowing, my desire for mastery. A beginning.

Jeannette Armstrong's poem, "History Lesson," begins in medias res: "Out of the belly of Christopher's ship/ a mob bursts." The myths of discovery, mastery, and manifest destiny are cracked open as priests, pioneers, traders, and red-coated knights surge and pitch haphazardly over the terrain of a "new world"—long home to "whole civilizations." The underside of the rock: the poem exposes a history of colonial violence but also instructs us on the violences of history-making. Typically, we are invited to understand the history of Canada in a linear, progressive fashion that begins with "discovery" and ends with "reconciliation" (a series of regrettable colonial harms nestled safely in between). The poem disrupts this comforting narrative of historical dissociation. It collapses hundreds of years of colonial history into a few lines; it poses provocative juxtapositions between contemporary mining practices and the frenzied extractions of the fur trade. Here, farmers sow skulls and bones while "breathing forests and fields" are buried "beneath concrete and steel."

This is a disorienting and dystopic journey—to be hurtled through centuries of violent destruction, to come to rest "among the remains/ of skinless animals" ("History Lesson"). Arguably most jarring: that "Pioneers and traders/ bring gifts/ Smallpox, Seagrams/ and rice krispies." A breakfast cereal is lifted from our wholesome table and set alongside Smallpox and Seagrams, set in the context of colonially-wrought disease and the dark ironies of unwanted gifts. No longer familiar or benign, rice krispies are so discomforting here precisely because they implicate us in the ongoing colonialism of our present. But rather than seeing this implication as threat, might we embrace it as an opening?

Then, there is the map depicting the Buffalo Commons in Ward Churchill's essay, "I am Indigenist"—a map that demarcates the boundaries of a proposed North American Union of Indigenous Nations. The seams of identity marked by the map—weather maps, classroom maps, clean lines and bright colours—are refashioned; the us is severed, divided, it appears, by the dark mass of land lost. Churchill provides an argument in the essay. An argument for redress as redistribution. An argument for a remedy to the inefficiency and distress of so much of the contemporary American

West. An argument for a new relationship and for collaboration. For the disassembly of the gigantic state structures produced in the era of formal imperialism. For an Indian Country open to anyone who wants to live under Native Law, up to the limits of "the carrying capacity of the land." For a transformed order. It is, of course, not an argument for a new map but for Indigenous autonomy, the recognition of separation as "the necessary point of departure for any exercise of self-determination" (292). When land can only be conceived as a map, and when our association with the land is depicted by that map, Buffalo Commons is the death of that hope that reconciliation means only incorporating "them" into what is already. Bringing them up. To imagine this new configuration transcends acts of empathy, mastery. It is threatening because it means we will have to change, too, and we can only see this as a loss, rather than a beginning.

How might we begin to imagine reconciliation beyond inclusion or loss—and instead as a transformed order of social relations? How might we come to recognize models for this transformation in what we typically understand as closed chapters or barriers? These models are articulated in treaty agreements and other nation-to-nation relations as understood in Indigenous traditions of diplomacy. Whether bonds of territorial, commercial, or political alliance and exchange, these pacts are ones for which we all inherit responsibility—Indigenous and non-Indigenous peoples alike. When we, as settlers, misunderstand treaties as the lawful means by which Indigenous peoples "gave up" land for settlement and exploitative development, we legitimize what is in fact a history of theft and dispossession; when we misapprehend our position as one of inevitable ascendancy and belonging, we efface what might more productively be understood as one of profound failure: the failure to uphold historical agreements governing peaceful interactions between sovereign political bodies and their citizens. Against the nation-to-nation model, the story of "inclusion" and of "accommodation" has become the official story that gets told about our relation to one another, and about how reconciliation might work as "the 'new' way for Canada to relate to Indigenous people" (Simpson 21). This

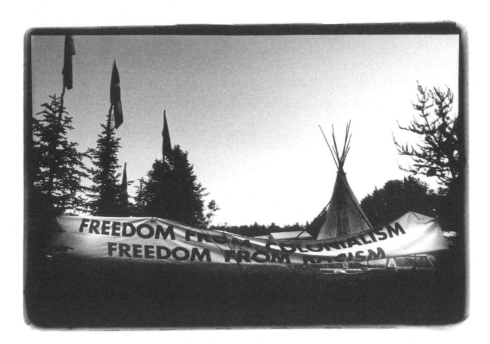

Jon Schledewitz. The longest running barricade in Canada, Grassy Narrows, Ontario.

is a continuation of colonial violence, as well as a dangerous violation of our own capacity to imagine and enact something different.

And so I think about barricades: the barricade as apparent threat, the barricade as unfathomable assertion, the barricade as the unwanted obstacle that stretches to its limits the tenuous fantasy of settler belonging. What if we instead understood the barricade—both as a physical barrier and as a practice of symbolic signification—less as an obstacle and threat, and more as something erected to protect "all of us" (McLean 118)? In her recent interview alongside activist-thinkers Russell Diabo and Lisa Monchalin, non-Indigenous Idle No More activist Sheelah McLean gives the example of grassroots land protection struggles from Oka to Grassy Narrows and observes that, through such struggles and their mainstream representation, "The Canadian public are socialized to believe that barricades are violent" (121). At sites of seemingly irreconcilable conflict between Indigenous and non-Indigenous communities, the barricade is mistaken in the mainstream as the violent embodiment of this impasse

rather than an opportunity for its transcendence. After all, there is no violence inherent to the barricade itself; its threat stems from its capacity to highlight the violence inherent in the colonial nation-state. Like the example of the Buffalo Commons map, then, the barricade could provide an opening onto a different relationship to land and to one another—one that both acknowledges the violence of settlement and resource extraction, and that affirms shared obligations to care-take the land for the well-being of future generations.

At the point of departure, both Armstrong and Younging suggest a kind of introspective process is necessary—but one that presumes interaction and collaboration with radical implications for social relations: this is reconciliation not "as vague and amorphous as a national hug (as it tends to be in forms such as conflict resolution or state apologies for past wrongs)" (Henderson 115), but as a material transformation made possible only by a dramatic shift in "headspace" and worldview on the part of non-Indigenous Canadians. This is to suggest that Indigenous and non-Indigenous peoples have different work to do in this shared process; that reconciliation might be less a process of coming together and then hurtling toward closure in the embrace of a shared national project, than a process of coming apart, of traveling separate if parallel paths of mutual obligation (S. Hill 23).

CONTRIBUTORS

JORDAN ABEL is a Nisga'a writer currently residing in Vancouver. Abel's conceptual writing engages with the representation of Indigenous peoples in Anthropology through the technique of erasure. He has been described as "a master carver of the page" who passes the work of sculpture along to the reader "who reads, and rereads, in three dimensions." Abel's chapbooks have been published by JackPine Press and Above/Ground Press, and his work has appeared in numerous magazines and journals across Canada, including *Prairie Fire*, EVENT, *dANDelion*, ARC, CV2, *The Capilano Review*, *Descant*, *Grain*, and *Canadian Literature*. He is an editor for *Poetry Is Dead* magazine and the former poetry editor for PRISM *international* and *Geist*. Abel's first book, *The Place of Scraps* (Talonbooks), was a finalist for the Gerald Lampert Memorial Award and the winner of the Dorothy Livesay Poetry Prize. *Un/inhabited*, Abel's second book, was co-published by Project Space Press and Talonbooks.

LEAH DECTER is an inter-media artist and scholar whose work includes video, digital media, installation, textiles, performance, critical collaboration, social practice, and writing. Based in Winnipeg, Treaty 1 territory, she has exhibited, presented on, and screened her work widely in Canada, including at the Winnipeg Art Gallery, Grunt Gallery, Dunlop Art Gallery, Images Festival, the Institute of Performance and Politic's Hemispheric Enquentro, and Trinity Square Video, and internationally in the US, UK, Australia, Germany, Malta, the Netherlands, and India. Her co-written and collaborative work (with Carla Taunton and Jaimie Isaac) has been published in *Fuse Magazine*'s Decolonizing Aesthetics issue and

West Coast Line's *Reconcile This!*. It also has been featured recently in *Studio: Craft and Design in Canada* and the *Journal of Canadian Art History*. Decter's work is primarily focused on considering histories and contemporary conditions of settler colonialism in Canada through a critical white settler lens, and rendering counter-narratives to dominant nationalist mythologies. Decter holds an MFA in New Media from Transart Institute (Berlin) and is currently a PHD Candidate in Cultural Studies at Queen's University (Kingston).

JONATHAN DEWAR is the Director of the Shingwauk Residential Schools Centre and Special Advisor to the President at Algoma University, where he leads research, education, and curatorial initiatives. From 2007 to 2012, he served as Director of Research and Evaluation at the Aboriginal Healing Foundation and he is a past director of the Métis Centre at the National Aboriginal Health Organization. Jonathan is of mixed heritage, descended from Huron-Wendat, Scottish, and French Canadian grandparents. His academic background is in Aboriginal literatures and drama (MA in Literature and Creative Writing) and Canadian and Indigenous Studies, with focuses on identity, (re)connection to culture and community, Indian Residential Schools and healing, and truth and reconciliation. A former SSHRC doctoral fellow, Jonathan is completing a doctorate in Canadian Studies at Carleton University. His research explores the role of art and artists in truth, healing, and reconciliation. Jonathan also served as the founding executive director of the Iqaluit, Nunavut-based Qaggiq Theatre Company from its inception in 2002 to 2006. While in Nunavut, Jonathan also served in senior roles with the Office of the Languages Commissioner of Nunavut and the Intergovernmental Affairs and Inuit Relations unit of Indian and Northern Affairs Canada.

DAVID GARNEAU (Métis) is Associate Professor of Visual Arts at the University of Regina. He is a painter of road kill and drive-by landscapes, Métis themes, maps, comics, and quilts. His paintings have been collected by The Canadian Museum of Civilization; Parliament Buildings; Indian and Inuit Art Collection; The MacKenzie Art Gallery; Mendel Art Gallery; Dunlop Art Gallery; The Glenbow Museum; NONAM, Zurich; Musée de la

civilisation, Québec City; and many other public and private collections. Garneau's curation and writing most often engage the collision of nature and culture, metaphysics and materialism, and contemporary Indigenous identities. He has curated several large group, two-person, and solo exhibitions and written numerous catalogue essays and reviews. He has recently given talks in Melbourne, Adelaide, New York, San Diego, Sacramento, Saskatoon, and keynote lectures in Sydney, Toronto, Edmonton, Sault Ste. Marie, and Vancouver. Garneau is currently working on curatorial and writing projects featuring contemporary Indigenous art and curatorial exchanges between Canada and Australia, and is part of a five-year, SSHRC funded curatorial research project, "Creative Conciliation."

AYUMI GOTO is a performance artist and painter, currently based in Kelowna, Traditional Okanagan Territory. Born in Canada, she draws upon her Japanese heritage to trouble sedimented notions of nation-building, cultural belonging, and political compulsions in her creative and critical work. She has served as the art facilitator at the Downtown Eastside Women's Centre in Vancouver, Traditional Coast Salish Territory. Ayumi guest co-edited the Summer 2012 issue of *West Coast Line, Reconcile This!*, which explores the interconnections between reconciliation, art, and activism through Indigenous and non-Indigenous perspectives and exchanges. Ayumi is pursuing her PhD in Communication Studies at Simon Fraser University, where she is exploring notions of radical inclusion and deep collaboration as expressed in the works and practices of Cree Métis multi-media artist Cheryl L'Hirondelle, Siksika interdisciplinary artist Adrian Stimson, and Tahltan performance artist Peter Morin. She is currently a Research Affiliate at the Centre for Indigenous Media Arts at UBC Okanagan.

ALLISON HARGREAVES and **DAVID JEFFERESS** are non-Indigenous scholars who live and work in unceded Syilx territory. Allison teaches Indigenous literatures and theory in the Department of Critical Studies at UBC, Okanagan Campus. Her current research investigates literary and policy interventions into the social issue of gendered colonial violence in Canada, looking to Indigenous women's writing as an intellectual contribution to

contemporary feminist anti-violence debate. David teaches courses in post-colonial studies in the same department. His book, *Postcolonial Resistance* (2008), theorizes reconciliation as a means of social transformation, and his current research critically assesses the "relations" imagined within contemporary humanitarian discourses. Their current collaborations focus on community-based dialogues on the idea of reconciliation and decolonization in both local and global contexts.

GABRIELLE L'HIRONDELLE HILL is a Métis artist from Vancouver, BC, who works in drawing, sculpture, and public installation. Her work has been exhibited at Sunset Terrace, Gallery Gachet, Grunt Gallery, and Red Gate in Vancouver, BC; at the TRU Gallery in Kamloops, BC; and also at Get This! Gallery in Atlanta, GA. Gabrielle holds a BA with honors in English from Simon Fraser University (SFU) and a BFA in Visual Arts, also from SFU.

JAIMIE ISAAC is a Winnipeg-based freelance curator, writer, artist, and arts administrator, is of Anishnabe and British heritage, and is a member of Sagkeeng First Nation from Treaty 1 Territory. Isaac holds a degree in Art History and an Arts and Cultural Management Certificate from the University of Winnipeg, and is completing graduate studies at the University of British Columbia Okanagan on Indigenous Curatorial Praxis. Jaimie has published essays, presented and participated at national and international conferences and artist residencies, and has curated and exhibited work nationally. She is a member of The Ephemerals Collective with Niki Little and Jenny Western. Jaimie has worked in several capacities with Indigenous organizations and communities, served on juries and committees, and volunteered on the boards of Urban Shaman Gallery, Aboriginal Curatorial Collective, National Indigenous New Media Coalition, and Aboriginal Music Manitoba Inc. Through academic, curatorial, and artistic interests, she engages interdisciplinary areas of reconciliation, Indigenous feminism, identity, representation, social justice, resistance, and decolonization.

LAYLI LONG SOLDIER holds a BFA in creative writing from the Institute of American Indian Arts and an MFA with Honors from Bard College. She resides in Tsaile, AZ, on the Navajo Nation and is an adjunct faculty member

at Diné College. She has served as a contributing editor to *Drunken Boat*. Her poems and critical work have appeared in *The American Poet, The American Reader, The Kenyon Review Online, American Indian Journal of Culture and Research*, PEN *America*, and *The Brooklyn Rail*. Her first chapbook of poetry is titled *Chromosomory* (Q Ave Press, 2010) and her forthcoming manuscript is titled *Whereas*.

SOPHIE McCALL is a settler scholar and Associate Professor in the English department at Simon Fraser University. Over the past four years, she has worked in a collaborative research group investigating the relationship between art and reconciliation, and was the Principal Investigator for a SSHRCC Public Outreach Grant, Reconciliation: Work(s) in Progress— An Innovation Forum, in 2012–13. She has published articles and scholarly chapters in the areas of Indigenous literatures, reconciliation, and decolonization. Her book, *First Person Plural: Aboriginal Storytelling and the Ethics of Collaborative Authorship* (UBC Press, 2011), was a finalist for the Gabrielle Roy Prize for English Canadian literary criticism and the Canada Prize from the Federation for the Humanities and Social Sciences for scholarly work in the Humanities. She is the editor of *Anahareo's Devil in Deerskins: My Life with Grey Owl* (University of Manitoba Press, 2014).

PETER MORIN is a Tahltan Nation artist, curator, and writer who recently relocated from British Columbia to Brandon, MB, where he joined the Visual and Aboriginal Arts Faculty at Brandon University. Morin studied art at Emily Carr University of Art + Design and recently completed his MFA at the University of British Columbia, Okanagan in 2011. In both his artistic practice as well as his curatorial work, Morin's practice-based research investigates the impact between Indigenous cultural-based practices and western settler-colonialism. This work, defined by Tahltan Nation epistemological production, often takes on the form of performance interventions, and also includes object and picture making. Morin has participated in numerous group and solo exhibitions including *Team Diversity Bannock* and the *World's Largest Bannock* attempt (2005), *A return to the place where God outstretched his hand* (2007); performative works at the Royal Ontario Museum, Toronto; *12 Making Objects*

AKA *First Nations* DADA *(12 Indigenous Interventions)* (2009) at Open Space, Victoria; *Peter Morin's Museum* (2011) at Satellite Gallery, Vancouver; and *Circle* (2011) at Urban Shaman in Winnipeg. In addition to his art making and performance-based practice, Morin has curated exhibitions at the Museum of Anthropology, Western Front, Bill Reid Gallery, and Burnaby Art Gallery.

THE NEW BC INDIAN ART AND WELFARE SOCIETY COLLECTIVE is an Indigenous artist collective interested in exploring questions of site, land, and the Indigenous imaginary. Our name references The British Columbia Indian Arts and Welfare Society, a mid-twentieth century organization that sought to advance Indigenous art as a means to promote awareness about and economic opportunity for Indigenous people. Our name is ironic and suggests the paternalistic bureaucracies surrounding Indigenous life in this province and country. The NBCIAWSC articulates our work within these histories and also through a process of engagement with Indigenous thought, spirituality, languages, and interactions with the land.

SKEENA REECE is the Tsimshian/Cree daughter of Red Power radical Cleo Reece and internationally renowned carver Victor Reece. An international multimedia artist whose work includes performance art, spoken word, "sacred clowning," writing, singing, and video art, Reece has performed at venues including The Power Plant, Toronto (2012), Modern Fuel, Kingston, ON (2011), 17th Biennale of Sydney (2010), Nuit Blanche, Toronto (2009), LIVE Biennale, Vancouver (2009), the UBC Museum of Anthropology (2008), and the National Museum of the American Indian, Washington, DC (2008). Reece studied at Northwest Community College and Emily Carr University of Art + Design and trained at the Banff Centre and Grunt Gallery as a curatorial practices intern. Reece is the recipient of the 2012 BC Creative Achievement Award for First Nations Art.

DYLAN ROBINSON is a Stó:lō scholar, Assistant Professor, and Canada Research Chair in Indigenous Arts at Queen's University. le xwel totí:lt te halq'eméylem sqwéltel. His publications include the collection *Opera Indigene*, co-edited with Pamela Karantonis, while his current research focuses on Indigenous art and performance interventions in public space.

Forthcoming work includes an edited volume on the aesthetics of recon-
ciliation with Wilfrid Laurier Press (co-edited with Keavy Martin) and
a collection on Indigenous musical modernity (co-edited with Victoria
Lindsay Levine).

SANDRA SEMCHUK is a storyteller, photographer, and video artist whose in-
quiry includes small animals that like to count coup on her, coming close
enough to make it impossible for her to video them. Her collaborations
and video works use the familial, autobiography, and dialogue as the basis
for recognition and identity across generations, cultures, and species. She
says, "it is important for those of us that share this land to listen with our
hearts, to move out of denial and to recognize the complex intergenera-
tional effects of our conflicted histories." As a partner in Treaties, mem-
ber of the settler culture, and widow of Cree orator and co-collaborator,
James Nicholas, Semchuk works with dialogue to disrupt myths that have
shaped settler relations to First Nations. She considers the larger more-
than-human world, flora, and fauna in order to glimpse possible relation-
ships between the Indigenous and the non-Indigenous. She incorporates
lenticular imagery, video including 3D technologies, and, most recently,
vocables and overtone singing to converse across constructed bounda-
ries. Her works have shown at Presentation House Gallery, Vancouver;
Mendel Art Gallery, Saskatoon; Center for Creative Photography, Tucson,
Arizona; San Francisco Museum of Modern Art; fotofeis in Scotland;
Museu D'art Contemporani in Barcelona; Urban Shaman in Winnipeg;
Canadian Museum of Contemporary Photography in Ottawa; and at the
Chapel Gallery in North Battleford, Saskatchewan. Semchuk is complet-
ing a book on Ukrainians in Canada, *The Stories Were Not Told, Stories
and Photographs from Canada's First Internment Camps, 1914-1920.* She
teaches at Emily Carr University.

ADRIAN STIMSON is a member of the Siksika (Blackfoot) Nation in south-
ern Alberta. He is an artist, curator, and educator with a BFA with dis-
tinction from the Alberta College of Art & Design and an MFA from
the University of Saskatchewan. As an interdisciplinary artist, Adrian's
work includes painting, installation, sculpture, and performance. Recent

exhibits and performances include Agnes Etherington Art Centre, Queen's University; *Sovereign Acts*, Southern Alberta Art Gallery; *Story Telling: Contemporary Native Art Biennial*, Art Muir, Montreal; *Witnesses* at the Belkin Gallery, UBC, Vancouver; *Reconsidering Reconciliation*, Kamloops; *Buffalo Boy's Coal Jubilee*; *House of the Wayward Spirits-* ANDPVA, Toronto; *White Shame Re-Worked*, Grunt Gallery, Vancouver; *Photo Quai*, Musee du Quai Branly, Paris, France. Adrian was awarded the Blackfoot Visual Arts Award in 2009, the Queen Elizabeth II Golden Jubilee Medal in 2003, and the Alberta Centennial Medal in 2005.

CLEMENT YEH holds a BFA in Drawing from the Alberta College of Art + Design and an MFA in Sculpture from Concordia University. His interests range widely across beauty, social injustice, environmentalism, craft, feminism, human rights, design, eroticism, pop culture, science fiction/ fantasy, and whatever else catches his fancy. He finds daily inspiration everywhere around him, and always seeks to make contemporary visual art accessible to the general public. Complementing his personal studio practice is Makerbros.com, his Montreal-based custom prop/sculpture company in partnership with sculptor Ian Langohr.

KEREN ZAIONTZ is Assistant Professor in the Department of Film and Media at Queen's University. Her research examines a range of cultural practices from socially-engaged performance to international arts festivals and mega events. Her publications include essays in *Theatre Journal*, *Theatre Research International*, *Performance Research*, *Contemporary Theatre Review*, and *Canadian Theatre Review*. Her book chapters have appeared in anthologies on site-specific performance and global festivals. Keren is currently writing a book for Palgrave Macmillan's Theatre & series, *Theatre & Festivals*.

WORKS CITED

Aboriginal Affairs and Northern Development Canada. "Fact Sheet: Treaties with Aboriginal People in Canada." Aboriginal Affairs and Northern Development Canada, February, 2010. Web. 14 July 2014.

Ades, Dawn, ed. *The Colour of My Dreams: The Surrealist Revolution in Art*. Vancouver: Vancouver Art Gallery, 2011. Print.

Alfred, Gerald Taiaiake. "Opening Words." *Lighting the Eighth Fire: The Liberation, Resurgence, and Protection of Indigenous Nations*. Ed. Leanne Simpson. Winnipeg: ARP, 2008. 9-11. Print.

—. *Peace, Power, Righteousness: An Indigenous Manifesto*. Don Mills: Oxford UP, 1999. Print.

—. "Restitution is the Real Pathway to Justice for Indigenous Peoples." In Younging, Dewar, and DeGagné (eds), 179-87. Print.

—. *Wasáse: Indigenous Pathways of Action and Freedom*. Toronto: U Toronto P, 2005. Print.

Archibald, Linda and Jonathan Dewar. "Creative Arts, Culture, and Healing: Building an Evidence Base." *Pimatisiwin* 8.3 (2010): 1-25. Web. 28 November 2014.

Armstrong, Jeannette. "The Disempowerment of First North American Native Peoples and Empowerment through Their Writing." *Gatherings V*. Ed. David Gregoire. Penticton: Theytus, 1990. 141-46. Print.

—. "History Lesson." *Breath Tracks*. Stratford: Williams-Wallace/Theytus, 1991. 28-29. Print.

—. "Literature of Our Land: An Ethos for These Times." *Literature For Our Times: Post-Colonial Studies in the Twenty-First Century*. Ed. Bill Ashcroft, Ranjini Mendis, Julie McGonegal, and Arun Mukherjee. Amsterdam: Rodopi, 2012. 345-56. Print.

Barman, Jean. "Erasing Indigenous Indigeneity in Vancouver." *BC Studies* 155 (2007): 3-30. Print.

Beaucage, Marjorie, dir. *Ayum-ee-aawach Oomama-mowan: Speaking to Their Mother*. mjb entre-prises, 1992. Film.

Belcourt, Christi. Interview. "Walking With Our Sisters." *Muskrat Magazine*, 5 September 2014. Web. 18 November 2014.

Belmore, Rebecca. "Ayum-ee-aawach Oomama-mowan: Speaking to Their Mother." *Rebecca Belmore*. Web. 11 November 2014.

Belshaw, John Douglas. "The Lost Plague: Why We Have Forgotten One of Canada's Most Devastating Smallpox Epidemics." *The Walrus*, May 2013. Web. 25 November 2014.

Bhabha, Homi K. "Democracy De-Realized." *Diogenes* 50.1 (2003): 27-35. Print.

Blackstock, Cindy. "Community-Based Child Welfare for Aboriginal Children: Supporting Resilience Through Structural Change." *Social Policy Journal of New Zealand* 24 (2005): 12-33. Web.

Boisjoly, Raymond. The Banff Centre. Banff, AB. 4 November 2014. Artist Talk.

Bose, Chris. *Jesus Coyote Died for Your Sins*. Digital Image. 2008. *Urban Coyote Teevee*. Web. 11 Nov. 2014.

Breton, André. "Le Cadavre Exquis." *Surrealism*. Ed. Patrick Waldberg. NY: McGraw-Hill, 1971. 93-94. Print.

—, and Paul Eluard. *Dictionnaire abrégé du surréalisme*. Paris: José Corti, 1991. Print.

British Columbia, Ministry of Aboriginal Relations and Reconciliation. "Aboriginal Arts Development Awards." Web. 14 July 2014.

British Columbia Treaty Commission. "Negotiation Update." 2009. Web. 30 November 2014.

Brooks, Roy L. "The Age of Apology." *When Sorry Isn't Enough: The Controversy over Apologies and Reparations for Human Justice*. Ed. Roy. L. Brooks. New York: New York UP, 1999. 3-11. Print.

Brown, Lorna and Clint Burnham, eds. *Digital Natives*. Vancouver: Other Sights for Artists' Projects and City of Vancouver Public Art Program, 2011. Print.

Campbell, Maria and Linda Griffiths. *The Book of Jessica*. Toronto: Coach House, 1989. Print.

Canada. "The Commission's Terms of Reference." *Looking Forward, Looking Back: Report of the Royal Commission of Aboriginal Peoples*. Ottawa: Minister of Supply & Services, 1996. 699-702. Print.

Castellano, Marlene Brant, Linda Archibald, and Mike DeGagné, eds. *From Truth to Reconciliation: Transforming the Legacy of Residential Schools*. Ottawa: Aboriginal Healing Foundation, 2008. Print.

de Certeau, Michel. *The Practice of Everyday Life*. Trans. Steven F. Rendall. Berkeley: U California P, 1984. Print.

Chambers, Natalie A. "Reconciliation: A Dangerous Opportunity to Unsettle Ourselves." In Younging, Dewar, and DeGagné (eds), 285-305. Print.

Christian, Dorothy and Victoria Freeman. "The History of a Friendship, or, Some Thoughts on Becoming Allies." *Alliances: Re/Envisioning Indigenous-Non-Indigenous Relationships*. Toronto: U Toronto P, 2010. 376-90. Print.

Churchill, Ward. "I Am Indigenist: Notes on the Ideology of the Fourth World." *Acts of Rebellion: the Ward Churchill Reader*. New York: Routledge, 2003. 275-300. Print.

City of Vancouver. "City and Aboriginal Leaders Celebrate Year of Reconciliation," 27 June 2014. Web. 30 November 2014.

—. "Motion 3: Designating Vancouver a City of Reconciliation," 8 July 2014. Web. 30 November 2014.

—. "Motion 6: The Protocol to 'Acknowledge First Nations Unceded Traditional Territory,'" 26 June 2014. Web. 30 November 2014.

—. "'Olympic Village Chronology of Events and Community Benefits.' Backgrounder –
 Fact Sheet," April 28, 2014. Web. 29 April 2014.

—. "Platforms: Art Marking Vancouver's Year of Reconciliation," 14 July 2014. Web.
 20 July 2014.

Claxton, Dana. RE:WIND: Transference Tradition Technology: Native New Media Exploring Visual
 and Digital Culture. Banff: Walter Phillips Gallery, 2005. Print.

Coetzee, J. M. Giving Offense: Essays on Censorship. Chicago: Chicago UP, 1996. Print.

Coulthard, Glen. Red Skin, White Masks: Rejecting the Colonial Politics of Recognition.
 Minneapolis: U Minnesota P, 2014. Print.

—. "Subjects of Empire: Indigenous Peoples and the 'Politics of Recognition' in Canada."
 Contemporary Political Theory 6:4 (2007): 437–60. Web.

David, Daniel. Foreword. People of the Pines: The Warriors and the Legacy of Oka. Geoffrey
 York and Loreen Pindera. Toronto: Little, Brown & Co, 1991. 9-12. Print.

Dewar, Jonathan and Ayumi Goto, eds. Reconcile This! Special Issue of West Coast Line 74
 (2012). Print.

Felipe, Alex. "Biimadasahwin – Cabin Build." Online video. YouTube. YouTube, 3 June 2013.
 Web. 11 November 2014.

Fletcher, Vanessa Dion. "Writing Landscape." In Dewar and Goto (eds), 80-87.

Fontaine, Theodore. Broken Circle: The Dark Legacy of Indian Residential Schools: A Memoir.
 Victoria: Heritage House, 2010. Print.

Fragnito, Skawennati Tricia. "Five Suggestions for Better Living." On Aboriginal
 Representation in the Gallery. Ed. Lynda Jessup and Shannon Bagg. Ottawa: Canadian
 Museum of Civilization, 2002. 229-37. Print.

Francis, Margot. Creative Subversions: Whiteness, Indigeneity, and the National Imaginary.
 Vancouver: UBC P, 2011. Print.

Garneau, David. "Imaginary Spaces of Conciliation and Reconciliation." In Dewar and Goto
 (eds), 28-38. Print.

Govier, Trudy. "What Is Acknowledgement and Why Is It Important?" Dilemmas of
 Reconciliation: Cases and Concepts. Ed. Carol Prager and Trudy Govier. Waterloo: Wilfred
 Laurier UP, 2003. 65-89. Print.

Greene, Joyce. "Towards a Detente with History: Confronting Canada's Colonial Legacy."
 International Journal of Canadian Studies 12 (1995): 85-105. Print.

Hall, Sheila. "The Site of To Connect." Web. 29 April 2014.

Henderson, James (Sa'ke'j) Youngblood. "Incomprehensible Canada." In Henderson and
 Wakeham (eds), 115-26. Print.

Henderson, Jennifer and Pauline Wakeham. "Colonial Reckoning, National Reconciliation?:
 Aboriginal Peoples and the Culture of Redress in Canada." ESC: English Studies in Canada
 35.1 (2009): 1-26. Print.

—, eds. Reconciling Canada: Critical Perspectives on the Culture of Redress. Toronto: U Toronto P,
 2013. Print.

Hill, Susan M. "'Travelling Down the River of Life Together in Peace and Friendship, Forever': Haudenosaunee Land Ethics and Treaty Agreements as the Basis for Restructuring the Relationship with the British Crown." In Simpson and Ladner (eds), 23-45. Print.

House of Commons Apology to Inuit, Métis, and First Nations Peoples for Residential Schools, 2008. Appendix A: Aboriginal Peoples and Residential Schools. In Henderson and Wakeham (eds), 335-39. Print.

Howell, Mike. "First Nations People Make Up 30 per cent of Vancouver's Homeless." *Vancouver Courier*, 15 October 2013. Web. 30 November 2014.

Janvier, Alex. "Alex Janvier: Reflections (Remarks and Interview)." In Dewar and Goto (eds), 12-21. Print.

Joe, Rita. "I Lost My Talk." *An Anthology of Canadian Native Literature in English.* 3rd ed. Ed. Daniel David Moses and Terry Goldie. Don Mills: Oxford UP, 2005. 107. Print.

Kelowna: The First 100 Years. CHBC Television, Kelowna, BC, 2005. DVD.

Kun, Krisztina. "Raising the Roof: Housing Activism in Vancouver's Downtown Eastside." *Upping the Anti* 4 (2007). Web. 2 December 2014.

Kwon, Miwon. *One Place After Another: Site-Specific Art and Locational Identity.* Cambridge: MIT P, 2002. Print.

LaDuke, Winona. *Recovering the Sacred: The Power of Naming and Claiming.* Cambridge: South End P, 2005. Print.

Lee, Jeff. "Some Key Facts Missing from Vancouver's Olympic Village Debt Story." Civic Lee Speaking, *Vancouver Sun,* 29 April 2014. Web. 29 April 2014.

Lepecki, André. *Exhausting Dance: Performance and the Politics of Movement.* New York: Routledge, 2006. Print.

Levasseur, John. "People on the Prairies Less Tolerant," CBC News, 16 November 2014. Web. 17 November 2014.

Levin, M. Simon and Henry Tsang, eds. *collective echoes: projects for public space.* Vancouver: collective echoes, 2006. Web. 14 July 2014.

L'Hirondelle, Cheryl, Elwood Jimmy, and Chris Bose. "Songlines, Stories and Community Engagement – A Conversation." In Dewar and Goto (eds), 94-106. Print.

Ljunggren, David. "Every G20 Nation Wants to Be Canadian, Insists PM," Reuters 25 September 2009. Web. 15 October 2014.

Loft, Steven. "Reconciliation ... Really? From MacDonald to Harper: A Legacy of Colonial Violence." In Dewar and Goto (eds), 38-45. Print.

Lowry, Glen and Eugene McCann. "Asia in the Mix: Urban Form and Global Mobilities – Hong Kong, Vancouver, Dubai." *Worlding Cities: Asian Experiments and the Art of being Global.* Ed. Ananya Roy and Aihwa Ong. Oxford: Blackwell, 2011. Print.

Mackey, Eva. *The House of Difference: Cultural Politics and National Identity in Canada.* Toronto: U Toronto P, 2002. Print.

Macoun, Alissa and Elizabeth Strakosch. "The Ethical Demands of Settler Colonial Theory." *Settler Colonial Studies* 3.3-4 (2013): 426-43. Web. 16 November 2014.

Martin, LeeAnn. "Remembering Our Future." *Close Encounters: The Next 500 Years*. Ed. Sherry Farrell Racette. Winnipeg: Plug In, 2011. Web. 15 October 2014.

Mauzé, Marie. "Totemic Landscapes and Vanishing Cultures: Through the Eyes of Wolfgang Paalen and Kurt Seligmann." *Journal of Surrealism and the Americas* 2.1 (2008): 1-24. Print.

McIllwraith, Thomas. *'We Are Still Didene': Stories of Hunting and History From Northern British Columbia*. Toronto: U Toronto P, 2012. Print.

McKay, Stan. "Expanding the Dialogue on Truth and Reconciliation – In a Good Way." In Castellano, Archibald, and DeGagné (eds), 101-15. Print.

McLean, Sheelah. "From Idle No More to Indigenous Nationhood: Growing Roots, Upholding Sovereignty, and Defending the Land." Roundtable interview by PJ Lilley and Jeff Shantz, with Russell Diabo and Lisa Monchalin. *Upping the Anti: A Journal of Theory and Action* 15 (2013): 113-27. Print.

McLeod, Neal. Email to Gabrielle Hill, 15 October 2014.

Metro Vancouver. Media release. "New Metro Vancouver Pumping Station Benefits the Environment and Celebrates Gastown's History," 17 October 2008. Web. 30 November 2014.

Monture, Patricia A. "White man tell me." *First Voices: An Aboriginal Women's Reader*. Ed. Patricia A. Monture and Patricia D. McGuire. Toronto: Inanna, 2009. 291-92. Print.

Morgensen, Scott L. "The Biopolitics of Settler Colonialism: Right here, Right Now." *Settler Colonial Studies* 1.1 (2011): 52-76. Print.

Pember, Mary Annette. "Tiny Horrors: A Chilling Reminder of How Cruel Assimilation Was - And Is." *Indian Country Today*, 1 January 2014 . Web. 6 November 2014.

Porter, Jody. "Homeless Woman Fined for Building Her Own Home." CBC News, 7 November 2014. Web. 11 November 2014.

Povinelli, Elizabeth. *The Cunning of Recognition*. Durham: Duke UP, 2003. Print.

"Poverty Activists Satirize Condo King, Vancouver Mayor.' CTV News, 15 May 2011. Web. 7 July 2014.

Razack, Sherene. "Memorializing Colonial Power: The Death of Frank Paul." *Law & Social Inquiry* 37.4 (2012): 908-32. Print.

—. "Stealing the Pain of Others: Reflections on Canadian Humanitarian Responses." *Review of Education, Pedagogy, and Cultural Studies* 29.4 (2007): 375-94. Print.

Reece, Skeena. *Touch Me. Witnesses: Art and Canada's Indian Residential Schools*. Vancouver: Belkin Art Gallery, 2013. Web. 14 July 2014.

Regan, Paulette. "An Apology Feast in Hazelton: Indian Residential Schools, Reconciliation, and Making Space for Indigenous Legal Traditions." *Indigenous Legal Traditions*. Vancouver: UBC P, 2007. 40-76. Print.

— *Unsettling the Settler Within: Indian Residential Schools, Truth Telling, and Reconciliation in Canada*. Vancouver: UBC P, 2011. Print.

Rice, Brian and Anna Snyder. "Reconciliation in the Context of a Settler Society: Healing the Legacy of Colonialism in Canada." In Castellano, Archibald, and DeGagné (eds), 43-61. Print.

Riddington, Robin. *Little Bit Know Something: Stories in a Language of Anthropology*. Iowa City: U Iowa P, 1990. Print.

Salloum, Jayce, Dir. "Terra incognita." Alternator Gallery for Contemporary Art. 2005. DVD.

Scherer, Jay. "Crisis of Capitalism and Deficits of Democracy: Lessons from Vancouver's Olympic Village Development." *Institute for Culture and Society Occasional Papers Series* 4.1 (May 2013). Web. 29 April 2014.

Schueing, Ruth and Ingrid Bachmann. *Material Matters: The Art and Culture of Contemporary Textiles*. Toronto: YYZ, 1998. Print.

Simon, Roger. "Afterword: The Turn to Pedagogy: A Needed Conversation on the Practice of Curating Difficult Knowledge." *Curating Difficult Knowledge: Violent Pasts in Public Places*. Ed. Erica Lehrer, Cynthia E. Milton, and Monika Eileen Patterson. New York: Palgrave, 2011. 193-209. Print.

—. "Worrying Together: The Problematics of Listening and the Educative Responsibilities of the IRSTRC." Paper presented at *Breaking the Silence: International Conference on the Indian Residential Schools of Canada*. Montréal: U de Montréal, 2008.

Simpson, Leanne Betasamosake. *Dancing on Our Turtle's Back: Stories of Nishnaabeg Re-Creation, Resurgence and a New Emergence*. Winnipeg: ARP, 2011. Print.

—. "Restoring Nationhood: Addressing Land Dispossession in the Canadian Reconciliation Discourse," 13 November 2013. Vancouver: SFU's Vancity Office of Community Engagement. Web. 14 July 2014.

— and Kiera Ladner, eds. *Lighting the Eighth Fire: The Liberation, Resurgence, and Protection of Indigenous Nations*. Winnipeg: ARP, 2008. Print.

O Siyam: Aboriginal Art Inspired by the 2010 Olympic and Paralympic Winter Games. Vancouver Organizing Committee for the 2010 Olympic and Paralympic Winter Games. Mississauga: John Wiley, 2010. Print.

Smith, Linda Tahiwai. *Decolonizing Methodologies: Research and Indigenous People*. London: Zed, 1999. Print.

Statement of Apology to Former Student of Residential School, 11 June 2009. House of Commons Debates: 39th Parliament, 2nd Session, Number 110. Ed. Hansard. Web. October 2011.

Stimson, Adrian. "Suffer Little Children." In Dewar and Goto (eds), 68-78.

Sullivan, Sean. "Activists threaten to turn Vancouver Olympic Village into 'tent city.'" Postmedia News, 19 December 2010. Web. 7 July 2014.

"The Thunderbird." The Vancouver Police Department, City of Vancouver. Web. 29 April 2014.

Thomas, Jeff. *Where Are The Children? Healing The Legacy of The Residential Schools*. Ottawa: Legacy of Hope Foundation, 2003. Print.

Thwaites, Reuben Gold, ed. *The Jesuit Relations and Allied Documents: Travels and Explorations of the Jesuit Missionaries in New France, 1610-1791*. Cleveland: Burrows, 1901. Print.

Truth and Reconciliation Commission of Canada. "Establishment, Powers, Duties and Procedures of the TRC." *Mandate: Schedule N of Indian Residential Schools Settlement Agreement*, 11 February 2009. Web. 21 August 2013.

—. "Open Call for Artistic Submissions," 29 July 2010. Web. 14 July 2014.

Tsang, Henry. "Welcome to the Land of Light," Permanent public art commission, Vancouver, 1997. Web. 29 April 2014.

Tuer, Dot. "Performing Memory: The Art of Storytelling in the Work of Rebecca Belmore." *Mining the Media Archive: Essays on Art, Technology, and Cultural Resistance.* Toronto: yyz, 2005. 35. Print.

Van Gelder, Sarah. "Why Canada's Indigenous Uprising Is about All of Us." *Yes! Magazine,* 7 February 2013. Web. 10 November 2014.

VANOC. Vancouver Organizing Committee for the 2010 Olympic and Paralympic Winter Games media relations. "Vancouver 2010 Olympic Truce Installations to encourage peaceful conduct among athletes at Games, leave legacy," 9 February 2010. Web. 29 April 2014.

Walking With Our Sisters Collective. "A Commemorative Art Installation for the Missing and Murdered Indigenous Women of Canada and the United States," 2014. Web. 28 October 2014.

Younging, Gregory. "Inherited History, International Law, and the UN Declaration." In Younging, Dewar, and DeGagné (eds), 323-36. Print.

Younging, Gregory, Jonathan Dewar, and Mike DeGagné, eds. *Response, Responsibility, and Renewal: Canada's Truth and Reconciliation Journey.* Ottawa: Aboriginal Healing Foundation, 2009. Print.

NOTE ON THE PROCEEDS FROM *THE LAND WE ARE*

Royalties from the sale of *The Land We Are* will be donated to the Unis'tot'en Camp, an Indigenous resistance community that has re-occupied traditional Unis'tot'en Clan lands in northern British Columbia in order to protect the land from multiple proposed pipelines. Since 2010, the Unis'tot'en have been working with their neighbours in the Likhts'amisyu Clan, the Gidem'ten Clan, and with other Indigenous and non-Indigenous allies to block access to their territory. They have built a log cabin, a traditional pit house, and a forest permaculture garden in the route of two proposed gas pipelines and the Enbridge Northern Gateway tar sands pipeline.

For more information go to **unistotencamp.com**

SHINGWAUK
RESIDENTIAL
SCHOOLS
CENTRE

WE GRATEFULLY ACKNOWLEDGE THE SHINGWAUK RESIDENTIAL SCHOOLS CENTRE (SRSC) FOR THEIR ONGOING SUPPORT OF THIS PROJECT.

SRSC is a cross-cultural research and educational development project of Algoma University, the Children of Shingwauk Alumni Association, and the National Residential School Survivor Society. Shortly after the closure in 1970 of the Shingwauk Indian Residential School, and in the early years of Algoma University College's relocation to the present site, Residential School Survivors who were connected to the Shingwauk School, along with their families, communities, and allies, became catalysts in the growing Healing Movement. Their efforts culminated in the development of the Shingwauk Project in 1979 and the Shingwauk Reunion in 1981. From these watershed events began the decades-long work of organizing, collecting, displaying, conducting research, and educating the public that led to the establishment of the Children of Shingwauk Alumni Association (CSAA) and the Shingwauk Project, now known as the Shingwauk Residential Schools Centre (SRSC), respectively. The SRSC is a partnership between Algoma University and the CSAA governed independently by the partners' Heritage Committee, which is majority Survivor-led, overseeing the mandated work of "sharing, healing, and learning."